for MICK
MIKE
MICHAEL
all of 'em
Cheers
BOFF manley X

🔊 talk about Oxfam's charity work and how
your £2.25 purchase will help their work,
by which time you've stopped listening to
David and you're picturing yourself in one
of those ancient booths that record stores
used to have, where you'd listen to a record
while you wondered whether to buy it.
"Kindly do so at once!"
 It's the aural equivalent of a book blurb.
A sentence or three to convince you to take

it to the counter and buy it. Blurb—the
word is onomatopoeic, it's a sort of childlike
babble, a reduction of ninety thousand
words to something that sounds like a short
and unexpected vomit. The world's first
blurb appeared as a wraparound cover to a
1907 book by American humourist Gelett
Burgess. It featured a photograph of a
woman cupping a hand to her open mouth
and presumably calling out, "… if you
haven't bought it yet, kindly do so at once!"
Her invented name was Miss Belinda Blurb,
and the photograph's caption explained that
Miss Blurb was "in the act of blurbing."

But whatever a blurb is, it isn't a book.
It's an ad, a sales pitch, a foot in the door.
Authors write their own blurbs, of course,
but mostly they write them in the third
person, as if the dollops of praise come
from an outside eye, someone objective
and impartial.

Back to vinyl records for a minute. The
sleeve of XTC's 1978 album *Go 2* is made up
almost entirely of typewritten text. It begins:

This is a RECORD COVER. This
writing is the DESIGN upon the
record cover. The DESIGN is to help
SELL the record. We hope to draw
your attention to it and encourage
you to pick it up.

And so on. It's very David Frost, isn't it?
The story behind the sleeve is that designers
Hipgnosis created it firstly for Pink Floyd
—who rejected it. Then they tried to
convince Paul McCartney to use it. He too
turned it down. Finally, XTC's Andy
Partridge was visiting the Hipgnosis studios

to discuss their forthcoming album design and spotted the discarded mocked-up sleeve sitting forlornly beside a radiator. Partridge asked about the design—whose album was it intended for? Storm Thorgerson, Hipgnosis designer, shrugged and replied, "Well, it's just an idea. We'll sell it to anybody." Partridge's eyes lit up. "I love it. I'll have it." Significantly, the band's name and the title of the album appear only once among the five-hundred-plus words written on the sleeve, smothered by the modest, self-effacing description of the role of the blurb:

What we are really suggesting is that you are FOOLISH to buy or not buy an album merely as a consequence of the design on its cover.

Book blurbs very often have quotes from critics or notables on their sleeves, somehow garnered and begged-for in the gap between the book's completion and its publication. I don't know many critics and notables, and the ones I do know I've used up on previous books. Or I don't feel confident enough to approach these people and ask them to read my book and give me a quote for the sleeve. What if they don't like it?

> "I read *But* in a single sitting and didn't unearth one decent sentence. It was cock-eyed, fussy and generally awful."
> —Semi-famous person that the book publishers sent the book to

Blurbs are little stories which, like most other stories, come out all neat and tidy,

a few pithy descriptive sentences with a happy ending. But life isn't like that, is it? This book is about life's stories, and life doesn't have blurbs. Epitaphs, yes. Blurbs, no.

Infamous playwright Joe Orton ended up in prison for scrawling his own (very witty) blurbs in library books. Jeanette Winterson, who gets a few mentions in this book by dint of being *a*) a brilliant writer and *b*) from Accrington, once burned a pile of her own reissued books when she discovered that the blurbs on them were too "cosy, domestic and suburban."

It's tempting to simply make up some quotes for this blurb that you might read while you're in the bookshop browsing through the thousands of titles on the shelves. Make up something that might make you want to buy the book.

Here goes, then:

"I'd like to loudly declare that this is the best book I have ever read. *But—*"

Recently I visited the famous Parisian bookshop *Shakespeare and Company*. Actually, Casey and me rented a tiny room on the fifth floor of a higgledy-piggledy building right around the corner from the bookshop, purely by chance. The room was dirt cheap but very Parisian, with a view from the squeaky window towards the scaffolded Notre Dame opposite. I had to queue to get in the bookshop, as it's a haven for literary tourists. Or maybe they're all there because a famous Hollywood film they love once featured the shop (there

have been several). The sign above the reading room's entrance reads:

BE NOT INHOSPITABLE TO STRANGERS
LEST THEY BE ANGELS IN DISGUISE

Which somehow fits with this meandering around blurbs—I felt drawn to buy books in this shop which sells itself on its own history, felt compelled to be hospitable towards the books themselves, books that might just be angels in disguise. I scanned the blurbs and made my choices. True to form, I bought three, and while one was angelically beautiful (Maggie Nelson's poetic *Bluets*), the other two sit on a pile at home with bookmarks two chapters in, waiting for me to finish them.

> "I loved this book. Well, the first two chapters anyway. Then I got distracted and found something better to read."
> —Belinda Blurb

And since you've got this far, I'll hazard an actual blurb for this book. It's a book about stories, not the stories we read in books but the stories we live in. Stories that don't go where stories traditionally go, but instead head off in a different direction, sometimes coming back, but more often continuing to find new and surprising paths to follow. And that's about as much of a blurb as you'll get. And if you've got this far without buying this book, then
kindly do so at once!

[BUT—]

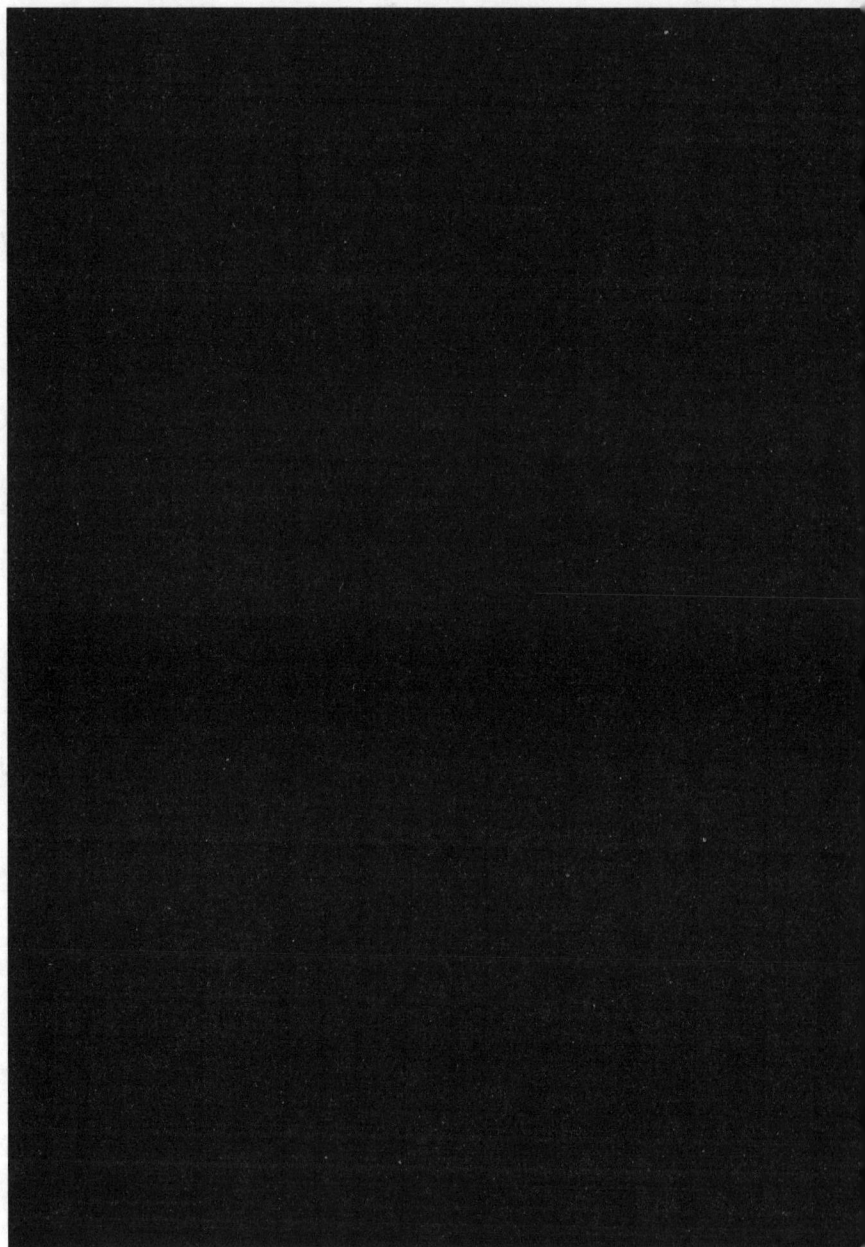

BOFF WHALLEY

BUT

——

LIFE ISN'T

LIKE THAT,

IS IT?

But: Life Isn't Like That, Is It?
Stories of Disruption and Digression
©2025 Boff Whalley

This edition ©2025 PM Press

ISBN 979-8-88744-089-7 (paperback)
ISBN 979-8-88744-091-0 (hardcover)
ISBN 979-8-88744-095-8 (ebook)
Library of Congress Control Number 2024939653

Copyediting by Wade Ostrowski
Typesetting and cover design by Bracketpress

10 9 8 7 6 5 4 3 2 1

PM Press
PO Box 23912
Oakland, CA 94623
www.pmpress.org

PRINTED
IN
U.S.A.

STORIES OF

DIS

RUPTION

AND

DIGRESSION

Contents

Dedicated to my dad.
Not the rubbish real one, the second, really good one.
The one who stayed curious and questioning
to the end.

Introduction

But first, a digression: This book is a series of stories and ideas that don't sit politely next to each other but instead fidget and shuffle and talk when they shouldn't be talking and spit chewed-up paper pellets at each other through the shells of biro pens. And in among the stories there is a thread of thank-yous, which I'll explain. I'll try to keep it short, since we haven't really got going yet and we have a lot to get through.

When I was growing up in Burnley, in amongst a Mormon upbringing and an obsession with playing football on the front street, I got to know about a group of misfits who were living in old caravans and trailers on some long-forsaken recreation ground near the town centre. One year these weirdly dressed characters held a procession sometime around bonfire night, parading through town playing loud music and carrying huge puppets and a massive bamboo-and-paper model of the Houses of Parliament. People from all over Burnley had been alerted to the spectacle, and the streets were lined with gawking, laughing kids; ten thousand people turned out to watch. At the end of the freakish procession, on the rough ground near their encampment, the Houses of Parliament were torched in a huge bonfire.

These people, I later found out, were called *Welfare State International*, a group of performance artists whose mission was to take art out of theatres and galleries and whose name suggested that they viewed art as essential to us all as education and health. To some of us kids, in our teens and in that hazy time before discovering punk rock, they made a lasting impression—they suggested a vision of the other, of something wildly different. They called themselves "engineers of the imagination." They made weirdness look like fun. They made art that danced around our streets, where we could see it and touch it. I didn't really understand it back then, but something about the spectacle made a huge impression on me. Got inside and stayed there.

[1]

A few years ago, Leeds Beckett University hosted a talk by two of the group's founders, John Fox and Sue Gill. This prompted me to look up Welfare State's ideas and history online, in particular their time in Burnley. I was shocked to read that, in the words of John and Sue, their work in the area had been "a failed experiment." That they had moved on from Burnley feeling like they hadn't been successful there. I found it really upsetting; I made a note to somehow tell them what an impact they had made (in a way they could never have noticed) on this fifteen-year-old boy. To assure them that their work mattered, that it had made its mark.

Over the next few months I kept thinking about John Fox and Sue Gill and about how they'd disrupted this teenage boy's life but didn't know it, and I decided to find them to say thank you. Because that's the thing, sometimes these rips in the fabric go unnoticed, and that doesn't seem right.

In o

st

So that's what we did, my wife Casey and me, we drove to John and Sue's strange and beautiful house teetering on the edge of the world in the south Lake District and sat down with a cup of tea and I told them the story you've just read, and I said, "Thank you."

:

r

It was a bit awkward, but they took it in the spirit it was intended and then we got on with the business of catching up with their lives and their work. A lovely afternoon in the company of inspiring people. Seeing them now, darting around to pick out books from their bookshelves and interrupting each other's stories, putting the kettle on again and offering us toast, it's hard to see them as *Disrupters*. But that's what they are, and as such they become the first such Disrupters to punctuate my life and this book. I'll call them *Disrupters No.1*, and through the book there'll be seven of these Disrupters' stories—journeys and road trips to meet and say thank you to a mixed bag of people who, often without realising it, knocked me off course and made the journey that much more interesting.

Digression over, back to the

ucture
d n
i

ALMOST ALL OF OUR STORIES FOLLOW THE SAME BASIC PATTERN: beginning, middle, end. That was Aristotle's version of the perfect dramatic structure, conceived 2,500 years ago; it works, and we stick to it. We have all sorts of words for the three "acts" that make a narrative arc:

O

Set-up, conflict and resolution
or
Exposition, action and climax
or
Introduction, confrontation and consequence
or even
Once upon a time, swordfight and happily ever after.

We're entrenched in this form—in novels, TV, film, theatre, jokes and just telling a story to your mate in the pub. It works. It's great. We're so happy with it that we use it to construct our own lives around it, wishing on ourselves a sort of neat and tidy way of letting people know who we are.

That's where I'm from
This is where I am
That's where I'm going.

I love the three-act structure; it's satisfying. It's a good way to make sense of the world, and it reinforces the idea that we can overcome life's obstacles.

The great Italian Jewish author Primo Levi was a survivor of the Nazi death camps. He wrote with great sadness and passion of the horrors he lived through—a story undeniably without, for most, a satisfying resolution. The Levi story I love above others is called "Rappaport's Testament," from the book *Moments of Reprieve*, a collection of personal stories of those who found ways to defy the German authorities in the concentration camps. I love "Rappaport's Testament" (with its central theme of "I never gave up"), because it offers hope. Sometimes, when the world is a bleak and unforgiving place, the traditional story structure reminds us of those moments of reprieve.

Here's another example of Aristotle's structure:

We'll be singing when we're winning (set-up)
I get knocked down (conflict)
But I get up again (resolution)

But—

Life doesn't often follow the three-act structure. Life gives us a million other kinds of stories. Stories that don't obey these rules, where events happen in the wrong order or with unexpected outcomes. Stories that give you a sense of where they're heading, that follow the accepted pattern, stories where everything happens in the way you know it's going to happen, *but*—but then it doesn't. Disrupted stories. Stories where the good guys lose. Stories where the bad girls win. Stories that just stop in the
middle.

Stories that fizzle out
or simply never get

going.
Stories that don't make sense. Stories that start where they should end and end where they should start. Stories that go round and round in a cyclical loop, forever. everevereverevereverevereverevereverevereverever...

Unfinished stories.

Unstarted stories.
 Stories that stutter and mumble, that
 cough and splutter. In short,
 life's stories are always prone to disruption
 and
 digression,
thwarting the neat storybook narrative we love so much.

But because we're so sold on the idea of Aristotle's narrative structure, because that traditional story is served up to us as some kind of perfect form, we're often surprised and disappointed when things don't go how we thought they'd go. And here's another idea: maybe it's because of our belief in the traditional *story resolution—the happily-ever-after—* that we're not doing enough to combat our biggest collective problems, like climate catastrophe. It's as if we're in a film where a disaster is threatening our existence but it's all right, someone will be along shortly to sort it all out and save the planet, like in the movies.

That's why this book is called *But*. Because the *but* is there to disrupt the easy normality of the way we tell our stories. Without a *but*, a story does what is expected of it and very little more. And that's not real life, is it? In reality, most lives come with a widespread scattering of *but*s. This book is a collection of stories that don't follow the accepted narrative structure, that instead stutter along in a series of unplanned disruptions and digressions—stories about real lives.

(Things didn't follow the perfect narrative arc for Aristotle either, whose own end was the result of a digestive complaint. The father of Poetics had plenty of stories left to tell, but at the age of only thirty-eight he died of tummy trouble.)

Some people make it their business to purposely

[6]

disrupt their own ongoing life stories. Malcolm McLaren, punk manipulator and cultural shape-shifter, made self-disruption his life's work. His great personal breakthrough came as a teenager when a teacher at art college told him not to be afraid of failure, that it's only by failing that we learn. McLaren adopted what we could call an anti-plan:

"Find a door you're not supposed to go through, and go through it."

His plan began when, as a sixteen-year-old, his mother got him a job as a trainee wine-taster. "But one day I followed some girls into St Martin's art school and saw a voluptuous woman sitting on a stool being sketched. I decided to get myself fired."

It's easy to see why Sex Pistols eventually became frustrated with McLaren's shock doctrine of unpredictability—McLaren wanted them to act out his own flamboyant disregard for the accepted rock 'n' roll narrative; he wanted chaos, not music. These four lads, they believed in the story as it's most often told, the one that takes a band from rags to riches and from pub stage to stadium. But...long before the chapter titled: STADIUM, McLaren had become bored with the book and started frantically tearing out pages and scribbling in the margins. He said:

What matters is this:
Being fearless of failure
arms you to break the rules.
In doing so, you may change the culture
and just possibly, for a moment,
change life itself.

Malcolm McLaren ended up living in Paris, a city he loved for its tradition of rebellion, saying it was a city "for wandering around and pretending you're Baudelaire." The streets of Paris were home to the Situationists, themselves heroes of McLaren, who championed the art of *dérive*, a walk without purpose or goal—a story whose middle and end would not be planned but would be chanced upon.

And it's precisely in the unplanned, in the unexpected, that the interesting stuff happens. It's not necessarily good stuff—the event that disrupts the story can be awful, calamitous, heartbreaking—but it so often makes the story that much more interesting.

The classic narrative structure, as used as a template by all film and TV writers, expands Aristotle's three acts into a slightly more nuanced five acts. It goes like this:

Set-up / Rising Action / Climax / Falling Action / Resolution

And somewhere in that forward slash
 between
 Set-up / and / Rising Action
 comes the
"Inciting Incident," the cause of all the action. The shark attack.

Life's *actual* narrative structure is neither three nor five acts, but is instead a rolling collection of Inciting Incidents, at various intervals, each with their own jumbled collection of actions and climaxes and resolutions, as un-neat and un-tidy as the tangle of wires, connectors, plugs and sockets behind the back of the telly.

Writer Rebecca Solnit talks of how real change often happens when cracks appear in the daily fabric of life. Sometimes these cracks are natural disasters—earthquakes, tsunamis, floods—and sometimes man-made disasters like financial crashes, mass unrest, collapsing governments. When these cracks appear, there is space to act.

The cracks are breaks in the narrative, the *but*s that cause the shifting tectonic plates that derail our stories. And when these cracks appear, everyday normalities can be questioned, new directions found. This book is, more or less, a collection of stories that

have grown through the cracks. It's also a way of saying, again and

<div align="right">

again and

again and

again and

again,

</div>

that **real-life stories don't
act like stories
are supposed to act.**

I have a drawing on my wall which I made when I was around six years old. It shows a boy in a claret-and-blue football shirt, kicking a brown ball through scribbled green grass. Above the figure—which is me—it says:

When I grow up

I Shall be a Footballer

It's the "shall be" that I love. Not "want to be," or "hope to be." I knew my story at that age, and nothing was going to derail it. At the age of eleven I was picked to play in the trials for the Burnley schoolboys' team—the trial was a rainy-afternoon match between Burnley East and Burnley West. I played as a left winger (I have no idea why. I'm right-footed. I can only assume I chose the position because I idolised Burnley's dynamic Welsh star Leighton James) and, at the end of the game, still in our muddy boots and kits in the sweat-stink shed of a changing room, I learned that I wasn't picked for the town team.

Suddenly the "shall be" disappeared. The best way that story could play itself out within the accepted storytelling rules would be if I took the tearful disappointment of that day and used it as defiant impetus to practise, practise, practise, until that fateful day when the team's star centre-forward is carried off injured—and I'm thrown on as a replacement, scoring a hat trick to win the match.

But that didn't happen. Instead, I started playing the cheap guitar that was in the cupboard under the stairs, got interested in pop art and the Liverpool poets, stopped going to church and waited for punk to come along and give me a stage to climb onto.

It's said that when you use the word *but* you negate everything that went before it. That's often true, but it isn't the real reason for the word. The purpose of *but* is to change direction. Force the story to go somewhere else. Somewhere real, somewhere true-to-life. And in that way, at least, the *but* becomes the part of the story that we recognise in our lives.

I get knocked down.

I tried to get up again, but didn't quite manage it. Wrote a book instead.

No. 1

Welfare State International

Normal is nothing more than a cycle on a washing machine.
—Whoopi Goldberg

John bends down awkwardly to fix the flagpole into its housing on the ground while Sue holds the pole steady. There's a wind getting up, whooshing in off the sea that's moving in slowly behind us, whistling up over the marshes towards the pebbled beach. On the flag is one of John's paintings of a hare, matching three other flags that the pair are setting up. Up along the beach there's a home-made waterfall constructed to carry water from the fields above to the sea, down a series of rickety wooden channels and wheels, and from here you can see that the house—where John and Sue live—is built on stilts. It's a properly home-made contraption of a building, constructed from reclaimed timber and found glass, oddly angled as if it's fighting against symmetry, and round its outside are signs, paintings and sculptures that the couple have tacked and fastened to posts and walls. The scene—flags, beach, house, John and Sue— is gloriously untamed.

John Fox and Sue Gill, performers, poets and theatre-makers, have been pitching their creative flags all their working lives, eight decades of creative energy and curiosity now based at the sea's edge at the foot of Cumbria on the Barrow coastline. There doesn't appear

to be any sign of them slowing down; they still travel around the country as "engineers of the imagination," teaching and exploring the role of ceremony and art through ritual and celebration. It's what they've always done—made challenging, fantastical art that rejoices in community and that encourages participation. As we head back inside the house, up misshapen steps and through into a room with a wall-length window that opens out onto the sea looking straight across Morecambe Bay, Sue puts the kettle on and John heads upstairs to ferret out some books he needs to show us.

Casey and me have driven up to this off-the-tourist-trail patch of the Lake District to talk, or rather to listen, to these two people who unwittingly redrew the course of my life. As they talk you can practically see the sparks of imagination, the bustle of ideas. "So anyway," I say when there's a pause enough to put down my cup of tea and speak, "I'm here to say thank you." And then I tell them a story, my story. The one about the recreation ground in Burnley and the bonfire and the puppets, the story with a narrative that changed direction.

That's my story, I tell them. A story that ends with a nervous thank you. As I suspected, Sue and John are too busy with the present to do much dwelling on the past (especially someone else's past), so they answer me by talking about whatever new adventures they're currently plotting and planning, sipping their tea among the bookshelves and paintings in the weirdly shaped house. They swap ideas and jokes with a sense of restlessness and curiosity, their minds darting and dashing. John has a wide smile and loves to talk. Sue seems to be constantly moving, making us comfortable, showing us books, photographs, drawings. Sue's musical, John's not—their life as performers has involved a lot of playing in street bands, jazz bands and marching bands. Just up the road in Ulverston, where the pair spent many years working, they've left a legacy of joyous communal gathering. It's a privilege to be here, a privilege to delight in all this fizzing energy, and the best word I can think of to describe this life of community-centred spectacle and celebration is, simply, brave. Sue and John's work has rarely been presented from the safety of art galleries and theatres; it's more often than not been out on the streets in places like Bradford, Glasgow and Burnley. Welfare State ran from 1968 until 2006, but this list of activities from 1979 gives an insight:

For several years I've worked with a health and arts organisation in Leeds called Space2. They're a compact operation but their reach, right across the densely populated housing estates of East Leeds, is huge. They work with schools, community centres, pubs, clubs, anywhere they can get a foothold into the area and get its people involved and engaged. I've worked on two huge musical projects with Space2 in the estates of Gipton and Seacroft, three years' work trying to encourage kids and parents, teenagers and pensioners, to help create and perform something big, something that tells their own stories. It's the hardest work I've ever done—suspicion of the arts and artists in working-class communities is huge, and I can see why. These are largely people who've been ignored and dismissed, whose sense of place is disappearing along with the area's jobs, pubs, corner stores, parks, bus routes, social clubs, bingo halls, cinemas and cafés. There are whole areas of working-class people (whose parents grew up with the promise of, ironically, the welfare state) who've had the carpet pulled from under their feet.

Going into any community and trying to encourage local people to get involved in music, theatre, art and dance can be hard work. In the end, when it all works

[13]

ACKWORTH
"Plague and the Cowman," a series of narrative processions for a Yorkshire village.

HELMSLEY, NORTH YORKSHIRE
Easter Naming Ceremony.

WELWYN
"When the Pie Was Opened," a theatrical feast.

BIRMINGHAM
"Volcano Junction," late-night water pageant on the canal.

CUMBRIA AND SOUTH WALES
"Blood Pudding," a touring street show.

THORPE THEWLES
Harvest Festival Celebrations.
First use of the Barn Dance format.

ACKWORTH
"Parliament in Flames."

CRAWFORD, LIVERPOOL
"Garden of Earthly Delights," an animated fantasy garden.

[14]

out and you're part of a big team of locals putting on a successful show for their families and their mates, you forget the evenings in strip-lit community centres, in Portakabins with grills on the windows, in church halls that smell of toilet bleach and that afternoon's free lunch. You forget all the trying to coax hooded teenagers to participate in something, even though you know they're only there to get a box ticked on their probation form. You forget the wilful ignorance of the big arts organisations who've promised to "partner" an event but who never set foot in the area. But somehow when I talk to John and Sue, these two people who've spent a lifetime bringing estate families onto the streets to dance, sing, make and perform, I don't forget all that stuff, I remember how difficult it all is and how much love, dedication and passion you have to have to make it work, again and again and again.

What Welfare State International did, along with an ad hoc, jumbled, nationwide network of cultural mavericks, was seize the spaces outside the formal art world and invite communities along to create, invent, make and explore. They found wiggle room in a space between art and ritual, taking age-old customs and practises that the people in an area knew and understood, bringing them into the present. Welfare State's pageants and theatre-play were influenced by what John Fox calls "the pre-industrial calendar of traditional church and farming calendars, which themselves overlaid pagan and Celtic festivals." So while Thatcher was telling us all that "there's no such thing as society," artists were celebrating these people-centred acts of joy and creation, fighting the privilege and snobbery of the theatres and galleries ("those neutralised white cubes").

Perhaps the reason that Welfare State International drew on this background of traditional and communal playfulness is because the 1970s and '80s were seen as a decade of "cultural closure," when the state's ruthless economic and social conservatism withdrew much of its support from the arts. How brave, then, to charge off around the country setting up dances, plays, bonfires and pageants. And how impactful, how disruptive.

As we get ready to leave, lingering in the small kitchen that leads out to the garden (and the ocean), we talk about what it was that influenced *them*, where the network of inspiration linked back to. They reel off a list, excitedly digressing over each of them. That's the trouble with people as friendly, open and full of ideas

as Sue and John—you're in danger of never being able to leave. It's the welcoming warmth of good energy, of lives well lived. As we head back along the coast road that skirts the peninsula, Casey and me talk excitedly about those few hours spent among such vital and animated people, whose spirit of creative playfulness is so infectious. They're still out there, roaming the country creating their rituals and ceremonies, lighting fires (real and symbolic) and testing possibilities.

"Ideally we would be trusted dream-weavers. In the old tribe, it would have been the shaman, who is given the right to take his audience on a trip and to earth them again, once you've taken them away on a trip. It's a contract, a deal you make with them. The audience is a guest, and you take them on a magic carpet, and you bring them back again."

Lines

An object in motion tends to remain in motion along a straight line unless acted upon by an outside force.

—Isaac Newton

Isaac Newton didn't discover gravity when an apple from a tree he was resting beneath hit him on the head. That's a story, a straight-line story, that simplifies years of observation and scientific study. Despite this, the apple-on-the-head story is a good place to start: in an orchard in the grounds of Woolsthorpe Manor in Lincolnshire, in 1666 (although there is a claim that the infamous apple tree was uprooted and transported to Grantham some years later. But let's not get waylaid along that line of enquiry, we're here to talk about the apple, not the tree). The apple falls in its downward trajectory until, says Sir Isaac, it is acted upon by an outside force, in this case, Isaac's head. The conclusion being that no matter how scientifically straight is the object in motion, someone will always stick their head in and mess things up.

Life's chronology is taught as a line——————————— left to right, it starts at birth and ends at death. The "narrative arc" will, if you like, introduce an obstacle to overcome, giving you the option of a long ascent (the top is the obstacle) followed by a long descent towards a satisfying ending (death). If you were to draw a line that illustrates your life, is this how it would look? Try to picture your life as a line—or better still, grab a pen and, starting with your birth, draw a line in this space below that approximates the journey of your life so far (we don't need to think about the end just yet).

Start here, on this dot. This is when you were born:

•

Laurence Sterne's *The Life and Opinions of Tristram Shandy, Gentleman*, published in 1759, was the first novel to successfully challenge the straight-line narrative, instead recounting a life made up of digressions and detours, the whole journey being a rambling, wandering path that doubles back, overlaps and forgets its place. In short, life as a squiggly line. In order to emphasise the point, he included in his book a series of illustrations—lines that traced the path his book was taking, in all its uneven, wayward unstraightness. Tristram's life, as recounted by Sterne, was (as Newton predicted) acted upon by outside forces, whether they be heads or whatever else gets in the way. One of the first of the interruptions in Shandy's linear journey is when, at birth, his head is mangled by the doctor's forceps during delivery. This misshapes Tristram's nose, giving the poor kid a complex that seems to constantly interrupt his life; somehow he draws parallels of sexual potency between noses and penises, a train of thought that only gets more complicated when the young Shandy has his penis hit by a closing window as he pees from its ledge. And if you haven't read the book then at least you'll get the idea from these small examples what a gloriously, crazily unstraight book (and life) it is.

Tristram Shandy's penis aside, there's a lot to be learned about life's unstraight lines. (As a young boy I spent hours and hours teaching myself to draw curved lines on an *Etch-A-Sketch*, trying to create faces with smooth cheeks and chins and not tiny jagged staircase lines.) Mathematics tells us that a straight line is "a figure formed when two points A ($x1$, $y1$) and B ($x2$, $y2$) are connected with the shortest distance between them, and the line ends are extended to infinity." Almost as mathematically, the great Brazilian footballer Roberto Carlos tells us that "from close range the free-kick is taken with the inside of the foot. I will take a run-up of two or three steps and take the kick with the inside of the foot and the ball will travel in a straight line towards the goal. If it is a long-range free-kick, then I will use the outside of my foot. The ball will turn in the air and head towards the goal." Anyone who watches football will know that the sight of a curving ball spinning along a seemingly impossible arc and into the top corner of the goal is

one of the game's most beautiful moments. Straight-line goals? Two-a-penny.

Straight, originally a variation of the word *stretch* or *stretched*, has been in use as a descriptive word since the late fourteenth century, when it became the antonym for *crooked* and started to be used as a way to describe someone who was direct and honest. This meaning mingled with the biblical version suggested by the stock phrase "straight and narrow way," and before long we ended up with *straight* meaning "good" and *crooked* meaning "bad." Then followed, inevitably, the homophobic version *bent* (in regular use when I was growing up), as if sexuality remains in motion on a direct line until acted upon by an outside force. Going further, we even had *bender*. You're not only bent, you are the outside force doing the bending.

I'm going to digress and talk about guitar effects pedals now. There they are, small clickable blocks in their variety of colours, strung out and linked by electrical wiring, cluttering up the space at the electric guitarist's feet. Nowadays they're neat, tidy things with improbable-sounding names like Shapeshifter and Deep Phase and (wait for it) The Chorusaurus. And the sounds they make when a guitar noise is fed through them are almost all crisply, cleanly digital. In the old days such effects, or their timidly named originators, were firmly analog.

We can see the difference between these two types of sounds as depicted in sound waves, lines on a graph that measure their movement. Let's look at the old-fashioned classic wah-wah pedal, as played most memorably by the great Jimi Hendrix—the wah-wah pedal can, in the right hands, make the guitar "cry" as if in a stretched, bending note of anguish. On a graph, that sound wave would be a smooth curve or series of curves, curves that draw sound as a series of different-sized, smooth-topped hills in a long line. Picture the Dartmoor tors, or the northern Pennines' Howgills mountain range, or the dome-shaped Black Hills of South Dakota, those lovely rolling hilltops and valleys, smooth and undulating.

But whereas analog sound is made up of the entire sweep between start and finish—that long-arced *waaaaaaaaaah* being

made up of an infinite series of points—digital sound breaks down the guitar's sound into a series of straight lines going up, down, up, down, an *Etch-A-Sketch* staircase of sound. Picture a cityscape, its definite straight lines at sharp ninety-degree angles, shopping centres, high-rise flats, multistorey car parks. Of course, both analog and digital can coexist perfectly well. But writing as a runner, my preference is for the analog hills rather than the digital cityscape. Talking of which:

I love a ginnel. A narrow path that runs between buildings, you might well know it under a different name. It's one of those nouns that enjoys regional variation, something for the neighbouring towns to fight over: alley, passage, snicket, twitchel, vennel, twitten, wynd, gully, byway, snickelway, a mapful of routes from here to there, usually without names or signposts, hidden arteries connecting the body of the town. Ginnels are a sign that a place has grown, not been preplanned, they are the afterthought that came when a city evolved around its hills and watercourses. Ginnels undermine the straight-line urban designs that wish to see everything on a grid, numbered and alphabetised.

Similarly, Desire Lines—sometimes called People's Paths—are pathways worn into the ground by decades of footsteps, pathways that ignore the planned concrete and tarmac of roads and pavements. There's a communal beauty in a Desire Line that will break through a hedge installed by supermarket car-park planners. A down-to-earth middle finger to the urban architects trying desperately to impose order and rigidity on a place.

Which brings me, in a roundabout way (and for the purposes of this chapter there is no other suitable way), back to Isaac Newton and his tree. The apple that fell, the apple that inspired the notion of gravity, met its outside force when Newton's head got in the way. And this is the point: people get in the way. Just when you start to believe that life can run according to straight-line thinking, someone pops up and, with a deft flick of the head, sends the apple soaring and curving over the wall of defenders and into the top corner of the net. *One-nil!*

The Iranian Wedding Pianist

Do you know what a foreign accent is?
It's a sign of bravery.
—Amy Chua

Contrary to a million inspirational quotes (in a hideous typeface
against a soft-focus photo of a road heading towards a mountain),
the journey isn't always more important than the destination.
Sometimes the middle of the story isn't the vital bit—no chicken/
road joke relies on knowing about the nature of the thoroughfare
that's being crossed.

"Why did the chicken cross the road?" was first asked by
American minstrel show players—white men wearing blackface
—and was a joke set up for a simple purpose: Two minstrel charac-
ters, Tambo and Bones, would make fun of a third minstrel, the
Interlocutor—the authority figure. They would fire questions at
him in order to make him look stupid, thus inventing the "anti-
joke." The audience would laugh with Tambo and Bones at the
idiot Interlocutor who expected a hilarious punchline but instead
got a puzzlingly straight answer ("to get to the other side"). And
the audience would laugh because this set-up (and bring-down)
would be repeated again and again, the Interlocutor never seem-
ing to get wise to their trick.

Working with asylum seekers for the past few years, one of the
first things I realised was that there is something strange that
happens on the journey from *there* to *here*. In the eyes of the world,
someone changes from being a person with a past, someone with
a family, friends, experiences, skills, a profession—to being a
refugee, a migrant, an asylum seeker. We forget that these people
are doctors, airline pilots, teachers, artists, shopkeepers, barbers,
musicians. The change is essentially from a person to a label.

[23]

Why did the chicken cross the road?
To escape persecution.

That's all we generally know, and this switch from person to label is a perfect way to avoid finding out someone's backstory, the essential histories that make up a person's character. The journey from there to here shouldn't be the only thing we know about someone—yet in this case it's the part of someone's life that the media is obsessed with. The border crossings, the small boats, the migrant camps. It's as if, by concentrating on the way people arrive, we can allow ourselves not to think about their lives in their homelands—not only their jobs and families, but war, torture, bigotry, censorship, imprisonment, threats and beatings.

Sometime in February 2022 I met up with Storm Eunice, who was busy battering the coast of South Wales. As I drove into Cardiff, wipers swishing torrential rain from my windscreen, the roads were covered in tree limbs and wheelie-bins and the radio was telling me that the storm, with winds of up to 100 mph, constituted a rare red weather warning, with flying debris "resulting in danger to life." I was working at Welsh National Opera and staying in the nearby Travelodge, both situated in what used to be called Tiger Bay, birthplace of Shirley Bassey and recently transformed from a red-light docklands area into an amalgam of retail parks, fashionable restaurants and the hugely impressive Millennium Centre.

The Millennium Centre is a domineering and oddly shaped fortress that was built looking out across the bay—the words on the front of the Millennium Centre, crafted in six-foot-high stained glass, read:

IN·THESE·STONES
HORIZONS·SING

These words, by Gwyneth Lewis, are said to constitute the world's largest poem, and they echo the Millennium Centre's view out across the sea. A beautiful boast, a bellow that shouts out

to the entire world. The Travelodge, on the other hand, several hundred yards away and backed onto a bowling alley, boasts only of cheap breakfasts and extra pillows (on request from reception). The day I arrived in Cardiff, Storm Eunice literally blew the roof off the Travelodge, slates raining down on the cars parked in the carpark below. Everyone (including me) was evacuated to other hotels as the staff ran around positioning buckets and mopping.

This dockland area along the River Severn is one of the world's oldest multicultural communities, with migrants settling in the area from over fifty nationalities—aptly, since the project I was working on was a collaboration with musicians and writers from all over the world, people who had been housed in Cardiff while they waited for their requests for asylum to make their way slowly through the hostile environment of the British Home Office.

The morning after the storm, in one of WNO's vast rehearsal rooms, I waited to meet some of the musicians who were taking part in our ongoing project. This was a mini-opera created by writer Sarah Woods and myself that brought together the professional musicians and singers of WNO with displaced musicians based at Cardiff's Oasis Centre, a busy converted church where a daily stream of asylum seekers could get a meal, a haircut or an English language lesson. Oasis is one of those places which you could easily miss but which is so incredibly vital to so many people. Over the years there we'd worked with people playing all sorts of beautiful musical instruments which, frankly, I'd never seen or heard before: the tanbur, the tonbak, the nay.

That morning-after-the-wild-night-before, we welcomed Masoud, a tall, quiet man accompanied by an interpreter. Greying and gaunt, he seemed awed by the vastness of the WNO rehearsal room. He kept his coat on, looking quizzically at his interpreter as we introduced him to the other participants. He sat at the piano. We'd heard him playing at one of Oasis's weekly music sessions, where he'd improvised on piano briefly to accompany the group. He'd only arrived in Britain a fortnight earlier and looked like a man caught inside a situation he could barely understand. And then he touched his hands to the piano keys, slowly

and tentatively, and paused. When he began playing, you knew this was his story: this music, elegant and flowing, all arpeggios and tempo changes, slowing and quickening, a strange mixture of Western classical style, Persian melodies and (strangest of all) wedding pianist frills. This was his connection to home—a visceral, gut-felt tie that bound this moment with a family he left behind. And crucially, this was the moment when Masoud switched back from label to person, the moment when everyone in the room —including experienced WNO orchestra players—stood still and listened to the story Masoud was telling, through the piano, without words.

Masoud had escaped from Iran, he later told us quietly at lunchtime through his interpreter, where he and his brothers—all artists and musicians—had been repeatedly persecuted and threatened. Masoud had, as I'd half guessed, made a living as a young man playing piano in bars and at weddings. That was until all Western music was banned in 2005 by the country's new president, Mahmoud Ahmadinejad. Since the earlier crackdown on Western-influenced culture after the Islamic Revolution in 1978, there had been a gradual return to a level of "normality" that included playing hip-hop in the streets, dancing in bars and starting rock bands. President Ahmadinejad put a stop to all that—from now on, he warned, playing any instruments with Western tunings, including guitars and pianos, was forbidden.

Masoud continued to play piano in secret for years, sometimes braving imprisonment by playing at underground weddings. It was at one such gathering that Masoud's playing was brought to an end by invading armed guards, who not only stopped the wedding but smashed up the piano as the guests stood by, petrified. That was four years earlier; since then Masoud had not touched another piano until arriving in Cardiff. Now here he was, sitting at a Steinway Concert Grand (a piano that costs over £100,000— and there were two more sitting outside in the corridor). To see and hear Masoud play was a privilege. A lesson in perspective, proportion and context. Masoud was a pianist who had made a living playing well-known classics to people toasting the bride and

eating too much cake. And in the same instant, Masoud was an ambassador for hope and opportunity, a musician whose first language was written in crotchets and quavers. In his performance, too, was his real story, and with it a shedding of the overly simple, A-to-B, there-to-here story we so frequently fit onto those seeking refuge in another country.

As Masoud sat at the piano later that afternoon, lost in his playing, the notes floated out through the Millennium Centre's windows, caught the tail-end of Storm Eunice and were lifted, tossed and blown all the way to the Houses of Parliament, where the then Home Secretary Priti Patel was presenting her Nationality and Borders Bill. This bill would dictate that asylum seekers arriving in the UK through anything other than resettlement would receive "a lesser form of protection," including temporary status, no access to financial support and limited rights to family reunion. Recognised refugees would, in effect, live in constant fear of return to persecution or death at any

moment.

And why? Because, according to the *Daily Mail*, the biggest problem we have in the UK is immigration, and specifically those people who, fleeing persecution and imprisonment for playing Mendelssohn on the piano, are forced into small boats to reach our shores.

> People are talking about immigration, emigration and
> the rest of the fucking thing. It's all fucking crap.
> We're all human beings, we're all mammals, we're all rocks,
> plants, rivers. Fucking borders are just such a pain in the
> fucking arse.
> —Shane MacGowan

Adrian Henri's Funeral

An old vaudeville hoofer once said to me, "Son, you don't follow one banjo act with another banjo act."
—Doc Humes

Adrian Henri was born in Birkenhead, across the Mersey from Liverpool, in 1932. A procession to mark the passing of the poet, painter and singer on 28th April 1979 wound its way through Liverpool after a cremation ceremony at Henri's home, the mourners making their way to the Pier Head and from there to the Liverpool Academy Gallery, where the gathering witnessed remembrances by poets, artists and musicians. More than any sense of sorrow, there was a sense of celebration of a life well lived.

Adrian Henri's motto was:

If you want to do it
And you enjoy it
Then do it

And he did it, and he made up a description for it: *Total Art*. As a Total Artist, Henri refused to stick to one thing, flitting around between poetry, art, music and performance "happenings"—there he is in a 1967 film of one of Yoko Ono's "events," at the Bluecoat Gallery, wrapping Yoko in gauze bandage until she disappears. And there he is in 1969, onstage with his band Liverpool Scene at the Royal Albert Hall, supporting Led Zeppelin. And look, there we see him in his Liverpool flat in 1965, across the breakfast table with Allen Ginsberg, a meeting which prompted Ginsberg to declare that Liverpool was "the centre of human consciousness in the world." This was the place where the world-famous psychologist Carl Jung (who had never visited Liverpool) had dreamt about

the city as a "round pool, and in the middle of it, a small island…. On it stood a single tree…. It was as though the tree…was the source of light."

Some years after Henri had led Ginsberg by the hand on a tour of Liverpool's pubs and clubs, a local Beat poet called Pete O'Halligan decided to interpret Jung's dream and find the exact spot where this "source of light" was positioned. By studying all Jung's inferred way-markers, he concluded that this epicentre of the universe was a manhole cover in the centre of Mathew Street. Subsequently, this manhole cover has entered Liverpool folklore and become a reference point for various influential Liverpool artists and musicians from The Teardrop Explodes' Julian Cope to KLF's Bill Drummond.

Fast-forward several decades to the almost-present, and a retro-spective exhibition of Adrian Henri's life/work/stuff at Liverpool's John Moores University, a beautiful jumble of canvases, films, photographs, music, flotsam, jetsam, kitchen sink etc, a huge, gloriously messy, cultural scrapyard that screams the word *eclectic* (*eclectic*, from an old Greek word meaning "select, and gather")— and it's here, while walking around this collection of a life lived in glorious technicolour, that I decide I should visit the manhole cover.

It's on the street that used to house The Cavern before it was flattened, a busy little road flanked by Irish bars and Beatles graffi-ti. The area around Mathew Street is called The Cavern Quarter now, and it's where I used to travel from Burnley for punk gigs at Eric's, long before I knew about Carl Jung's dream of a hole in the ground "where the streets converged…"

And there it was, the manhole cover, situated under a bust of Carl Jung that has been helpfully attached to a nearby wall, along with the inscription "Liverpool, the Pool of Life." I stood awkwardly looking at the everyday humdrum square manhole cover for a few seconds, trying to work out which part of this myth I was playing into by being there, staring at an iron drain cover.

FAX NO. 44 1733 240 201
124 CLASS D 400
CLASS D CATV
CLARKSTEEL

[29]

I noticed someone looking at me as I looked at the ground, and I quickly moved on. I wasn't going to get involved in attempting to explain why I had my attention fixed on a manhole cover.

As a teenager I'd fallen in love with Liverpool; it seemed, even before I'd ever been there, to be the place where art, poetry, music and football met. I was catching up on The Beatles' back catalogue, second-hand album by second-hand album, I had a minor school-boy obsession with a Liverpool FC player called Jack Whitham who'd lived in the same street as one of my many aunties in Burnley, and I'd discovered the Liverpool Poets (Adrian Henri, Brian Patten and Roger McGough), with their throwaway pop version of poetry. I'd been writing poems myself for the school magazine—awful, awful poems, obviously—and these had caught the attention of fifth-year English teacher Mr Cryer. Bob Cryer dressed in a blue velveteen suit with huge lapels and outrageously flared trousers, wore outsized spectacles and seemed determined to look like a cut-price Elton John. He was the only teacher at secondary school that I liked, or at least the only teacher I felt taught me anything useful. The first lesson with him consisted of him saying, "Today we're going to study poetry—" [*class groan*] at which point he scrawled on the blackboard:

AWOPBOPALOOBOP

"—that's Little Richard, and that's the finest line of poetry this side of Wilfred Owen."

That was it, I was hooked. If that was poetry, then there was hope for me yet. Bob Cryer collared me after a lesson and said, "We've been told we can apply for someone to have a place at a residency for writers. Three days learning under a professional writer. Do you fancy it?"

No, I didn't. I was fifteen. I didn't want to go away for three days being taught how to construct sentences by some posh cordu-roy-jacketed author of dense verse. Cryer handed me a leaflet and I glanced at the list of tutors teaching on the courses—and lopbam-boom, there it was, "Poetry & Music with Adrian Henri and Andy Roberts."

A couple of months later I was on a train to Devon, to spend a few days in a remote farmhouse inhabited by the ghosts of Sylvia Plath and Ted Hughes (who had lived just up the road in North Tawton). The whitewashed house—Totleigh Barton, isolated and idyllic—sat quietly, surrounded by rolling green meadows, like a sugarcube on a snooker table. Adrian Henri was as funny, as strange and as unpredictable as I suspected he might be, but what came out of that short adventure was that I realised that this thing—this *playing with words and music*—was (oh my goodness) something that could be done as a job. The thrill of that realisation hit me like some big heavy poetic metaphor, banishing the voices in my head that echoed what John Lennon's Aunt Mimi had repeatedly told him:

"The guitar is all right as a hobby, John, but you'll never make a living at it."

When Henri read his poems each evening accompanied by Andy Roberts's beautifully empathetic guitar-playing, the low-ceiling, real-fire, scattered-cushion living room became a universe of ideas and possibilities, a call to action, and a disruption.

ALOPBAMBOOM!

But anyway...
where was I?
—Jello Biafra, Komotion Klub, San Francisco, 1992

What Adrian Henri did, in and around the bars, halls and theatres of Liverpool in the 1960s and 70s, both with and without Andy Roberts, was refuse to be hemmed into any particular corner.

You think you know who I am and what I do, but—

His Total Art meant he could shape-shift between worlds, bringing along with him enough chutzpah to wear all of his different hats with confidence, in much the same way as Malcolm McLaren would do after him. Henri cast himself as a living version of the inspirational title character in playwright Alfred Jarry's *Ubu Roi*, who encouraged wilful chaos and disruption. Ubu, who appeared as an absurd anarchist king in several of Jarry's plays, appealed to Henri as a way of expressing his desire for "a systematic

derangement of the senses." To a schoolboy from East Lancashire, this was all eye-opening, a sort of tantalising madness that morphed beautifully into punk with its ensuing disruptiveness.

Punk came roaring in around the time of that memorable weekend away in Devon. Another of those cultural shifts in art's historical timeline that seem to happen every few years (more than five, less than ten) and constitute the *but*s in the story. I'm not talking about gradual, evolutionary changes, styles and fashions that rearrange themselves slowly over the years—I'm talking about unexpected jumps. The Leeds-based art school band Mekons called it "history's stutter," this sudden shock of the unexpected. Elvis on the radio, Rotten on the telly, hip-hop on the streets and acid dance in a warehouse.

These jumps don't come from nowhere, they are pushed into the world. People make them happen. They are the tyre that some kid rolls into the path of oncoming traffic. Early reviews of Jarry's *Ubu Roi* referred to Ubu as a cross between schoolboy and savage. Playful, wilful, destructive and clever, at one point Ubu declares:

"That's a beautiful speech, but nobody's listening. Let's go."

In 2007 *Mojo* magazine voted Little Richard's "Tutti Frutti" number one in their "Top Hundred Records That Changed the World." Such was the shock of Richard's sexually charged holler of "Awopbopaloobopalopbamboom" that All-American white-boy Pat Boone was enlisted to quickly record and release a cleaned-up version. Little Richard's first (unrecorded) version of the song centred around homosexual sex ("Tutti Frutti, good booty / If it don't fit, don't force it / You can grease it, make it easy"), but even with a rewrite the song still retained dollops of dirty-mouthed sensuality. Boone's version reduced the song to a quaint and uptempo nursery rhyme. Of Boone's take on it, Little Richard said soon after that "they needed a rock star to block me out of white homes because I was a hero to white kids. The white kids would have Pat Boone on the dresser and me in the drawer 'cause they liked my version better, but the families didn't want me because of the image that I was projecting." Boone's version climbed to

number 12 in the pop charts; Little Richard's version reached only 21. Nevertheless, it's Little Richard's cry of delight that changed the course of pop music history.

Pat Boone on the dresser, Little Richard in the drawer. 1955, that was the same year Rosa Parks was arrested for refusing to give up her seat on the bus in Montgomery, Alabama. Thirteen years later, the USA was still grappling with the colour bar. By 1968 Charles Schulz had been drawing and publishing his *Peanuts* comic strip in the *Washington Post* for eighteen years, characterising a child's view of America with beautifully understated (but exclusively white) humour. But just eleven days after Martin Luther King was assassinated, schoolteacher Harriet Glickman wrote a letter to Schulz suggesting that the artist might be able to "help change those conditions in our society which led to the assassination and which contribute to the vast sea of misunderstanding, hate, fear and violence."

What she politely and eloquently asked Schulz to do was to introduce a nonwhite character into the weekly comic strip. It was Charles's

"Yes, *Peanuts* is very funny, and clever, and beautiful … but—"

moment. Within a few weeks, Schulz wrote back to Glickman to say he had listened to her request and was introducing a black character, much to the fear and consternation of his publisher. So against a noisy background of segregationist protest, black kid Franklin took his place alongside Charlie Brown, Snoopy, Peppermint Patty and the rest. The cartoon story of that young, innocent suburban middle America suddenly grew up and became a lot more real.

By the time Schulz died in February 2000, Franklin's appearance as part of the *Peanuts* gang was taken for granted, to the extent that black comedian Tim Meadows eulogised Schulz on the TV show *Nightline*, saying, "Charles Schulz understood that regardless of race, we're all the same; we have heads as large as our bodies, and our mouths disappear when we turn sideways."

Even cartoon characters are allowed to change direction, especially at the hands of serial disrupters—look at Banksy's infamous

Dismaland, with its fairy-tale princesses dying in car crashes (more of that later). In the meantime, here is a verse from Adrian Henri's "Batpoem," suitably accompanied by Andy Roberts playing the *Batman* theme on guitar:

> *Help us out in Vietnam*
> > *Batman*
> *Help us drop that Batnapalm*
> > *Batman*
> *Help us bomb those jungle towns*
> *Spreading pain and death around*
> *Coke 'n' candy wins 'em round*
> > *Batman*

Adrian Henri's funeral on that overcast spring day in 1979 exemplified his life, as a public, noisy, joyous spectacle. The sun shone (weakly) and crowds gathered to pay their unruly respects. But the most beautiful part of the events of that afternoon—with a horse-drawn carriage leading the way as jazz musicians played on the walk to the banks of the Mersey in memory of the late poet— was that Adrian Henri himself was there, dressed in a white suit and mask, enjoying the occasion. Together with artist Rob Con, Henri had decided that having a funeral wake while still alive was a much more sensible idea than waiting until you were dead. It wasn't until twenty or so years later that Adrian actually, factually, died.

Art, Yachts and Crayons

The rise of the art market and the commercial art world in the past few decades seemed to erode political engagement—oligarchs don't want to buy art that says that they are crap [*laughs*]. The Young British Artists bought into all that. That lot shifted the democracy of who was making art by embracing wholeheartedly the commerciality of the market. I think we are all a bit sickened by that now.
—Bob and Roberta Smith, August 2015

We're ushered around the edge of a large open-air pool that, in the moonlight, is oil-black. Its centrepiece is a police riot van, smashed and wrecked, half submerged. Then we pass through the gateway to a fairy castle, all turrets and portcullis, except here it's decrepit and ruined, smoke rising from its tumbledown innards, and into a corridor that twists and turns before opening out into a large hall. There in the centre of the dark room is Cinderella's fabulous pumpkin-coach, upturned, lit only by the glare and stuttering flash of a row of paparazzi photographers, kneeling and leaning in for a better angle. Halfway out of the coach's window lies the inert and bleeding body of Cinders herself, the people's princess chased to her death by tabloid fascination. Away and around the corner, a bank of TV screens shows images caught by the paparazzi featuring us, the spectators, and we're invited to pay our £5 to take home a souvenir of our complicity in the spectacle. Now that's what I call art; now that's what I call *Dismaland*.

When I was not long into my twenties I hand-printed a leaflet that reproduced the great surrealist André Breton's essay on art and revolution—art as a revolutionary act, challenging and "astonishing," art that plays a part in social, cultural and political revolutionary ideas, art that links explicitly to life, to the turbulent

politics outside the gallery walls. I took a bus to London and stood on the steps of the Tate Gallery, handing out the leaflets and trying to engage visitors in a discussion about the current state of British art, and its irrelevance to the upheavals that were going on in the country under 1980s Thatcherism.

Security guards, unmoved by my argument that these were simply the words of André Breton, author of the *Surrealist Manifesto*, a certified and culturally tick-boxed art genius, moved me away from the steps and onto the street. I pressed my point, but in truth, my disillusionment with the art world had hardly recovered from the time when, as a younger teenager, I realised that all the relevant, culturally influential artists and art movements had been and gone long before I was in my teens. Nobody likes to admit that the best stuff happened before you even knew it was there.

> The role of the artist in a decadent capitalist society is
> determined by the conflict between the individual and
> various social forms which are hostile to him. This fact
> alone, in so far as he is conscious of it, makes the artist
> the natural ally of revolution.
> —André Breton, 1938

In 1997, year of Spice Girls and the killing of Princess Diana, I went to see the infamous *Sensation* art show at the Royal Academy. This was Charles (Thatcher's ad-man) Saatchi's collection of Young British Artists, a show that heralded the arrival of Damien Hirst, Tracey Emin, Sam Taylor-Wood and Chris Ofili (among others). I went mainly because it was the first time in ages that the media had gone all "front page" on art, by expressing shock and outrage at Marcus Harvey's portrait of child-murderer Myra Hindley. Most of the artists (and especially Emin and Hirst) seized their moment and ran, laughing hysterically, to the bank (or to the man on the corner selling cocaine).

The established art world in the UK increasingly became/ carried on being simply a tool of capital, both as a means of exchange for the super-rich (a currency that plays out between the

mansions and yachts of oligarchs, heads of state and CEOs) and a way of denying a thriving, active, purposeful and politically engaged subculture of art and artists. Frankly, if you're a British artist that rocks the boat (or the multimillion-dollar yacht) then you probably won't get your work in the galleries. This may be different in other countries, where art's currency might still include words like *challenging, shocking, confrontational* and *anti-establishment*.

Recently, though—*but*—this has begun to change. Slowly and slightly. There are artists here who have understood this state of affairs and, using their status within the art world, are making declarations, stirring up debate, siding with people against the galleries and the patrons. Of course there's always been an undercurrent of politically engaged and vital, relevant art, but it's too often been sidelined and hushed up to the extent that, unless you're in the know, you wouldn't have a clue it existed. But now we're starting to see this politically curious, establishment-challenging and critical art on the telly, in the newspapers, on the radio phone-ins. Banksy, and his *Dismaland* project—a collaboration with thirty or forty varied and contrasting artists—is an artist who has always been determined to make art that talks of wider culture (and indeed, relentlessly slags off our political masters and their corporate buddies). *Dismaland* was without doubt a show as close to the relevance and timeliness of Dada's Cabaret Voltaire as my generation has seen.

That the *Guardian* would go to great lengths to rubbish *Dismaland* is as good an indication as any that this was an exhibition that didn't kow-tow to the up-its-own-arse snobbery of art criticism that does nothing but dance to the tune played by the art buyers' market. But because *Dismaland* was politically further left, more radical and unashamedly harder-hitting than *the Guardian*'s editorial position, the editorial felt the need to rubbish it, pulling out every condescending elitist cliché to undermine the work.

"Banksy's one-dimensional jokes and polemics lack any poetic feeling. Devoid of ambiguity or mystery, everything he has created here is inert and unengaging."

[37]

Dismaland was hugely popular, to an audience far wider than the usual art-show crowd, a mass of young people, families, lads 'n' lasses, me and my two young kids—and every one of us smiling, talking, pointing and laughing. Acting, in short, like an art lover isn't supposed to act.

A couple of days after my *Dismaland* experience, I went to see Richard Long's retrospective at Bristol's Arnolfini gallery. I like the Arnolfini, huge and welcoming, half a century old and on the banks of the Avon. It supports local artists, its exhibitions are free, and it's an open, family-friendly space perched on the river and in the centre of the city. I like Richard Long too. He makes mammoth prints of landscapes overlaid with details of walks he's done—walking as art, treading a path somewhere between conceptual art and Happening, between environmental and land art. But after *Dismaland*, it all looked and felt a little stale and irrelevant. For all his ideas of movement and journeying, Long's art is static and fixed, untouchable, existing within its own conceptual rigour. The gallery's huge white rooms, each with its own security guard, ushered in a sparse audience of knowing visitors, nodding, appreciative and alone. My young son and teenage daughter went through the three floors of the exhibition in around two minutes flat, holing up in the Arnolfini's top-floor kids' room, which was scruffed up and alive with toddlers, mums, books, puzzles and pots of coloured crayons and blank paper. It was the liveliest, noisiest, most interesting room in the building, and significantly the room that most echoed the city outside.

Dismaland, for all its directly political messages, said to us, *have a good time*. Hook a Duck. Ride on the Carousel. At *Dismaland* you could find yourself in a world that attempted to do what that kids' room did by accident—a world that deliberately echoed the brash, ridiculous, sad, funny, desperate, angry world outside its tatty, crumbling walls. Where information, ideas and polemic crash in a dark chaos of clever beauty. Now that's what I call art.

In my mind's eye I can see him still standing
With his grey beard waving like the foam of the sea
With his shaggy hair shaking and his clear eye shining
As he tells all who listen how different life could be
And he rages at the wealthy at their mutilated vision
Making money the measure of everything they do
And the ugliness that kills and the lives that are broken
On the wheels that turn for the profit of the few

—Leon Rosselson, from "Bringing the News from Nowhere,"
a song about William Morris

During the 2011 Venice Biennale, an international gathering of new art neatly separated into "pavilions" and situated throughout the city, Russian multibillionaire Roman Abramovich together with his then wife Dasha Zhukova gatecrashed the party by sailing their megayacht (next size up from a superyacht) right into the harbour. The normal view across St Mark's Bay was blocked by the 337-foot-long £115 million behemoth so that Roman and Dasha could waltz around the galleries and pavilions buying up the art. One local café owner, objecting to what was effectively a tower block moored outside his front door, attacked the "idiotic" boat: "There are so many beautiful places here. Why do these people have to bring their houses with them?" he said.

Two years later, British artist Jeremy Deller was invited to represent his country at the Venice Biennale, being given the freedom of the British Pavilion. Never one to shy away from confrontation, and being particularly critical of the way the markets try to dictate tastes and attitudes in art, Deller structured his show around ideas of wealth, and in particular wealth inequality. A crushed Range Rover (the elite's car of choice) was used as a visitors' bench, and more of the four-wheel-drive vehicles were fed into a crusher to a soundtrack of steel drums playing Vaughan Williams.

But Deller's most notable piece that year took up one huge wall of the pavilion. A giant mural depicted renowned socialist artist William Morris standing in the Venice Canal with his trousers rolled up, holding Abramovich's yacht above his head, ready to

smash and dunk it into the sea. The painting is called *We Sit Starving Amidst Our Gold*, and when I saw it I laughed and laughed and laughed. Jeremy Deller, he's funny.

I went to see him speaking recently in Bradford, about his recent book *Art Is Magic*. It's partly a retrospective look at his life's work and partly a motley collection of his exhibitions, events and performances. He's a softly-spoken man with pinched features and lank hair who dresses in socks 'n' sandals (and still somehow looks good), looking a bit bemused as he took to the stage in the lecture theatre of some faceless college building across the road from Bradford's Alhambra Theatre. (I once took my daughter to the Alhambra to see a Christmas pantomime, featuring local legend Billy Pearce, a man with the cheeky grin of a fifteen-year-old and the birth certificate of a seventy-five-year-old. All I remember was that, at various points in the show, three horses—actual horses—were brought onto the stage to adoring "aaaaaaaaaaahs" from the under-fives.)

Jeremy Deller's most famous work—his "Stairway to Heaven," as he refers to it—is his reenactment of the Battle of Orgreave, a filmed staging of the infamous daylong combat between riot police and striking miners in 1984. For the event he used actual reenactment enthusiasts, those folk who dress in period costume to act out famous historic battles. By having them dressed as police during a 1980s industrial dispute, he was commenting on how we view history, how we trap historic events inside accepted narratives, and how we tend to accept history only if it's several generations old. But the Battle of Orgreave is history, a history that should inform our present much more than the sixteenth-century fights between warring royal houses.

Deller's reenactment took place in 2001, and in response to a question from the audience, he explained why he'd done it:

"This was in the years after what was called 'Cool Britannia,' when pop culture seemed to be hand-in-hand with government, and young British artists were falling in with that cosy nationalistic feel-good mood. Making pop videos, shaking hands with the prime minister. And I wanted to disrupt that view of things,

remind people about who's in control of that version of our country."

Not five minutes' walk from where Deller was talking stands the Science and Media Museum. Looming over the city centre, it is at the centre of a network of roads and is guarded by a giant-sized statue of local lad J.B. Priestley, renowned writer, pipe in hand and overcoat flapping in the wind. The Science and Media Museum— now here's a story. Opening in 1983, the museum was originally the National Museum of Photography, Film and Television, seven floors of stuff about how we represent ourselves, with exhibitions, IMAX films, photography, a worldful of images that told our collective story. I remember it being one of the first places I'd been where the exhibitions were "interactive"—buttons to press, handles to turn, displays that lit up and moved. And memorably, a whole floor given up to showing images from the archives of the Royal Photographic Society, held by the museum. Life captured since 1827 on photographic plates, this was us looking back at ourselves, pictures from all over the world, see, here we are working in mills and factories, unsmiling, wondering what magic the camera might conjure. And here we are at the football match, thousands upon thousands of us, flat caps, pipes and dark overcoats. Here is the circus, the wedding, the demonstration, the suffragettes and the newborn royals. A wonderland of photographic history.

Then in 2016 it was decided that the Royal Photographic Society's collection would be better served being housed at London's Victoria and Albert Museum—let's stick it in the capital with all the other art. The reason? According to Michael Pritchard, director general of the Royal Photographic Society, "The media museum has suffered declining staff and funding cuts over recent years which has impacted on public access to the collection, despite the very best efforts of the curatorial staff. The move will increase the collection's accessibility in both a geographical sense and through the resources that the V&A is able to bring to ensure public and research access."

Basically, the collection being housed in Bradford suggested a clear interruption in the capital's claim to be Britain's cultural

centre, and so the capital clawed it back. Red double-decker buses, guardsmen wearing big bushy hats, postcards with punk rockers on them and every famous bit of art you could ever consume: all in one city.

Banksy's *Dismaland* was situated in the quiet seaside town of Weston-Super-Mare, famous for its strange name. Banksy called it "a family theme park unsuitable for children." (My children went. They loved it. But then maybe they've been badly parented.) He chose Weston-Super-Mare because (in his words) it was "run-down, and it represented a run-down country." And crucially, it wasn't in London. This dislocation can't be overemphasised. To most of the world's population, the UK is London. Never mind that the Industrial Revolution, The Beatles, William Wordsworth, Hadrian's Wall, Factory Records, Ben Nevis, the Brontë sisters, the railways and Manchesters United and City (just for starters) all belong at least two hundred miles to the north of the capital—the South and its capital still holds a cultural, economic and political stranglehold on the rest of us.

I live beneath a hill called the Chevin, a long lump that defines the Wharfe Valley by towering above it. It's forested and cut across by paths and steps, streams and rocky outcrops, but climbing the hill to its summit gives you a view north to the Yorkshire Dales that's unsurpassed. The Chevin is at the very southern foot of the Dales and allows you to see how far that almost uninterrupted landscape of moorland and mountains stretches.

The skies you can see from the top of the Chevin are incredible —clouds gather and break from the West and hurry across towards the East Coast of England, daubing themselves across the vast pale emptiness where sky meets horizon. It's from here that the great artist William Turner would come to paint, paid a wage by a local landowner at Farnley Hall who wanted Turner to capture the forests and fields that he owned.

What Turner drew and sketched and painted up there on the Chevin was that Yorkshire sky, and in particular the sometimes stormy skies that seemed to stretch right across the heavens. In time, when he was painting one of his huge masterpieces, *Snow*

Storm: Hannibal and His Army Crossing the Alps, he re-created one of his earlier studies from the Chevin as the snowy sky that raged around Hannibal as he crossed the mountains into Italy. And there hangs the huge canvas to this day in the Tate Gallery—Tate Britain, on the banks of the Thames—with that enormous Yorkshire sky fooling the thousands of visitors into believing it's swirling above the Alps.

In 2015 I was commissioned by the Tate Gallery to create a song that could be performed in situ in one of the gallery rooms housing the J. M. W. Turner Collection. I agreed, and chose *Snow Storm* as the focus of the song. After a week of hurried rehearsals, our pop-up choir stood in front of the imposing canvas and sang the song I'd written, seemingly drawing some kind of circle back to when I was standing outside being "moved along" by the Tate Gallery security for leafletting. I didn't quite know if this was a betrayal or me getting my own back. It wasn't the neatest of stories. But it reminded me that my first visit to the Tate Gallery—on a school trip as a sixteen-year-old—was one where me and my mates dodged out of actually going in the gallery and instead snuck off to visit the Rough Trade shop on Ladbroke Grove, off Portobello Road. Me and Sage—guitarist with Burnley band Notsensibles—bought copies of *Sniffin' Glue* fanzine and travelled back on the bus to Lancashire clutching these photocopied, hand-stapled works of art as if they were priceless treasures. Which they were, really. On the back page of *Sniffin' Glue* were the following felt-tip-penned instructions:

[43]

The Decisive Moment

What dictators know is that joy has a propulsive force, and
that anything that gathers and channels that energy
threatens to upend the rigid control of a population.
Music, dance, art, eroticism: all of these fuel an emotional
response that creates momentum, one that can be hard
to control.

 —Ingrid Fetell Lee

I went into Leeds city centre on both weekend days. That's a rarity.
Since the hub of the city became a self-styled "retail experience"
I avoid it like the plague. On Saturday I went to see a play at the
Grand Theatre and then nipped across town to buy the new Randy
Newman album, and on the walk down one of the thronged
pedestrianised streets I heard some badly distorted ranting. A
neatly dressed bloke with a microphone and a small speaker which
he had on full volume. He was reading from the Bible, and he
reminded me that it was Pride weekend in Leeds, he reminded me
because he was citing the Bible's homophobic passages, declaim-
ing and decrying and denouncing, fuzzy and rasping.

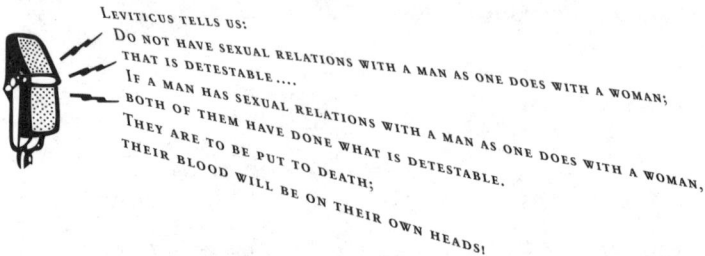

LEVITICUS TELLS US:
Do not have sexual relations with a man as one does with a woman;
that is detestable....
If a man has sexual relations with a man as one does with a woman,
both of them have done what is detestable.
They are to be put to death;
their blood will be on their own heads!

And a woman he was with was handing out leaflets along with the
bellow and the bluster, and I had to get up close to this man to
have a good look at him, to see what was in his eyes. And what I

saw there was joylessness. Not a sad or melancholic joylessness, just a spiteful peevishness, a lack of fun, a lack of heart. And the joylessness was old and tired and out of date. His face seemed to say that all this Saturday-afternoon preaching, this waving around of an ancient book of stories, was more duty than fun.

The next day I cycled into the city to join the Pride parade—though it wasn't so much a parade as a takeover of the entire city centre. Every street and square filled with people wearing bright colours, smiling and laughing and singing and shouting. And what hit me as I became swallowed up in this mass of life and energy was the word *joy*. And I almost felt sad for the man who'd been standing there with his rubbish little amplifier the day before, but I didn't actually feel sad because in times like these, with fundamentalists of all religions still wielding a lot of political power, there's no room for feeling sorry for the spiteful, joyless people. Not when there's work to be done with all this spirit and energy of hope and power and strength and youth—glitter-faced schoolkids linking arms everywhere you looked—not when there's joy to be enjoyed in all this colour and laughter.

There's often a grimness in activist politics, I'm not denying it. Black-and-white images of civil rights protestors in Birmingham, Alabama, attacked by police dogs, human rights advocators in El Salvador beaten and bloodied, striking miners at Orgreave battered and bruised. It's not all songs and smiles and face paint. The media likes to paint protest in stark blacks, whites and reds, it records the chants and not the songs. There's a photograph I love: it's the Argentinian revolutionary leader Che Guevara in full combat suit, boots and beret—only he isn't staring down the camera and holding a gun, he's on a golf course, leaning on his five-iron, laughing. The power is in our understanding of how Che is always portrayed, in the simple idea that revolution, in reality, has to be built on love and *joy*. —what

are we fighting for, if not a belly laugh with friends on a golf course?

At the risk of seeming ridiculous, let me say that

The True Revolutionary is Guided by a Great Feeling of Love.

It is impossible to think of a genuine revolutionary lacking this quality.

—Che Guevara

That's why Pride is important; over the years it's turned from protest to celebration, from defiance to

JOY. It's a reminder of how far the LGBTQ+ community has come. And significantly, the story of Pride began not with rainbow flags and balloons but with several days of rioting in New York City in 1969. At a time when police raids on gay bars were common, one such attack on the Stonewall Inn didn't follow the usual pattern of raid/beatings/arrests, as patrons and onlookers joined together to resist arrest and retaliate against the surprised cops. Marsha P. Johnson was a black transgender woman and activist, a regular at the bar and, according to some, the person who threw **"the shot glass heard around the world"** which started the fightback against the police. Like the other participants in

[46]

the riot, Marsha made it clear that it was unplanned, spontaneous, born out of years of frustration and rage: "History isn't something you look back at and say it was inevitable, it happens because people make decisions that are sometimes very impulsive and of the moment."

The Stonewall riots marked the first time the queer community had fought back, together, in such numbers—here was history being written in an instinctive moment of rage. To mark the Stonewall rebellion, on the first anniversary of the riots, marches were organised in New York, Los Angeles and Chicago. French author André Gide wrote that "the most decisive actions of life are most often unconsidered actions." And out of this historic moment came a worldwide movement, and out of this moment of chaos came effective organisation, an understanding of power and a steady march towards equality. One of Pride's founding organisers, Foster Gunnison Jr, claimed that Stonewall and the subsequent marches instilled a "new feeling of pride and self-confidence... feelings of dignity and self-worth."

The story told by many of my peers is that Pride is now just an excuse for a big dollop of corporate whitewashing, or that, less judgementally, it's a complicated tale that is still unfolding in all sorts of ways we didn't expect—but for me, here on a Sunday afternoon in the swirling, colourful heart of the thing, it's still a reminder that change has happened in my lifetime, is still happening. That the story is changing, as stories do.

My first riot was in Amsterdam, sometime in the late 1980s. It grew from a protest against American warships docking in the port there and somehow erupted

into a

c h A O T i c

[47]

m e s s

of missile-

throwing

and

sprinting

from

tear- gas

canisters.

I was in Holland with Chumbawamba, there to play a tour with The Ex— who, unlike us, were savvy continental radicals who knew the **drill**, understood the CHAOTic and unpredictable way RIOTS work; we were a bunch of pasty-faced Northern English punks marvelling at the way the Netherlanders turned up wearing crash helmets and knee pads, organised and alert. The cops were attacking and retreating in waves, and our gang got split up from each other in the melee. During one retreat— a flat-out run along a narrow dockside with several thousand other people— my friend Alice stumbled and crashed to the ground, suddenly unable to move and in pain. We helped to drag her to safety amid the shouting and the smoke, got her into a vehicle and escaped to hospital. Alice had broken her leg, and she played the rest of the tour in a wheelchair.

Riots are messy.
That's the point of a riot
as opposed to a march or a demonstration.
Riots can be dangerous, awful, chaotic things.
They can be stupid, useless and counterproductive.
But what riots do is signify a need for something outside the accepted way of
doing things. They run on adrenalin and spontaneity, on passion and
foolhardiness. Riots can happen when people aren't being listened to,
when people feel disenfranchised and ignored.

A RIOT IS THE LANGUAGE OF THE UNHEARD.

—Martin Luther King Jr

And perhaps strangely, as well as being messy and chaotic, riots can be **fun**. Despite the risk of violence and danger, there's a childish abandoning of the rules that opens up all sorts of possibilities, and that sense of **freedom**—however brief— is in the moment, immediate and reckless. It's not often we get to experience this stuff, this not knowing, this shedding of social constraints. Poet Matthew the Horse puts it like this: "It's hard to go on adventures when you've got a map.... Perhaps to reach the very edge, you can't know where it's at."

The spontaneity of a riot is what makes it so difficult to police, and in turn what makes it more likely to get media attention. The rioters at Stonewall, they admitted later, had nothing planned, nothing prepared, their main weapons being the anger that had been building over many years of brutal discrimination and their lack of any respect for the moral and cultural codes of the day—the Stonewall Inn's clientele were homeless LGBTQ+ teens, trans women of colour, lesbians, drag queens and gay men. Their entire *lives* were about breaking rules. There's a photograph taken on the second night of rioting, right outside the bar. The Stonewall Inn sign, dilapidated and fading, acts as a backdrop to a crowd of young people who have gathered to protect the building, both regulars and local residents who have joined them. What's immediately striking in the picture is that people are having fun, laughing, pulling and pushing each other and mugging for the camera. They have no idea yet that this handful of days will change the course of queer history, no idea that their tiny drinking club will become a revered landmark. The people in the photograph, they don't look like rioters; they're kids, teens, young and fed up with being targeted and labelled. And it works, this eruption of anger, this wayward, unruly breaking of the rules. The *New York Sunday News* ("Largest circulation in Manhattan-Bronx") leads on its front page with—

Homo Nest Raided, Queen Bees Are Stinging Mad

—and the story it tells is of the underdog having its day, of the voiceless having their say.

[51]

In 1990 I travelled down to London for a day out in the Trafalgar Square sunshine as part of our "Armley Against the Poll Tax" group. We had a banner and carried drums and trumpets to protest against the government's imposition of an unfair and unequal tax. One friend cadged a lift down in our van to watch Blackburn Rovers playing in London that afternoon, telling the rest of us that "protest marches are boring. Nothing will happen." We met up with him about eight hours later having been in the centre of a huge and continuing city-centre riot, a pitched battle on the roads and side streets spreading out from Trafalgar Square. Expensive restaurants were trashed, a McDonald's was completely gutted, the South African embassy was under siege and everywhere were people and police fighting hand-to-hand between the frequent horse charges. Riots make the news; marches don't. Marches are great for sensing the strength of shared ideas, for gathering physically rather than through a computer screen, for swapping ideas, for meeting people you didn't know. But (forgive me repeating) marches don't make the news, and riots do. It doesn't matter that the news media portrays rioters as despicable, ignorant thugs, because what matters is that people see that the government, the police and the law have lost control, even for the briefest time. Those in power have to be seen to be in control at all times. They actively support our right to march because with a march the status quo is unaffected, unmoved.

My father didn't riot. He got on his bike and looked for work.
—Conservative MP Norman Tebbit

In 1993 Chumbawamba played a concert in Copenhagen as part of a ridiculously long European tour. The gig was in one of the city's open squares and was timed to coincide with a protest against the European referendum vote—and even as we played, it became clear that trouble was brewing, with cops wedged into vans parked up along every side street. As darkness fell, crowds gathered and tear gas was fired into the protestors. I remember running, first one way then another, not knowing where I was, hoping not to get split up from the people we knew. As the night got darker, the police became more aggressive and the pitched battles grew uglier. The night was full of noise, of shouts and chants,

screeching cars and sirens.
The tear gas made it hard to breathe,
 and smoke filled the streets.
 It wasn't until much later, back in the
 safety of the place we were staying,
 that the news came through that the
police had been firing live ammunition.
No-one was killed, but there were
many injuries.

Historian E. P. Thompson describes
how riots can be essentially a form of
"moral economy," in opposition to
the political economy associated
with neoliberalism and the free market.
The moral economy can occur
spontaneously, in a crowd gathered to
oppose unfairness. The basic logic of
Thompson's ideas here is fairly clear:
that there are instances of historic
public disorder ("riots"), and there is
a hypothesized "notion of right"
or justice that can influence
and motivate participants.

In 2001 I was in Genoa, Italy, to protest
outside the G8 Summit. It was a balmy,
hot day and the black blocs—masked
anarchists formed into formidable-
looking groups—were padded and
scarved up against the tear gas. Charges
and skirmishes were happening right
across the city as protestors tried to get
inside the heavily fortified G8 conference
compound. On the other side of the
huge barriers, Bono and Bob Geldof
were shaking hands with leaders Bush,
Blair and Berlusconi. A protestor,
Carlo Giuliani, was shot in the face
at point-blank range and killed.
We didn't hear about Guiliani until
much later—to me this was a day when
the polite conversation of world leaders
was drowned out by news of the riots.

Back in 1977 The Clash released
"White Riot" after Joe Strummer and
Paul Simenon had found themselves
caught up in the Notting Hill Carnival
riot. Leeds's own Mekons responded
with the glorious racket that was
"Never Been in a Riot," disgusted with
what they saw as The Clash's voyeurism.
Two great records arguing with each
other over the merits of rioting.
I'm with Strummer on this one:
when he rasps
"Everybody's doing what they're told to"
he's echoing down through
generations of compliance
and conformity.
For every Carlo Giuliani,
for every bystander caught up
in the ugly chaos of a riot,
there are a thousand people
who experience that bellyful of fire,
burning with the sense that they shared
in E. P. Thompson's "moral economy,"
that they celebrated in something
passionate and
raging.

Create a society that values material things
above all else. Strip it of industry. Raise
taxes for the poor and reduce them for the
rich and for corporations. Prop up failed
financial institutions with public money.
Ask for more tax, while vastly reducing
public services. Put adverts everywhere,
regardless of people's ability to afford the
things they advertise. Allow the cost of
food and housing to eclipse people's ability
to pay for them. Light blue touch paper.

—Andrew Maxwell

[53]

The Stonewall riots took place when I was eight years old, the year I was baptised into the Mormon Church that I'd attended since being a toddler. By the time I was a young teenager, I was typically and understandably homophobic. Why wouldn't I have been? The only queer role models were joke figures on TV, Larry Grayson's "Shut that door!", Kenneth Williams rolling his eyes. It wasn't until Tom Robinson's "Glad to Be Gay" came out, at the height of my obsession with punk, that I even thought twice about what it all meant. Even then it took me ages to disentangle myself from all the years of being taught that civilisation was under threat from same-sex relationships. Fifty-odd years after that explosion of anger at Stonewall (a finger-snap in terms of the slowly turning wheel of social change) and we've shut the door on Larry Grayson and seen gay culture become firmly entrenched in our everyday day-to-day.

I want to march (and sing, and laugh) both as a celebration of where we have got to and as a commemoration of the people who bravely seized that decisive, we're-not-taking-any-more moment. Pride is a reminder that protest isn't just a duty, that marches are more than Socialist Workers Party placards and shouty repetitive megaphone slogans. In among the righteous anger there's time to remember how far we've come, to remember those 1969 rioters and all the protestors and the writers and organisers and activists who followed them into our city centres and brought the younger generations with them, singing and shouting and proudly sporting their "I Never Kissed a Tory" badges.

There's a line translated in Beethoven's "Ode to Joy"—
"This kiss is for all the world!"—
a line that was heard at
Tiananmen Square in 1989,
where students played the Ode (from Beethoven's Ninth Symphony) over loudspeakers as the army came in to crush their protests
for freedom.
In Chile, women under the Pinochet dictatorship sang Beethoven's Ninth outside the torture prisons, where those inside took hope when they heard the music being sung. Pete Seeger and Billy Bragg have both sung their own versions of it; it's the soundtrack to a version of history that's ours, not theirs.

Look at the faces of the people who'll spend their
Saturday afternoons quoting death threats
from their Old Testaments.
Look at them, pinched
and old and sour.
Joyless.
Compare them
to the faces of those singing
and dancing in the streets at Pride.
It's easy to be bogged down in the everyday joylessness
of world leaders and Leviticus and the old ways and their old
repetitive stories, and all their rotten stinking foul energy,
but wheeling my bike through a city centre
wall-to-wall full-to-bursting with Pride,
it felt like some things are changing,
some things really are getting better.

In the dark times
Will there also be singing?
Yes, there will also be singing.
About the dark times.
—Berthold Brecht

I went home after Pride
feeling energised and uplifted,
a headful of hope to counteract my
daily disgust at superpower politicking.
The mean old man, sour and bigoted, his heart stuffed
with foul, worn-out lies, stuffed with Trump and Brexit and Tories,
that mean old man with his distorted amplifier is on the losing side,
and you can see it in his grimace.
It's the face of someone
who's about to be
swept away by
progress.

I got lost in the music.... I got lost at Stonewall.
Heard it through the grapevine. 1969!
I got lost in the music and I couldn't get out.
—Marsha P. Johnson

[55]

Ziggy Visits Sabden

Pendle, old Pendle, majestic, sublime
Thy praises shall ring till the end of all time
Thy beauty eternal, thy banner unfurled,
Th'art dearest and grandest old hill in the world
—Traditional folk song

Pendle Hill is a huge humpback of a hill surrounded by towns and villages, and everyone in those places (including me) feels that the hill belongs to them, that it's a vital part of their history. It's known for its tales of witchcraft, with several local women from the surrounding farms and villages being accused, tried and executed by misogynist Puritans in the 1600s. It's the place where George Fox, on a walk to the summit in 1652, had a vision which led him to start the Quaker movement:

"As we travelled we came near a very great hill, called Pendle Hill, and I was moved of the Lord to go up.... When I was come to the top, I saw the sea bordering upon Lancashire. From the top of this hill the Lord let me see in what places he had a great people to be gathered."

It's also the place where Harry Walker, running for Clayton-le-Moors Harriers, was renowned for running every step of the absurdly steep climb up the hill's infamous "Big End," earning him seven victories at the Pendle Fell Race.

I have my own story about Pendle Hill, which I've told and retold many times as part of a touring show I made with theatre-maker Daniel Bye. The show was ostensibly about running, but branched out in all sorts of directions (as stories often do) to talk about land ownership, escaping technology, trespassing, class and David Bowie. Here's the story:

As a kid born within the shadow of Pendle in Lancashire, I'd

been up there several times with my family, until one summer weekend when me and a few mates—all of us bridging the awkward gap between primary and secondary school—decided to walk from Burnley up to Pendle's summit. It was a scorching hot morning and we packed sandwiches and a transistor radio and set off along the trail that goes past Burnley FC's training ground at Gawthorpe and heads north across the river Calder.

A couple of hours later and we reached the village of Sabden, a small village nestling at the foot of the hill, where we nipped into the single local shop to buy cans of pop. The shopkeeper greeted us townies with a grin before telling us that, if only we'd been there a few minutes earlier, we'd have seen "that there Ziggy Stardust feller."

You mean, David Bowie? He was here in your shop?

"Yes, the feller with the orange spiky hair. Ziggy Stardust. Platform shoes and everything. His auntie lives in the village, he comes to visit her sometimes. Nipped in for some bacon and eggs. Said he might be back in later for a pint of milk."

We were all of us big fans of Bowie—on the way we'd listened to Radio One playing his new single "Rebel Rebel"—and we left the shop in shock. Much as we wanted to conquer the mighty Pendle, we couldn't miss the chance to meet Bowie. So instead of treading in the footsteps of George Fox, the witches and Harry Walker up to the summit of the hill, we sat outside the shop for three hours as the afternoon dwindled away, hoping to see David pop back for a pint of semi-skimmed.

As an eleven-year-old, it never occurred to me that this adult might not be telling the truth.

Looking back through Bowie's timeline now, I see that at that time he was probably hanging out with Lou Reed and Iggy Pop in New York, not visiting his auntie in Sabden. I can also presume that, since Bowie was at the time going through a period of heroin addiction, bacon and eggs would have been the last thing he'd be buying.

Eventually we got up and left, realising we'd missed our chance to reach Pendle's summit, and walked the five or six miles home

feeling defeated, but happy in the knowledge that we would be able to tell our mates at school that we were *this* close to meeting David Bowie, and that we knew where David's auntie lived, and what she cooked for breakfast.

And that's the story, and as far as anybody knows, it's true.

But in fact, there's a big lie in the story. So here's the truth:

Several years ago Daniel Bye and me were in his living room in Lancaster looking at a huge sheet of paper covered in Post-It notes in various colours, each with a scribbled idea, stuck in some sort of order around the sheet. We were trying to put together a story (or a series of stories) about running as escape, seeing how the themes connected to off-road running were linked, how they could work as a single narrative but with a variety of digressions and detours and by-the-ways. And since we had a section on Pendle Hill, I began to tell my story about the walk, the little shop, the waiting outside eagerly for the glam-rock hero. Except that the hero wasn't David Bowie at all—in truth, the shopkeeper told us he'd just served glam superstar Gary Glitter. It was Glitter's auntie that had needed the bacon and eggs. And it was the thrill of meeting Glitter that prevented us reaching the top of the hill.

Daniel thought for a minute and then pointed out that, yes, it's a good story. In a show about getting to the top of hills, it's good to have a story about not getting to the top. But Gary Glitter? As we were writing the show, Glitter (real name Paul Gadd) was serving time in a Category C prison in Dorset for child pornography, child abuse and rape. People wouldn't remember the village, or the eggs, or the summit we failed to reach—they'd remember the child abuser. So we changed the story, accepting that switching glam rockers didn't materially affect the basis of the tale.

David Bowie famously constructed his entire life as a spectacle. He shed his real name by the time he was eighteen, and he spent several years crafting various versions of himself as a pop star and actor before having a hit with "Space Oddity." Not content with sticking to the formula (or persona) that had brought him fame, he then spent a lifetime challenging the accepted narrative of art—the narrative that says, when you create a style that sells, stick to it.

[58]

Look at Andy Warhol, a maverick artist who painted dark interiors, pen-and-ink drawings of shoes, lithographs, blotted-line drawings, even jazz album sleeves—until he screen-printed a single Campbell's soup can in 1962. The painting was his first to be shown in an art gallery and marked the point when collectors began to buy his work. Thereafter, he became the guy who did the soup cans, using the repetitive silkscreen technique on any cultural icon that caught his attention, from Marilyn to electric chairs. And that was that—he found a market and never strayed too far from it. The same could be said of a thousand pop groups attempting to churn out copies of their early hits or filmmakers returning again and again to a familiar (and successful) style the public demanded. I hear Bowie's voice as a background to all this, saying, "You can't stand still on one point for your entire life." He was different. He wouldn't stick to the story. Shortly after our schoolboy hike to the foot of Pendle Hill, the by-then wildly successful Bowie was finishing the British leg of his Ziggy Stardust tour at London's Hammersmith Odeon. His manager, Tony DeFries, had been busily planning the next twelve months: a long tour of Europe followed by an even longer tour around the US, with up to seventy concerts beginning in Toronto and ending in Texas. After that, Bowie would, according to DeFries, continue the Ziggy tour in China and the USSR. Onstage that night, and with perfect timing, David calmly announced before the final song: "This show will stay the longest in our memories, not just because it is the end of the tour but because it is the last show we'll ever do." With that, the band played "Rock'n'Roll Suicide" and exited.

There was a young man from Peru
Whose limericks stopped at line two.

There was a young man from Saigon.

Perfect Story Structure

My self...is a dramatic ensemble. Here a prophetic
ancestor makes his appearance. Here a brutal hero shouts.
Here an alcoholic bon vivant argues with a learned
professor. Here a lyric muse, chronically love-struck, raises
her eyes to heaven. Here papa steps forward, uttering
pedantic protests. Here the indulgent uncle intercedes.
Here the aunt babbles gossip. Here the maid giggles
lasciviously. And I look upon it all with amazement, the
sharpened pen in my hand. A pregnant mother wants to
join the fun. "Pshtt!" I cry, "You don't belong here. You are
divisible." And she fades out.
 —Paul Klee, artist

For many of us, life itself is a story, a self-fulfilling story, one in
which we try to construct a meaningful and simplified pattern of
events that we can show to the world. I'm not one of those "many
of us," and I suspect most of you aren't either. The chronology that
tells my tale was already, by the age of about eleven, a mess of
tangled storylines that ended in all sorts of diversions, lucky breaks
and unexpected shifts in direction and tempo, a Zappa-esque piece
of music full of upset rhythms and surprising drum breaks and
surreal vocal interludes. (*"Call any vegetable! Call it by name!"*)
Most of us have similarly unhinged narratives, no matter how
much we try to present a neat, concise version of ourselves.

 When we're getting to know someone, we make up their
three-paragraph inside-back-cover biography—the pointy tip of
their iceberg. Then when we're getting to *really* know someone we
see all the stuff beneath the water line, with all its heaving cracks
and flaws. People don't tend to advertise their complications to
you straight away (unless, perhaps, they're stand-up comedians).

The complications come oozing out slowly somewhere down the line. The story you thought you knew about someone is suddenly filling up with footnotes and parentheses and a lot more *but*s than you imagined. There's a telling (anonymous) saying that "inside every person you know there's a person you don't know." But maybe inside every person there are a *multitude* of people you don't know, a motley collection of them that appear and disappear according to time and place, jostling with each other to head up the gang.

In truth, we are all a collection of our former selves. The kid who winced as his parents fought didn't just disappear as we got older. The teenager who suffered acute embarrassment in a school changing room is still there—hiding, but still there. A lifetime of different people all compressed into one beautifully complicated person, a story made up of a thousand other stories.

*

Act One (set up)
Chapter 1: Introduce lead character
Chapter 2: Dramatic development
Chapter 3: Withholding action

Act Two (rising action)
Chapter 4: Obstacle
Chapter 5: Obstacle
Chapter 6: Mid-point twist
Chapter 7: Obstacle
Chapter 8: Disaster
Chapter 9: Crisis/twist

Act Three (climax and resolution)
Chapter 10: Obstacle
Chapter 11: Denouement
Chapter 12: Resolution

*

IT'S SPRINGTIME IN THE ANCIENT, wonderfully mad seaport of Napoli, perched on the edge of the Tyrrhenian Sea on the lower shin of Italy's booted leg. The city is a jumble of grand stone architecture and wrecked, graffitied concrete, with motor scooters roaring through packed market squares and narrow alleyways, and everywhere shop after shop after shop selling plastic figurines of Maradona and the Virgin Mary. Both are equally popular in the cultural life of this fascinating city. A month to go before the end of the football season, SSC Napoli are way ahead at the top of the table and heading for their first Italian Serie A championship victory since 1990, and so along all the city's streets—everywhere, absolutely everywhere—there are light blue and white flags, banners and bunting.

Against this backdrop—and let's not forget the noise, the constant honking of horns and shouting, radios, church bells, police car sirens and, again, the high-pitched throttles of the motor scooters—against this backdrop we enter Pio Monte della Misericordia, the "Pious Mound of Mercy," a church built to accompany a hospital in the 1600s. The church has several famous artworks hanging around the place, but none more notable than Caravaggio's stunning *Seven Works of Mercy*, specially commissioned by the church. The painting is huge, side-of-a-garage huge, and hangs above an altar that is so ridiculously ornate (carved wooden gold-painted flourishes and gaudy tapestry) that it threatens to steal the spotlight,

but even at a first glance upwards towards the painting it's clear that *Seven Works* is something out-of-this-world special, a painting to leave you open-mouthed. It is also a painting that challenged the strict Catholic orthodoxy by depicting the biblical characters as modern-day human beings, dressed in ordinary working clothes—the models for the painting were prostitutes and beggars. Caravaggio himself was no stranger to this side of life, and even as he painted *Seven Works* he was on the run for murdering a rival. He was known as an often-violent drunk and womaniser, a flawed man in every sense, and these flaws were brought into this painting.

Some of the Catholic Church's higher-ups complained at this "humanising" of biblical myths, but the painting was just too good, too popular, to suffer from such criticism. In a sense, the genie was out of the bottle—the mythic characters of the sacred texts were real people, ordinary people, common people. The church wanted the painting to tell the story they'd been telling from their pulpits, a story set in Nazareth over one and a half millennia earlier. Instead Caravaggio gave them the world around them. It's funny to imagine that were he painting the *Seven Works* today he'd have a few Napoli banners strung around the place. Caravaggio's daring to disrupt the basic story of Catholic theology was rewarded by the painting's incredible popularity: crowds mobbed the church and queued for hours to see the infamous work.

Organised religion of all kinds, being

based upon written guidelines, strictures and commandments, will always struggle with the fact that stories are subject to change. Political ideologies suffer the same problem. (How could Marx have foreseen feminism, environmentalism or the sweeping revolution of digital technology?) The Catholic Church's seven acts of mercy are:

Feed the hungry
Give drink to the thirsty
Clothe the naked
Give shelter to travellers
Visit the sick
Visit the imprisoned
Bury the dead

The final act of mercy was added after the rest; the church didn't want dead bodies piling up in the open, because of the stink and the threat of disease, and making burial an Official Act of Mercy would ensure people took it seriously. This "amending" of religious commandments isn't uncommon—but it's usually dealt with in as quiet and discreet a way as possible. Pope Francis recently tried to add an eighth act of mercy to the list, much to the consternation of his detractors: "caring for the environment." Francis proposed the change during a Catholic World Day of Prayer, even making reference to the importance of recycling and carpooling (and who doesn't read that and immedi-

ately conjure up images of the famous Popemobile being used in some kind of holy share-and-care system?). Francis's attempt to update Catholicism has met with criticism from those within the church hierarchy who believe that the pope is "flirting with modernity."

When I was growing up as a Mormon in the 1970s, I was aware that the church's original scriptures advocated polygamy, and that the resulting and long-standing outcry from wider society (and specifically from the communities closest to the church's more popular congregations) had led to a change in policy by means of a decree from the church's then leader. Since then, a number of scriptural teachings have been reversed in line with cultural and societal changes, when they become too toxic within wider society. The specific rules and commandments surrounding people of colour (including exclusion from all church office and the idea that dark-skinned people could, through their righteousness, have their skins turned "white and delightsome" in the afterlife) were not changed until 1978.

These changes to various religions' printed scriptural edicts necessarily change their story, to such a degree that their history becomes a hotch-potch of amendments and refinements. Like that pair of trousers that have so many holes you just keep on stitching in new patches, thread by thread, fabric by fabric, until eventually there's nothing left of the original pair of trousers.

Caravaggio, master painter of divinity, shocked the church by using common

people to represent mythic religious tropes. His depiction was, said a church leader, "unacceptably vulgar." But those myths, as we've noted, quickly break down as they encounter a changing world, as the stories become a tangle of complications, thick and elusive as tree roots. One final digression in Caravaggio's story: After completing *Seven Works of Mercy*, the infamous brawling artist decided to make a trip back to Rome to meet a benefactor and, no doubt, to petition the pope for a pardon for his earlier murder charge. Along the way, under a fierce sun, the artist collapsed and died from suspected lead poisoning caused by the accumulated lead in his paints. Death by oils.

Leonardo's *Last Supper* has its narrative told in every painterly glance and gesture, from the wave of Jesus's hand to the stereotyped crook of Judas's nose. This is the story that Da Vinci was telling at the end of the fifteenth century, and for all intents and purposes it's the story we can see today. Except that in the intervening six hundred years, the painting has been altered through repeated overpainting as the original began to flake off the wall. Modern photographic techniques which can see through the many layers of paint (and the many layers of history) show how much subsequent painters have changed Leonardo's original. The work changes from century to century, sometimes echoing the political and cultural sensitivities of the times—Judas, for instance, has his skin darkened and then lightened, and his nose grows and shrinks and grows in line with contemporary antisemitic sentiments. So there it is— the story of the *Last Supper* as told by Leonardo Da Vinci and a score of lesser-known craftspeople down the years.

> Perhaps we can say one other thing: any story one may tell about anything is better understood by considering other possible ways in which it can be told.
> —Jerome Bruner

No.2
Andy Roberts

Brighton, England. I pull up to the kerb and park up the camper van on a busy terraced street, minutes before the locals come out armed with tape and bollards to cut off the road at both ends, creating a beautifully organised "guerrilla play area" for their kids returning from school. Suddenly the thoroughfare is full of children and teenagers playing football and frisbee and running in and out of the parked cars as their parents stand guard at each end of the street fixing up the tape barriers to prevent vehicles entering. Brilliant, and so very Brighton. The parents grin as they let me through their cordon. What lovely people.

A couple of streets away, I climb the steps to a tall Victorian terraced house and knock on the door, armed only with a "thank you" and a headful of a book I've only half written. Andy Roberts opens the door—bristle-haired, smiling, welcoming. He suggests we head off to a local café and before we've found a corner table and stirred the tea he's away, storytelling—long and winding threads of stories that connect and fall apart, names coming and going among the flotsam and jetsam of bands, projects, studios and a thousand half-remembered people. It's a wonderful telling of an utterly mad personal history: a disjointed roadmap of a life incredibly well lived.

I tell him my story as briefly as I can—that's not what I'm here for—the abridged story that culminates in a fifteen-year-old kid catching a train to Devon to spend a weekend with a poet, a musician and a handful of aspiring writers. I explain that, until that weekend, it

hadn't occurred to me that my love of poetry might be coupled with music—the way Andy used the guitar, on the fly, to set a mood alongside words that had just been written was brilliant, but somehow (and I really can't remember why) I thought to myself, "I could do that." Not play guitar like Andy, obviously; I just couldn't muster that mixture of innate musical genius and decades of practising, practising, practising. No, I mean using music to help make words come to life.

"It was a shock," I tell Andy, "but I travelled home with a new idea of what I wanted to do with my life. So...thank you."

Andy is surprised—he remembers the specific weekend well, as being mostly "middle-class people who wanted therapy, not poetry!" And truthfully, there is no reason on earth that he would have imagined that a pleasant weekend's work in an old cottage would lead to being charged with the label "Disrupter." Especially in and among a lifetime of collaborations, projects and musical experiments.

His words reminded me of the surgeon at Leeds General Infirmary who, several years ago, was delving around inside my lower arm to somehow fix the results of an axe wound—I'd broken the bone, cut the tendons and mashed up the ligaments as well as losing a fair amount of blood. As he carefully worked away on my anaesthetised arm with its spaghetti junction of exposed innards, I asked if he was able to really appreciate the magic of what he was doing. "I know it's your job, but can you see how extraordinary and—even—spellbinding it is? You're basically performing a miracle." The surgeon looked like he was regretting allowing me to watch my own arm being operated on, ready to pull across the plastic sheet that had been drawn open between us.

"It's just what I do."

"But you must get the sense of what it means to people like me and everyone else you operate on?"

"No, not really. I do this multiple times every day. I'm just used to it, I suppose."

I'd met Andy around a decade ago, very briefly after a concert at Leeds Irish Centre, through a mutual friend. That wasn't the time or place for any discussion about disruptions or thank-yous, and here in this late-summer sunshine in a café in Brighton, with Andy happily munching through an almond slice in between putting together some of the more memorable snapshots of his mad life ("...I did a tour playing guitar with Pink Floyd, that was fun...") it makes sense to downplay his role as

this book's Disrupter Number 2. So my thank you to Andy barely registers, as we leave the closing café with a polite but impatient waitress gently ushering us away from all this talk about touring the USA, scoring Hollywood movies and popping round to Paul McCartney's flat for a drink (that's all for Andy's book, not mine).

I walk back up to where I was parked, and the guerrilla play space is still in full swing. Kids chase the van down the road as I pull away slowly, and concerned parents smilingly lift the makeshift barriers so I can escape. Andy waits on the corner and waves goodbye. These Disrupters, they're not, in the main, mad, super-confident people—they're often people who don't need to shout. As writer Sue Heatherington says:

"It's about the ripples, not the splash."

Jah Wobble,
Davey Graham
 and Hs

I recently watched a little film on social media made by former Public Image Ltd bassist Jah Wobble. It's 1'27" long, in fact, and is a camera-phone selfie wherein Wobble sings the praises of the Amazon bagless hoover—or to give it its full and proper title, the Amazon Basics Powerful Cylinder Bagless Vacuum Cleaner, for Hardfloor & Carpet, HEPA Filter, Compact and Lightweight Vacuum, 700w, 2.0l.

Jah Wobble of course understands the ridiculousness of advertising his love for a hoover to his thirty-five thousand followers on X (formerly Twitter)—it's a lovely twist on the idea of artists slavishly advertising their brand-new and shiny work-in-progress, *here's an extract from my upcoming album featuring my famous friends.* Hoovers are just so damned down-to-earth and domestic, they're generally bloody ugly and they spend most of their lives in the back of a dark cupboard. So this is funny,

this legendary musician telling us that "it's not my intention to do a regular series of consumer reviews of domestic appliances—but this I need to speak about."

After a brief detour into Wobble's history of using Henry hoovers, he returns to the task in hand and demonstrates how the Amazon Basics Powerful Cylinder Bagless Vacuum Cleaner can lift up a small side table with its suction nozzle. And then with a "this hoover is good value for money," he signs off. The last time I looked, the tweet had had 543 likes and 70 retweets. Seventy people who decided that Jah Wobble's review of a hoover should be shared among their own followers. People love their hoovers. There are people who collect them. (One Texan hoover-obsessive has 330 of them in his house.)

I was sitting backstage at a show in London in 2002, immediately after coming off stage, when someone from the venue asked if it was all right to invite someone into the dressing room for a chat. Not just anyone—famed folk guitarist Davey Graham. Of course he can come in! We'd sampled a small section of Davey's tune "Anji" on our album *Un*, looping it to back a gentle antiwar lyric. We'd declared the sample, of course, and Davey was credited as a cowriter of the song. Graham was a hero to me: one of the original 1960s British folk revival musicians, one of those who sang his own songs (specifically in what was then a rare guitar tuning, DADGAD). Despite his following on the traditional folk circuit, he was always keen to adapt his guitar-playing to include Eastern and Arabic tunings and scales, pushing beyond the boundaries of trad folk.

Davey had written "Anji" when he was just nineteen; now a thin and bent-backed sixty-two, he ambled into the room supported by a minder, all smiles and handshakes. He sat with us and chatted, hesitantly—his years of heroin addiction had taken its toll. But no, he said, wait, wait, here's what I came here to tell you:

"I came to say thank you. Thank you for writing that song and for using my music. And thank you especially because…the royalties I received from the song meant that I could afford to go out and buy a new hoover."

[71]

Dorothy Wordsworth's Socks

All the Journals contain numerous trivial details, which
bear ample witness to the "plain living and high thinking"
of the Wordsworth household—and, in this edition,
samples of these details are given—but there is no need
to record all the cases in which the sister wrote, "To-day I
mended William's shirts," or "William gathered sticks," or
"I went in search of eggs," etc. etc. In all cases, however, in
which a sentence or paragraph, or several sentences and
paragraphs, in the Journals are left out, the omission is
indicated by means of asterisks. Nothing is omitted of
any literary or biographical value.
> —Preface to an edition of *Journals of Dorothy Wordsworth,
> Volume 1*, edited by William Knight

Between 1800 and 1803, Dorothy Wordsworth, sister of the
Romantic poet William, kept a journal of their shared everyday
life in a small cottage in Grasmere in the Lake District. The jour-
nals are fascinating—they tell of a life balanced between expres-
sive literary sensibilities and daily hard and laborious work. The
rhythm of the writing sways between long walks in the Lakeland
landscape, drinking in the changing light, the unpredictable
weather, the glorious summer colours and the smudged-white
winters—and the arduous routines of cooking and cleaning,
stitching and mending, building fires and washing clothes.

The quote above is telling. This incredible woman, a fine writer
and adventurer in her own right—was also able to spend slabs of
her time darning William's socks, cooking his meals, collecting his
post and seeing to his dental and digestive problems. In various
editions of Dorothy's journals, we are saved some of the entries
detailing these tasks as they are deemed by the editor to be "of no

literary value." But those passages which tell us stories of tooth-aches and upset stomachs create a balance that is missing from the great literature and poetry of the time. Yes, we all know about the daffodils dancing on the hillside. That's the story we learned as kids at school. But the real story counterbalances the daffodils with visits to the doctor and running out of wood for the fire. The two stories belong together to make up a life.

What's that joke about Fred Astaire? Yes, he's regarded as the world's best dancer. But his partner Ginger Rogers did all the same moves, only backwards. William Wordsworth is rightly revered for his writing, but let's not forget that Dorothy was writing too—while cooking.

> *The swallows have completed their beautiful nest. I baked bread and pies.*
> —5th July 1802

Anyone who's visited Dove Cottage—the Lake District cottage beside the main Ambleside-to-Grasmere road—might be surprised at how little of the experience has to do with the mechanics of writing poetry. Life there in the 1800s was hard. The cottage was spartan, all cold stone floors and bone-hard furniture, with a kind of built-in larder (actually a tiny room with a stream running through it to keep it cold enough to store meat). The whole place seems to tilt this way and that, and the rooms are hemmed in and gloomy. The dancing daffodils might as well be on another planet —this is a house for patching up trousers while roasting chunks of lamb on an open fire. And it's this austerity which peppers the (unedited) journals and which gives such incredible life to the writing. It's real.

And those daffodils—it's worth pointing out that William's most famous poem was written after Dorothy had been for a walk and recorded her own description of the flowers:

> *I never saw daffodils so beautiful they grew among the mossy stones about & about them, some rested their heads upon these*

stones as on a pillow for weariness & the rest tossed & reeled &
danced & seemed as if they verily laughed with the wind that
blew upon them over the Lake, they looked so gay ever glancing
ever changing.
 —15th April 1802

(William's lines—When all at once I saw a crowd,
 A host, of golden daffodils;
 Beside the lake, beneath the trees,
 Fluttering and dancing in the breeze.
—were written two years later.)

The term "Romantic poets" wasn't a label that existed in the time
of Blake, Wordsworth, Coleridge and Keats. It came much later,
and does those poets a disservice since the ideas that defined them
had little to do with romanticism (with a small *r*). These men were
driven by the desire for change, for revolution (Wordsworth and
Coleridge were spied upon as seditionaries by government agents)
and for a fierce, passionate championing of the people. When
William Wordsworth and Samuel Coleridge wrote of the land-
scape, they were doing so as adventurers and freedom-lovers.
William, in the preface to his book of *Lyrical Ballads*, maintained
that poetry should be democratic; it should be composed in "the
language really spoken by men."

 Looking at Dorothy's journals now, we see the language really
spoken by women, a language that could perform a daily dance
between the calls of the songbirds at dusk and the routine of
preparing pastry and laundering sheets. Often, as she writes, these
two appear together in an entry, side by side:

> *I baked bread & pies. Before dinner worked a little at Wm's*
> *waistcoat—after dinner read German Grammar.... That Dear*
> *thrush was singing upon the topmost of the smooth branches of the*
> *Ash tree at the top of the orchard. How long it had been perched*
> *on that same tree I cannot tell but we had heard its dear voice in*

the orchard the day through, along with a cheerful undersong
made by our winter friends the Robins.
—Tuesday 23rd February 1802

The journals' original editor, William Knight, missed a trick by omitting the day-to-day balancing act that Dorothy describes, for it's this juxtaposition between darning waistcoats and listening to birdsong that makes the diary authentic, relatable and compelling. Like Jah Wobble, Davey Graham and their vacuum cleaners, we get a real insight into the whole of a person and the whole of their story when we get the prosaic along with the poetic.

Of course we want poetry rather than laundry lists. We want the words and ideas that go further, that detour, that take risks. We don't want the story of the mountain climber who, getting to a difficult section of the rock face, turns around and climbs back down again, sensibly. No—give us the against-the-odds triumph or the tragic failure, anything but practicality and prudence.

But what Dorothy brings to life in her journals is a helping of both, where the humdrum of sock-darning accentuates the descriptive sweep of her love of nature. On one day (5th May 1802) we switch from "planted three-fourths of the bower. I made bread" to "The thrush sang all day, as he always sings. We walked in the twilight.... The moon had the old moon in her arms, but not so plain to be seen as the night before. When we went to bed it was a boat without the circle."

That's a life being well lived, and fortunately for us, well told.

Leeds, Leeds, Leeds

How do you do a sculpture of a horse?
You get a big block of stone and chip away
all the stuff that isn't a horse.

The problem with stories is that people can get stuck in them, especially if they're about where you're from. The story of being from the North of England (or "Oop North") is one of rain and raincoats, Joy Division and football, locally brewed bitter and bingo players. The tropes and clichés are never flattering, yet for some reason we often shrug our shoulders and take them on board (or even make TV soap operas out of them). The least flattering regional characterisations of them all arguably belong to Yorkshire, Britain's largest county, and boy have the Yorkshire natives—or should I say, the higher-ups in the town halls and the press rooms —taken them on board.

The story about people from Yorkshire is still retold by The Old Guard in a regional dialect that sounds gruff and clipped. It's a story of taciturn suspicion of outsiders, miserly penny-pinching, acceptance of menial work and obsession with tradition. When Yorkshire won the bid to host the opening stages of the Tour de France in 2014, it was a chance to welcome a truly international audience to the region—people came from all over the world to watch the race pass through incredible countryside, cheered on by vast crowds of spectators. The county celebrated by filling gift shops with cards, mugs and posters declaring things like "Ey up, that's a reet big hill," happy to regurgitate the stereotype.

Back in 1988 Leeds councillors took a decision which deprived the city of a unique landmark—*The Brick Man*. Standing 120 feet tall, Anthony Gormley's proposed sculpture was due to be built on Holbeck Triangle, unused scrubland near Leeds city station,

which the council had long earmarked for a sculpture park. The sculpture, a towering naked figure made entirely of red bricks (echoing the city's notably redbrick housing), was to have a set of steps inside which could be climbed, giving access to windows in the figure's eyes—from which vantage point (the proposal was for the statue to be twice as tall as Gormley's later *Angel of the North*) the viewer could look right across the south of the city.

In Leeds Art Gallery is a maquette of the proposed sculpture, and even at a lowly seven feet high it's easy to see how impressive the finished work would be: a gigantic welcome to the city for everyone travelling from the south, it would stand for everything Yorkshire's self-deprecating image was not—a towering symbol that declared Leeds as ambitious, outward-looking and grand.

Despite having some plaudits, the project was never built. Mutterings in the council chambers were fed to the local conservatively minded *Yorkshire Evening Post*, which set up a campaign against the £600,000 project after a phone poll (which they carried out among their conservatively minded readers) revealed eight hundred in favour of it but more than two thousand conservatively minded people against it. During this campaign of parochial derision against *The Brick Man*, the *Yorkshire Evening Post* asked their conservatively minded readers what might be a better symbol to represent Leeds in a giant sculpture—the most popular choice was "a giant cup of tea."

When word got out that *The Brick Man* was to be built using bricks sourced from a Manchester-based brickworks, Leeds City Council decided to put an end to the whole project, flabbergasted that Yorkshire folk might have to be footing a bill that put money into a rival city's industry. Leeds City Council leader Councillor George Mudie said, after the results of the *Yorkshire Evening Post* poll were discussed in council chambers, "I am delighted but not surprised with the formidable common sense of the Leeds public. The result demonstrated the scheme should not go ahead." He added: "Their common sense contrasts sharply with the airy-fairy views of celebrities who don't live within 100 miles of the city."

Anthony Gormley took his idea for a giant figure, reshaped it

and plonked it alongside the A1 motorway in Gateshead, in the northeast of England. The steel figure, named *Angel of the North*, standing twenty metres tall and with a wingspan of fifty-four metres, was commissioned by Gateshead Council, who persuaded the initially reluctant Gormley that the work would be a success. It was opened to the public in 1998 and is now seen by an estimated thirty-three million people each year and is a much-loved and celebrated work of art that local people are incredibly proud of.

In the same year that *Angel of the North* first spread its wings, in May 1998, the *Yorkshire Evening Post* comments section declared:

COMMON SENSE TAKES A HOLIDAY

The paper was following up its big news story of the day, accompanied by photographs of students in swimwear drinking beer on an unnamed beach:

> **Cheeky art students at Leeds University spent a £1,000 grant for an end-of-term exhibition on a Spanish holiday. A 13-strong group of Fine Art students spent six days sunbathing, drinking and enjoying the nightlife of the Costa Del Sol to make an art statement … at the expense of the students' union.**

The news story ticked all the boxes—lazy students, wasting public money, modern art is rubbish. Forgive me for quoting the entire comments article, it's just too perfect.

> **THE FRENCH** painter Georges Braque famously asserted: "Art is meant to disturb." Final-year Leeds arts students have clearly taken

Georges's dictum to heart. They blew grants and donations earmarked for an art show on a Costa holiday. Then they smirkingly called it performance art. One student confessed they needed to "court controversy." Well of course they did. Modern art isn't about technical competence or making marks on paper and canvas. It's a branch of showbiz where self-promotion—a la sheep-pickler Damien Hirst—comes before any graphic skills.

In this freewheeling climate, any-thing goes. So long as it gets up the noses of ordinary people and causes a stir. The Leeds students have achieved a masterpiece of such in-yer-face arro-gance.

Art is what we say it is. That's the battle cry of a new generation of artists. Many can barely write their own names, let alone create a competent sketch or life drawing. All that classical stuff is boring. And hard work.

How much easier to play jokey scams, ligging your way to a free Costa break. Then, barely keeping a straight face, do a snowjob on the ignorant punters with buzz words like the "semiotics of post-modern aesthetics."

Is it a con? Well, it's lazy, half-baked and puerile. But saddest of all, the students and their tutors probably believe their own publicity, believe they are striking a blow against boring bourgeois expectations.

The *Daily Mirror, Telegraph, Guardian* and *Express* all followed suit, dutifully and gleefully using their outrage at the stunt to have a go at "kids today" and poke fun at modern art.

Then one week after the story broke, a member of the now-notorious "Leeds 13" appeared on national BBC Radio to declare the whole thing a hoax. The money hadn't been spent; the photographs were faked on local east coast seaside beaches; the students had even hired a sunbed to give themselves fake tans. The entire performance—for that's what it was, a delicious piece of theatre aimed at pricking the bubble of a staid and lead-footed media—was perfectly executed and, contrary to all the editorials slamming the lazy students, a hell of a lot of work. Nevertheless, the group stated, "During our brief foray into the limelight, we have added greatly to the jollity of the nation."

This level of jollity clearly didn't tickle the *Yorkshire Evening Post*'s funny bone. Over the next three days the newspaper published a series of pieces and letters continuing to attack the art students, even attempting to ridicule them for not making money from the reproduction of the "holiday" snaps. ("Had the students really been on the ball they could have made a mint by charging [for the photographs]. That way they would have made enough money to have a proper holiday.... So who really had the last laugh?") Red faces, sour grapes and the wish to retain some moral high ground (even as they were slipping rapidly back down the hill towards the swamp) wouldn't allow the grey men from the press to appreciate the joke and laugh at themselves.

Twenty-three years later, in 2011, the *Yorkshire Evening Post* was in public mourning for the death of local celebrity Jimmy Savile, a former radio DJ who was famous for smoking cigars, running marathons to raise money for charity, and somehow avoiding being investigated for a series of barely disguised serial sex offences. Jimmy Savile died in late October, and by the following week it was announced that his body would "lie in state" at Leeds's Queens Hotel. As mourners in their thousands queued to see the open casket, Leeds City Council was already discussing how they could memorialise Savile—the *Yorkshire Evening Post* reported that "the

people in Leeds are to be asked their views on what form a permanent memorial to Sir Jimmy Savile should take." Judith Blake, Labour deputy leader of Leeds City Council, said any future memorial should mark Sir Jimmy's "enormous contribution" to the city.

"We want it to be a tremendous celebration of his life and everything he contributed to the city," she said. Mrs Blake said Leeds City Council was "definitely" planning some sort of memorial to Sir Jimmy. Rebecca Papworth, a comedy producer who was working with Sir Jimmy on a TV comedy drama based on his life, said she supported any move to erect a permanent memorial in Leeds. "As it is, there isn't even a plaque to commemorate that achievement. He was at the birth of popular culture, an absolute figurehead, and Leeds should get behind that and celebrate that."

I like to imagine that, somewhere in a storeroom in the basement of Leeds City Hall, there are the drawn-up plans for a plaque dedicated to Sir Jimmy Saville. It sits next to a small-scale maquette of a cup of tea and a fading photograph of some young holidaymakers on a beach in Spain.

Money,
Money, Money

An Interview with the Man Who Filmed the K Foundation
Burning a Million Quid

I have a postcard on the table in front of me, one side of which is a
photograph of a framed photograph.

The framed photograph is suspended in a barn doorway with
rough twine.

The photograph in the frame is by Richard Long—famous
landscape/environmental artist who has been at the forefront of
"environmental art" since the 1970s, when he made his infamous *A
Line Made by Walking.* That piece was a photograph of a field where
Long had walked up and down a few dozen times to make a line
in the grass, which he then photographed. I've loved Richard
Long's work since the 1970s; in my all-too-brief time at art school
(three months), I used to ape his style, thinking no-one else at the
college would know who I was mimicking. Went on walks, took
photographs of the ground, that sort of thing.*

Photographs, lines, walking—what's all this got to do with
money?

Bill Drummond of KLF (remember them?—massive dance hits
in the 1990s, did a song with Tammy Wynette, burned a million
quid) bought for himself a Richard Long photograph of a walked

* Once, on a weekend back in Burnley and with a camera borrowed from
 Maidstone Art College, I was arrested in the town centre while taking
 photographs of the floor. I was kept in a cell all day until they could
 ascertain the camera wasn't stolen. The duty officer's first words to me
 on being admitted to the police station were, "Why do you dress like
 a cunt?"

Icelandic landscape called *A Smell of Sulphur in the Wind*. It cost $20,000.

Bill loved this photograph and loved Richard Long's work. It had pride of place on a wall in his house for a while, and then he started to feel uneasy about it. About having a piece of art that cost $20,000, hanging in his house. It didn't feel right, he said.

So he decided to sell the work. And in doing so, he would make a point about money, and art, and value.

On the reverse of the card in front of me is Bill's **WARRANTY** (it's written in capital letters so we take it seriously), which states that the framed photograph/artwork in question has been cut into twenty thousand pieces and that each piece will be sold for $1.00.

The twenty thousand dollar bills thus accumulated by the sale of this artwork are to be (according to the **WARRANTY**) locked in an oak box and buried in the middle of Iceland. Somewhere.

I love this little artwork, because it brings together two strands of my life separated by almost two decades—a place where punky teen meets dance culture situationist across the great divide of a Richard Long walk. This little postcard, the tie that binds a life. (One of Long's works quotes Johnny Cash, beautifully—"I keep an eye out for the ties that bind.")

But I love it too because it is basically an excuse to discuss art, value and money.

Art, value and money is what, through the years, has occasionally, but repeatedly, kept me awake at night. How do you evaluate something you love to do? What is art worth? How do we measure our worth as artists? If you work in the NHS, I can probably measure your worth in diagnoses and operations and patient care and, in a lot of cases, survival. If you work as a postal worker, I can measure your worth in letters delivered. If you work as a builder, I can measure your worth in bricks and mortar. My worth as an artist? It's, at best, up for debate.

So this is why my acquisition of Bill Drummond's little postcard, and my little twenty-thousandth piece of a famous artwork, is so important. It's a chance to think about value, and worth.

To me, art is worth a thousand times its weight in ideas. Art is

worth its weight in inspiration, in provocation, or in simple, objectified beauty. (Anyone who is upset about the K Foundation burning a million quid ought to wonder about Conservative MP Jacob Rees-Mogg's present wealth of over £100 million, almost all of it inherited.)

Here are the facts: In 1994, K Foundation—formerly KLF's Bill Drummond and Jimmy Cauty—drove up to the island of Jura off the coast of Scotland and burned a million quid. They took along with them one journalist and the irrepressible Gimpo, a filmmaker and trusted sidekick who went on all sorts of KLF/K Foundation adventures with the pair. He was there to simply record the burning, to prove to the world that it wasn't a hoax. I've always loved this destructive, shocking act. Loved it because it provoked outrage and debate and arguments. Loved it because it exposed how much people, even left-thinking people, are tied in to the sacred power of money. As Cauty later said, had the pair spent the million quid on a swimming pool for their garden, no-one would have batted an eyelid.

So when my friend Alison McIntyre said she knew Gimpo— and that she could arrange for us to have a chat with him about the whole Million Quid thing—I jumped straight in. And we loved talking to Gimpo: he's a salt-of-the-earth bloke who knew what was going on and had a laugh along the way. To be honest, he made me a bit embarrassed to be holding on to my little Bill Drummond postcard of the fragment of a Richard Long artwork. I didn't mention it. Let's pretend I took it to Iceland and buried it in a box.

So, between Alison and me, we give you: the man who was there when the K Foundation burned their money. A proper gent.

ALISON: So first off, we were wondering what it was like to be there and film it?

GIMPO: It was just early in the morning. I went to bed drinking whisky and, erm, then they were in my room in the morning saying, come on, we're gonna go do it now. So we went down there with more whisky and, erm, just set fire to it.

[84]

I didn't know what they were going to do. I knew they had the money with them because we'd picked it up from the armoured car, somewhere in South London, then got a private plane up to Islay, next to Jura, and then got a private car over to Jura and just had the money in the back of the car.

BOFF: You didn't know what was going to happen to it?

GIMPO: No, no. I never asked. Didn't have a clue.

BOFF: Why didn't you ask?

GIMPO: I never ask, I just get on with it and see what happens. People are always asking—what are they gonna do? And I just say, whatever, it'll happen when it happens. I just turn up and work for the day, and erm...that's it.

BOFF: What was your first reaction, seeing the money, that much money?

GIMPO: Just laughing!

BOFF: And you didn't think, "Blimey, I might as well stuff some of this in my back pocket. Nobody will ever know."

GIMPO: Well, when they started burning it, I stole £50,000. It was just on the floor, and I had £50,000 in my hands and got to the back with it. I was gonna hide it in the boot of the car, and I thought, "Oh, I want another one." And I thought, "Erm...it'll never stop!" So I went back and just kicked it back into the pile. The journalist we had with us wanted a £50 note to prove that it was real to people, but they wouldn't let him keep that because they only took a million pounds out of the bank, not a million and fifty. But you know, there's one bit in the film where I had the camera on the floor and, erm, he had a wad in his hand and put it behind his back. Then he looked down and saw the camera and went, "Oh fuck," and threw it back into the pile. Same as me. You see money getting burnt, it's easy, it's stealing, but you don't feel like you're stealing. It's just there, innit, getting burnt?

ALISON: Yeah. I wanted to ask actually if you were aware of what was happening in the moment while you were filming,

deciding that the thing that was happening was more important than the money?

GIMPO: Yeah, it's your mates, isn't it, and if I'd taken that I'd have wanted it all. Where would it stop? You know what I mean, I'd have to go back and get another one, and another one, until I got caught or whatever. And then I'd be pissed off that they'd burnt the rest of it, thinking that I should have took more. But, you know, it was just there and they were burning it. It was funny. It still is. They definitely regret it, every day they regret it and every day they're happy about it, aren't they? It's like, "Oh, what did I do that for?" But they'd have only spent it on something, wouldn't they?

BOFF: What if it was your money?

GIMPO: I'd be in trouble now, wouldn't I? My wife at the time wouldn't talk to me, she was sick. Members of my family don't even want to discuss it because they're sick about it, the ones who are bothered about money. It's greed, it's whatever, it was just a pile of paper, wasn't it? It's not much now, is it? Everyone's house is worth half that amount! But at the time there was the lottery and everyone wanted to win a million pounds. Yeah, it's just killing dreams, innit!?

ALISON: I was watching the Gay Byrne interview on *The Late Late Show*, and Jimmy Cauty said, "If we'd spent it on swimming pools and cars, nobody would have been bothered."

GIMPO: Yeah, they wouldn't, would they? It's your money, you can do what you like with it, can't you?

ALISON: Except burn it!

BOFF: I think it's really funny and brilliant. But is there an argument that it's only people who have loads and loads of money that can afford to make a joke out of it like that?

GIMPO: Yeah yeah, I suppose so. People have burnt tenners and twenty quids in front of [Bill and Jimmy] just to join in and, erm, waste money or whatever. People can do whatever they want with how much money they've got. It's

[86]

just that million-pound thing, innit, everyone wants to be a millionaire, you don't say two or three million. It's just the one. But now it's a billion, innit?

BOFF: Yeah, so you've no regrets at all?

GIMPO: No. Not at all. It was entertaining and fun, we had a laugh doing it. And it wasn't my money! I mean, hell yeah. It's great. I mean, it's growing all the time with people talking about it, it's still alive. So I mean, that's the main thing about it. It's amazing that it's lasted so long. It seems to get bigger as it gets older or whatever.

BOFF: Like a lot of stories that start small and grow into folklore.

GIMPO: Yeah, you're right. And it's just grown by itself.

Motivational Sports Quotes

Quotation is a serviceable substitute for wit.
—Oscar Wilde

Sport is theatre. And then sometimes, it's competition.

I used to think of it this way: that the best sport was theatre without a script, without a synopsis, without a plot. And that the worst sport was, against its raison d'être, scripted and plotted. But a lifetime of being hooked on sport means a broad jumble of assorted perspectives and the conclusion that the beauty of sport is that it's just unfathomable, unpindownable. Sometimes it's well-rehearsed theatre. Sometimes it's the unknowing thrill of competition. And mostly it's a mixture of both, a ridiculous complication.

When cyclist Lance Armstrong was revealed to be not only a serial drug cheat but also a bully who could emotionally batter the entire Tour de France peloton into submission, it rang the death knell for the sport of professional cycling. It undermined everything we loved about the sport, the belief that this most gruelling of all sporting endeavours was a simple mano a mano race between incredible athletes pushing themselves to their limits.

I once cycled a stage of the Tour de France—the iconic stage race was setting off from Leeds, just down the road, and passing through my town, Otley. The sense of excitement at this legendary sporting event speeding through our high street had been building up for many months. That first stage of Le Tour, a gruelling 118 miles along some of the Yorkshire Dales' finest rural roads (and up and down some of its sharpest gradients), would set the scene for the whole race, ending up in Paris three weeks later.

I decided to cycle that first stage, not as some sort of fitness challenge but to give myself some perspective on what the professional

riders would be cycling each day (and for twenty out of the next twenty-two days). I set off early enough in the morning to beat the dawn chorus, carrying enough sandwiches, muesli bars and energy gels to fuel an army.

Without going into too much detail, what that day taught me was that cyclists are superhuman. Or if not superhuman, then unreal. As I headed south along the A roads towards the stage's finish, with the sun dipping ominously below the horizon, I experienced a weariness I'd never felt before. I've run two-day-long mountain races, spent eight hours on my feet running up and down mountain ranges, I've been so exhausted I could drop on the spot, but this was different—it wasn't a puffing, panting knackeredness, it was an aching, drooping sleepiness that threatened to overwhelm me. A slow descent into utter insensibility.

The following day I stayed in bed until noon and basically sleepwalked through the afternoon until I was allowed to admit that I needed to go to bed again. The Tour riders do this and then get up and do it again and

again and

again and

again and

again and

again and

again and

again and

again and

again and

again and

again and

again and

again and

again and

again and

again and

again and

again and
again and
again and
again and
again and
again and
again and
again and
again and
again and
again and
again and
again and
again and
again and

DO iT
AGAIN and
AGAIN and
aGAIN

So, as a noncyclist, I've always been in awe of those riders who not only finish the stages but win them—and, of course, the legendary winners of the Tour itself.

Sometime during one of his Tour-winning years, I read Lance Armstrong's book *It's Not About the Bike*. Brilliant title. The implied subtitle is "No, it's about the person riding the bike."

Who could resist his story? Cancer survivor battles the odds and works his way to the top of the sport. The underdog story in a sentence. Like most other people, I completely fell for the idea that someone who had been so close to death would never play roulette with drugs and their body. No, Lance was the real thing. And to prove it, he started the Livestrong Foundation, whose aim was to "give cancer survivors more than just hope for a better future; your support fuels solutions for a better today." What a guy.

When Armstrong was finally outed as a cheat—and not only as a cheat, but as an arrogant control freak who enforced a gag on both his teammates and riders from other teams—we began to learn more of the Tour tradition which the riders name *the omertà*. In Italian, "the silence." It had been going on for years, but Armstrong was its toughest adherent.

When caught, Lance was forced to climb down from that perfect narrative frame and watch it collapse behind him. All those
years of gruelling stage battles—just a story.
The miraculous time trials—just a story.
The one-to-one duels on mountaintop finishes—just a story.
An untrue story.

The irony was that,
even though we'd wanted so badly
to believe in Lance, this new story,
which was basically a complete smashing of the old story,
was *even better*.

Traditionally, sport is the one story
we can't predict.

It's competition, and in competition there will always be upsets, there'll always be the unexpected. That's why we root for the underdog, because sometimes...well, there's always a

chance. My friend Mark Hodkinson has been a fan of Rochdale FC his whole life, and in that time he's not only followed them faithfully but has written a variety of books about the club. At the start of the 2022–23 season, Rochdale had spent 102 continuous years in the Football League—most of them, if you believe Mark, a litany of depressing defeats, bad management and rain. Constant rain. Mark seems to wear the mantle of the continuously disappointed fan like a big, heavy woollen coat that doesn't so much keep out the rain as collect it. *I'm not a pessimist*, he'd say. *I'm a realist.* Over the years I've argued this point, telling him that Rochdale's very presence in the league is a success for a small-town club with little or no investment. It's a story that combines battling against the odds with rich working-class tradition, and in an age where football is owned by oligarchs, criminals and even entire governments with little interest in the game other than advertising themselves, that's something to cheer.

But Rochdale's particularly rainswept fairy tale came to an end in 2023 when they finished the season bottom of the league and were, for the first time, ejected from it, dropping to non-league status. Talking to Mark after news of the drop, it felt like Mark's gloomy and overcast view of the club and of football in general had been confirmed. This is his story of football: an inevitable slide towards the bottom, the rich getting richer and the poor getting bundled through the trapdoor. So much for the underdog. I'm counting on Rochdale FC bouncing back soon, winning their division by an unfeasibly big margin and climbing back into the Football League, thus proving that sport doesn't have to have inevitabilities, that sport can always surprise us—because in competition, no matter how many Goliaths strut around with their Premier League medals, there's always going to be an occasional David with a slingshot and lot of luck.

Which isn't what sport's governing bodies want—increasingly, sport is being treated more as theatre and less as competition. And theatre, of course, is all about that perfect beginning-middle-end story. Dereje Kebede-Tulu was an Ethiopian distance runner who arrived in the UK in the early 2000s, covered in scars and burns

from being tortured. His father had been murdered by govern-
ment soldiers with a single shot to the head. Claiming asylum,
Kebede-Tulu was forced into the ruthless claims system and had
to fight for three years to gain refugee status, all the while trying to
fulfil his athletic potential, and in the hope of running for the UK
in the 2008 Olympics. Living in a single-bed flat on just £53 a
week, he couldn't hope to maintain the protein-rich diet it takes to
reach his peak, and neither could he afford to travel to races—but
despite that, and with the help of fellow runners, he clocked up
remarkable times, easily meeting the standard required to qualify
for a British vest. This is the underdog story writ large, and all it
needs is an Olympic appearance, a medal and a homecoming cele-
bration—but within weeks of being finally granted citizenship,
Kebede-Tulu was found dead in his flat, his body emaciated and
partly decomposed.

Presumably you've never heard of Dereje Kebede-Tulu. Neither
had I until recently. He barely made the papers, never mind the
hallowed sporting back pages of the tabloids, where at the time of
the inquest into Kebede-Tulu's death, the big news was that
Manchester United's Cristiano Ronaldo had started negotiations
on a wage increase which would rise from its then-current £120,000
a week to £200,000 a week.

The first football match I went on was with my dad to see my
hometown club Burnley FC playing Chelsea in an FA Cup replay.
Even back then, and despite the incredible spectacle of floodlights,
sell-out crowd and constant chanting, even then I knew this was a
David v Goliath game. Burnley lost, of course. But the beautiful
idea at the heart of sport stayed with me: this wasn't Hollywood,
there was no three-act structure, because in sport the ending isn't
predictable. That's it. It doesn't matter who plays who, you can't
know for sure what the outcome will be. There is no script. I really,
truly believed it.

I clung onto this idea of sport even as it gradually changed and
became more and more predictable. On the one hand, football
became tied to big-money investment and corporate insistence on
winning (and selling TV rights, advertising and shirts). On the

other hand, it got less and less likely that the underdog could actually win. My team slipped down the leagues and spent decades playing in front of tiny crowds with no prospect of delivering a narratively satisfying happy ending. I've discovered that a lot of sports supporters like myself incorporate this mistrust of the narrative—this idea that "on the day, anyone can win"—and use it as a badge of martyrdom, a test of loyalty. Bloody-minded devotion, whatever you want to call it, when a team becomes part of your identity, for good or ill. "It's the hope that kills you," we mutter, resigned and self-pitying, huddled into scarves and hoods as the rain swirls around the ground, fishing in our deep pockets for one of sport's thousands of "inspirational" quotes that seem to plague the games.

Vince Lombardi—considered to be the best American football coach in the sport's history—famously said:

WINNING
ISN'T EVERYTHING,
IT'S THE ONLY THING.

This quote might as well have been on his headstone, it's the sentence he is remembered for—a few words to gather a worldful of single-minded, focussed determination on that one thing, winning. But later, Vince was at pains to discuss the quote, to undermine it:

> I wished I'd never said the thing.
> I meant the effort. I meant having a goal.
> I sure didn't mean for people to crush
> human values and morality.

Bill Shankly, legendary manager of Liverpool FC, had a quote, like Lombardi, that followed him wherever he went. It was this:

THEY SAY THAT FOOTBALL
IS A MATTER OF
LIFE OR DEATH,
AND I SAY LISTEN, IT'S
MORE IMPORTANT
THAN THAT.

What doesn't get mentioned enough is what Shankly actually went on to say. Here's the full quote:

They say that FOOTBALL IS A MATTER *of*
LIFE OR DEATH,
and I say LISTEN, IT'S
MORE IMPORTANT THAN THAT.
The SOCIALISM I BELIEVE IN *is*
EVERYONE WORKING FOR EACH OTHER,
EVERYONE HAVING A SHARE OF THE REWARDS.
IT'S THE WAY I SEE FOOTBALL,
THE WAY I SEE LIFE.

Sport is theatre, and then sometimes, importantly, it's not.

Likely Lads

The Likely Lads—old mates Bob Ferris and Terry Collier—spent the early 1970s as British TV's favourite mismatched couple, in a sitcom that was somehow both funny and an incisive critique of class mobility. Terry was just out of the army, single, broke, a caricature formed of beer, football and casual stereotyping. While Terry was away on active duty, Bob had left his shifts in the factory and acquired a job in middle management, an aspirational girlfriend and a neat semi-detached on the new Lodge Moor estate. Despite the nonstop tension between them, the lads shared a passion for football.

There's a particular episode—called "No Hiding Place"—where Bob and Terry decide to avoid the result of the afternoon international match between England and Bulgaria so that they can watch it on the TV highlights in the evening. In an age before rolling news and nonstop digital communication, they still run an entire day's gauntlet of shop televisions, newspaper sellers and a mate who seems determined to ruin their plan by attempting to tell them the final score.

There's a punchline (of course there is), which I'll come to later in this story. But that's not the important thing here; the triumph of this single episode is how it has endured as a *universal*, a common, recognised idea. Avoiding the score, leaving the best bit of the meal until the last bite, practising impulse control and understanding delayed gratification.

An experiment carried out at Stanford University in the '60s (how come all the weird and memorable experiments seem to begin "Stanford, 1960s"?) by Professor Walter Mischel tested hundreds of children, each placed in a private room and left alone with a single, tempting marshmallow. "If you don't eat the marshmallow for the few minutes we're out of the room," the researchers would tell the kids, "you can have another one. But if you eat this first marshmallow, there won't be a second one."

[96]

We all know the results, or we can guess them—almost all the children ate the first marshmallow. But what's interesting is that the subjects were tracked for the next forty years, and the children who had chosen to delay their reward did consistently better in tests, were healthier, responded well to stress, had fewer substance abuse issues and showed better social skills. As Abraham Lincoln said: Good things come to those who wait. (His actual quote was "Things may come to those who wait, but only the things left by those who hustle." Which is better.)

The final of the 2005 Champions League, played in Istanbul, saw Liverpool FC playing AC Milan. Upwards of forty thousand Liverpool fans who'd travelled to Turkey to watch the match saw their side go 3–0 down by half-time to a much superior team. Photos of Liverpool fans at half-time show them slumped in their seats, heads in hands. After the break, Liverpool came roaring back to score three goals in a twenty-minute period to draw level and then win the game on penalties. Some Liverpool fans who'd had enough at half-time, despondent and having lost all hope, had left the ground and were making their way back to their hotels when they heard the news. Playwright Nicky Allt, who was at the game, wrote a play about the fans who missed the victory, and the play was made into a feature-length film.

You'd think, wouldn't you, that these Liverpool fans would learn their lesson—understanding that walking away from the story before the end not only disrupts the narrative (competitive sport relies on *not knowing the ending*, having to wait until the last minute to get the end of the story) but sets you up for a crash. But just over a decade later, Liverpool, playing Borussia Dortmund in the 2016 Europa League quarter-final at Anfield, went 3–1 down with half an hour to play. Again, some disgruntled fans left the ground, including (and let's admire his honesty) one Spencer Evans. Lifelong fan Spencer missed a dramatic twenty-five-minute spell where Liverpool scored three times to win the game 4–3. Hearing the news, Spencer immediately took to social media to declare:

I am officially the biggest cunt in Britain.

My head went at 1–3 and I left the ground.

Feel physically sick.

The next day, facing a barrage of torment from his mates, he added:

My head just went.

Will rank as one of the biggest regrets of my life.

Absolute knobhead.

When Bob and Terry sit down to watch the football match they've (successfully, by the skin of their sitcom teeth) spent the entire day avoiding, they are merely setting up the punchline to their half-hour-long joke: the mechanics of this comedy device being to undermine traditional storytelling and allow the ending to be, for the Lads, a big disappointment. Instead of the football, an announcer cheerily explains that with the England international match being postponed, there will instead be "an hour of figure skating." It's perfect. You, the viewer, get your reward, which is to see two grown men have their reward snatched away from them. There is no happily ever after, and that makes us happy.

Writer Nora Roberts maintains that we demand the happily-ever-after myth precisely because it isn't lifelike. "If justice doesn't triumph and love doesn't make the circle in entertainment fiction, what's the point? Real life sucks too often."

Let's picture Bob and Terry all set up to watch the football but instead they are given the chance to watch Terry Gilliam's acclaimed film *Brazil*. The general plot is this: Sometime in the future, an innocent man (played by Jonathan Pryce) finds himself in a Kafkaesque dystopian nightmare, accused of a crime he didn't commit. The man spends the film trying to assert his innocence in a world run by a dark and clunkingly oppressive bureaucratic machine run by mad scientists. The original title of Gilliam's film was *1984½*, which goes some way to explaining the general storyline. And, as in Orwell's *Nineteen Eighty-Four*, there is an unhappy ending—our main character's final, exhilarating break for freedom, driving down a road towards freedom's sunset, is

merely a dream; he wakes up strapped to a chair in a torture chamber. And that's it.

The End.

But Universal, the film's distributor, refused to release the film, demanding a less-bleak ending. They asked that the ending of Pryce's dream, concluding with his dramatic escape and (literal) drive into the sunset, be the film's ending. The bit where our man wakes up and finds himself back in a nightmarish reality? Simply chop it off. Gilliam refused to cut the film, telling Universal boss Sid Sheinberg: "Listen, Sid, the film we made is the film we all agreed to make. If you want to make another film, you have my support. Just put your name on it. *Sid Sheinberg's Brazil.* Very simple."

The dispute over the ending went on for months, and was only resolved when Gilliam leaked copies of the (uncut) film to reviewers, who all publicly praised it to the extent that the cat couldn't be stuffed back into the bag; Universal relented, and the film went on to great success—unchopped.

The unsightly scrap over the ending of *Brazil* tells us a lot about how rigidly we are fixed to traditional storytelling. But it was never as simple as happy ending versus unhappy ending—the difference between *Nineteen Eighty-Four* and *Brazil* is that in Gilliam's dystopia there is a triumph, of sorts, of the imagination; as the director puts it, "He escapes into madness, which I've always considered a reasonable approach to life in certain situations. To me that's an optimistic ending. The main character's imagination is still free and alive; they haven't got that. They may have his body, but they don't have his mind."

And now we're taking you to Wembley for the England-Bulgaria soccer match. The finals of the European Figure Skating Championships, in Vienna, have been postponed because of a waterlogged ice rink.

Writing

Of all fatiguing,
futile, empty trades,
the worst, I suppose,
is writing about writing.

—Hilaire Belloc

On the Road

If the Beat Generation is a label for our time, I'll not
submit to it. If there is one thing in this year 1959 that is
cheap and phony, it's the cancer called the Beat Generation.
Most of the poets and writers who consider themselves
Beat make the same nonsense on a typewriter, create
worthless literary dissonance—and get away with it!
—Stuart Mitchner, *Chicago Daily Tribune*

Jeanette Winterson is right when she says that the best way to
learn how to write is to read. By reading, we pick up the necessary
rules, patterns and nuances of written language, and if we're smart
then we can get going on our first novel sometime towards the age
of twelve or thirteen. Mine was about a kid who saw Lee Harvey
Oswald pull the trigger in Dallas, and I didn't finish it. Actually I
only got as far as page 10, but that's not the point.

And all the while, you know that all the words and sentences
and paragraphs are full of grammatical terms and word classes
stuck together with punctuation's Sellotape. But if you're like
me, you don't necessarily know all the correct words for these
grammatical terms because you don't *need* to know them—unless
you're a British kid aged seven to eleven, in which case it is now a
requirement of the government's national curriculum that you
learn them. Here are some zingers from the primary-age curricu-
lum that baffle me: coordinating and subordinating conjunctions,
fronted adverbials, and determiners. I don't know what they are
and I don't care, because instead I acknowledge their use and get
on with using them, without even knowing it.

And it's good that there are these rules that help us read and
write and understand each other. But it's also good that we have
people who, having learned all the rules and patterns, wilfully

ignore or twist them, subverting the accepted way of writing and poking fun at storytelling's rules.

Which is a long-winded way of introducing Jack Kerouac and his famous scroll. Several years ago I visited the British Library to see it, the original manuscript for Kerouac's novel *On the Road*. A long scroll of yellowing paper (so thin you could see through it) in a glass case that stretched almost the entire width of the room, a scroll that Jack had fed through his knackered typewriter in one continuous roll, writing both from his own notepads and journals and scraps of paper and from his 100-words-per-minute imagination. It's a thing of beauty, a physical artefact that fits perfectly with the ideas behind the novel. In a letter to his friend Neal Cassady, Kerouac said that he "wrote whole thing on a strip of paper 120 foot long... just rolled it through typewriter and in fact no paragraphs... rolled it out on the floor and it looks like a road."

Kerouac was influenced in his writing style by Walt Whitman and James Joyce, writers who had consciously broken storytelling's rules. Hammering away at his typewriter, Kerouac tried to conjure the near-breathless movement of a journey, its fast-paced conversational style betraying the writer's use of amphetamines, ideas jumping from sentence to sentence, writing that read like thinking aloud.

Sometime after the kick-up-the-arse of punk rock had inspired me and my friends to pick up musical instruments and start bands, my friend Dan decided he'd learn to play guitar. He'd already written poems—he recited one on national radio during a John Peel session for local band Notsensibles in the late 1970s—but wanted to put music to them. By then we'd become obsessed by Salford band The Fall, and two years of our lives were seemingly spent hitch-hiking around the UK to see them play, this rag-tag bunch of unlikely scruffs fronted by Mark E. Smith's cynical (but for all that, magnificently unique and compelling) vocals. He was a poet, could barely sing, and taught the rest of the band the tunes by humming rough melodies which they attempted to emulate. The Fall's first guitarist was Martin Bramah, a skinny, brooding figure who wore scrappy brown leather jackets that were literally

falling apart at the seams. His guitar-playing, which defined the early sound of the band, was scratchy, dissonant and fantastically unusual—tunes came out of his guitar as broken-glass scrapes, treble dial turned up to full.

Dan saw Martin Bramah and thought, *That's how I want to play.* Unconventional, eccentric, weird. To that end, Dan steadfastly refused to learn chords or even to tune his cheap acoustic guitar in any "normal" manner. Sitting for hours in his room in the house several of us shared in the student-let redbrick oasis of Leeds 6, he twisted the tuning pegs until he thought it made an acceptable sound and moved his fingers up and down the fretboard making whatever noise might fit his words. It sounded awful. Really, excruciatingly bad. The musical equivalent of scratching nails down a blackboard. He tried this for several defiant months, until, at last, giving in to tradition (and to our well-meaning suggestions that he learn about tuning), he borrowed a book of simple chords. Life in the house suddenly became a little sweeter. Once Dan had learned to accept standard guitar tuning and had found his way around a handful of chords, he then started to write a hatful of peculiar, eccentric and fantastically odd songs which were, nonetheless, listenable.

It's a common story (as stated by the author himself) that Jack Kerouac wrote *On the Road* in three weeks, from start to finish. In fact he'd been writing, rewriting and editing different versions and sections of the book for several years; what took him three weeks was the 120-foot scroll, that beautiful thing full of typos and skewed grammar and pencilled-in notes, the scroll that even began —yes, the very first sentence—with an error:

`I first met met Neal not long after my father died ...`

And it's the scroll that has no ending, where even on display at the British Library it reaches its unwound conclusion with a ripped and ragged edge, missing the final words—and onto which Kerouac himself has scrawled,

"Ate by Patchkee, a dog."

That was his friend Lucien Carr's cocker spaniel, which genuinely (as Kerouac might confess to his teacher to explain the

missing homework) bit off the end of the manuscript. "No, honestly, sir…"

Around two decades ago, when our daughter was a baby (or in the words of my art teacher at Burnley Technical College, "a pink meat tube"), after performing at a festival in Devon, Casey and me decided the best way to drive home in some semblance of peace would be to travel through the night, three hundred miles back to Leeds in a rented camper van. We knew it would take around six hours, but we had a secret weapon which I'd found in a charity shop: a three-CD recording of Kerouac's *On the Road*. We started the engine and pressed play—"I first met Dean not long after my wife and I split up…"—and off we went, heading north, driving nonstop the entire way until, with the summer sun just starting to rise behind us, we reached the final, beautiful paragraph of the audio book just as we reached the top of the M1 motorway and our hometown of Leeds—

"So in America when the sun goes down and I sit on the old broken-down river pier watching the long, long skies over New Jersey…"

It was perfect. And then we saw the blue flashing lights in the rear-view mirror, and were pulled over for speeding.

Two Blackbirds

1. (Hopeful) Blackbird

Paul McCartney's "Blackbird" was written in 1968, at a time when the US civil rights marches were at their height. McCartney was in Rishikesh, India, with his bandmates, and when he wasn't sitting cross-legged in front of the Maharishi he was messing around strumming an acoustic guitar and coming up with new songs for The Beatles' next, as-yet-unnamed album (the one that would be titled simply *The Beatles* but nicknamed *The White Album*). While he was messing around with a tune by Bach that George and he had learned as teenagers (no, really), he heard a blackbird singing outside the window of the tiny white-walled room he shared with Jane Asher and started to put words to the tune. He told the pop singer Donovan—who was also on the Rishikesh trip—that the song "was about, you know, the black people's struggle in the southern [United] States, and I was using the symbolism of a blackbird. It's not really about a blackbird whose wings are broken, you know, it's a bit more symbolic."

As early as 1964—when The Beatles were still hitting the top of the American charts with "I Want to Hold Your Hand" and "She Loves You" and shaking their moptops—the band had taken a public stand on civil rights when they became the first act to refuse to perform to a segregated audience, at the Gator Bowl in Jacksonville, Florida. Segregation was the law there, but when The Beatles refused, city officials relented, allowing the stadium to be integrated, and the band took to the stage. Being interviewed before the show, McCartney said: "We don't like it if there's any segregation or anything, because it just seems mad to me, to segregate people. 'Cause, you know, I mean—yeah, I just think it's stupid! You can't

treat other people like animals! That's the way we all feel, and a lot of people in England feel that way, you know, 'cause there's never any segregation in concerts in England and, in fact, if there was, we wouldn't play them, you know?"

That was 1964, so it would seem inevitable that a Beatle would sooner or later write a song in response to the marches, speeches, riots and killings happening in the States through the rump of the '60s, especially since the civil rights movement was joined at the hip to the counterculture that The Beatles were integral to. Inevitable, too, that Paul McCartney's solo acoustic Rishikesh song wouldn't be a lament or a blues; it would be a song of hope, melodically memorable, a wishful, optimistic song. *Take these broken wings and learn to fly*… it's the opposite of the blues, it refuses to cry. And it's beautiful.

Unlike so many of their peers—The Rolling Stones, Yardbirds, Cream, Led Zeppelin—The Beatles somehow managed to swerve the great British blues boom. Other than their love of down and dirty rock'n'roll, their musical influences included Motown, country and western, American girl groups and music hall. But typically, their one foray into the blues is Lennon's "Yer Blues," written in those same surroundings in Rishikesh, when his marriage to Cynthia (who was there with him) was dead on its feet. So we have John wailing, "Yes I'm lonely…wanna die," and Paul next door cooing, "Blackbird, fly."

A few years ago a friend of mine declared that "all the best songs are sad songs, break-up songs, songs of pain." I challenged this, instinctively recalling the upbeat thrill of songs like "Teenage Kicks" and "You Are the Sunshine of My Life." Go on then, he'd said, make me a compilation of happy, positive songs. And so I did, twenty-five songs full of declarations of love, spirit and power. But my friend was right—as I looked through my collection, I realised those songs were heavily outnumbered by songs of anguish, heartbreak and melancholy.

Which makes McCartney's "Blackbird" all the more re-markable—a song inspired by injustice, oppression and a continuing struggle to be treated as equals ends up sounding so gloriously optimistic. It's not that Paul McCartney couldn't write a break-up song—"Yesterday" will do as an easy example—but this is Mr "take a sad song and make it better," it's what McCartney does. And it works—The Beatles' "Blackbird" is, as I write, the eighth most recorded song of all time.

But let's be clear: McCartney writes from the standpoint of an outsider. Not only an outsider to the fight for civil rights, but an outsider to the idea of a life of hardships and knock-backs. McCartney's talent as a songwriter was always matter-of-factly encouraged by his musician dad Jim, in stark contrast to John Lennon's Aunt Mimi, who made an art of deriding and dismissing his desire to be a musician. And maybe it's this ability to stand outside the subject—this confidence—that gives McCartney the license to make "Blackbird" a song of joy, hope and possibility.

Nina Simone's blues weren't about form or style; they were blues from a life of disappointments, setbacks and lost loves. Nina is Cruikshank's character, "tormented by the miseries of life." Given the choice of singing the blues—with its emphasis on cruel reality rather than unreal optimism—or exhorting the blackbird to do something, to react, to simply *take flight*—Simone simply shakes her head and wonders why, in this world of sadness and pain, her "Blackbird" would ever want to fly.

wrote the seminal, memorable song "Mississippi Goddam" in response to the racist murders of Emmett Till and Medgar Evers. "Mississippi Goddam"—immediately popular at Simone's live shows—was released as a single in a sleeve reading: **MISSISSIPPI**

But where "Mississippi Goddam" burns with an uptempo fury, "Blackbird" simmers, darkly. In anger there is some form of emotional release, but "Blackbird" is the blues, and it can only cry in despair.

The blues I'm thinking about here isn't a twelve-bar pattern, it isn't the thirds, fifths and sevenths you can notate on a musical stave—it's music that sings a history of oppression that grew from slavery. The origins of the word *blues* is from three centuries earlier, when melancholy and sadness linked to depression was known as "the blue devils."

On a visit to Philadelphia Museum of Art some years ago, I found a room titled *Biting Wit and Brazen Folly*, a collection of satirical cartoons from the 1800s, including a number by the great British illustrator George Cruikshank. Alongside the political satire—the French Revolution portrayed as a monstrous guillotine—was a detailed, hand-coloured etching with the title *An ill man next to his empty hearth tormented by the miseries of life; presented surrounded by assorted chastising demons*. The blue devils swarm around the man, pulling and pushing him, setting up a tiny gallows, urging our man towards death and even carrying a coffin in readiness. Why the devils were blue isn't known, but as the phrase crossed the Atlantic, the "devils" were dropped and only the blues remained, so that by the start of the twentieth century the first blues songs were being sung. Writer David Ewen talks of the early blues songs as being generally about "personal woes in a world of harsh reality: a lost love, the cruelty of police officers, oppression at the hands of white folk, and hard times."

actually about a black prostitute about to take to the streets.

Significantly, Nina Simone's version of the song omitted the lyric altogether, steering the song instead through what has been called "a classicalised jazz" instrumental. Nina wasn't packing up all her cares and woes—Nina had the blues.

A natural (but skewed) successor to her version of "Bye Bye Blackbird," Simone's song "Blackbird" is hauntingly, chillingly sad. It offers no redemption, no easy melody line to catch on to, just an aching blues. In an era of black power, Nina Simone often opted to portray instead the black struggle; she sang the blues like nobody else. Simone's was a life of struggle, and her songs pinpointed the moment when "intersectionality" came into the public consciousness (even though there wasn't a word for it yet), singing her songs at the crossroads of class, colour and gender, three battles she was always ready and willing to fight. Nina Simone's marriage to a New York police detective was a litany of physical beatings and psychological abuse, and her own struggle with drink, drugs and a diagnosis of bipolar was lifelong.

Despite her early years of training to be a classical pianist, Nina was forced—by circumstance—to play the blues. The first song she learned to play on the piano (aged three!) was the dreary and mournful "God Be with You till We Meet Again," with its chorus of elongated repeats of "Till we meet, till we meet, till we meet at Jesus's feet..."

After failing the audition to attend the Curtis Institute of Music in Philadelphia—an audition she'd pinned all her hopes on, even so far as having the family relocate from North Carolina to Pennsylvania—Simone was forced to give up her dreams of playing classical piano and find work as a lounge pianist in a local cocktail bar, where she was also required to sing. By the early 1960s, fired by the increasing racial tension across the USA, she began to work out how to articulate her anger as a musician.

"Blackbird" was written around the same time as she

2. (Hopeless) Blackbird

Nina Simone's "Blackbird" was written in 1963, when Simone came across a short piece of writing by Herbert Sacker of New Jersey, USA, eight lines that carry the ugly weight of segregation and which Simone decided to sing a cappella over a light drumbeat. It's a cry of woe, an almost fatalistic despair sung as a languid bluesy chant over the echoing hand drums.

A year earlier, Nina Simone had recorded a cover of the well-known song "Bye Bye Blackbird" and played the song in her live act. "Bye Bye Blackbird" was popularised in 1926 by Eddie Cantor and became a standard right through the Great Depression, presumably because it coupled an unswervingly upbeat and optimistic melody with the cheery opening "Pack up all your care and woes..." This blackbird, a synonym for a young black woman, was ready for a night out on the town.

As a kid in Northern England, I grew up singing the songs of my grandparents' generation. We had The Beatles on the radio, but the songs everyone sang together were the old standards. At every family gathering, all the christenings, marriages, birthdays and funerals, our huge mob of aunties and uncles, mums and dads would finish the evening in some upstairs function room with a long buffet table and a smooth DJ, dancing not to the Stones or The Kinks or even Elvis, but to the dickie-bow-tied crooners and swingers, Frankie Laine, Guy Mitchell, even Engelbert Humperdinck. I was taught how to waltz by my grandad—by standing on his shoes and learning the 1–2–3 step patterns. And one song that everyone knew, that everyone joined in singing—that was "Bye Bye Blackbird." It felt utterly optimistic and joyous, and that final line—"...I'll be home late tonight!"—said, don't wait up, mum, I'm having a good time. Except that, if you believe the various articles written about the song, it's

No.3

Dick Witts and Louise Alderman

Manchester—the belly and guts of the nation.
—George Orwell

Dick Witts leads me down a tiny winding staircase into the basement room of a coffee shop in Brighton's Kemptown district, lights low and small tables flanked by upholstered sofas and chairs. We find an empty table and I sit in an armchair that swallows me up, steadying my hot chocolate and wondering just how puzzled Dick is by my request to meet up to say thank you.

Witts is a genuine polymath: he's been a TV presenter, bandleader, academic author, lecturer and classical percussionist (with the Hallé orchestra). And sometime back in my teens he hosted the Manchester Musicians' Collective from a basement room in central Manchester. Sage and me—he was guitarist in fledgling punk band Notsensibles—had heard about the MMC through a mention in the *Melody Maker* music paper and had decided that catching the bus to the big city to attend a meeting might be a smart way to get his band a gig there. We didn't know what a "collective" was, or how it worked—I think I half imagined some kind of committee who added your band's name to a big list muttering "We'll let you know" as you stood before them like a plateless Oliver Twist. Up until then, Notsensibles had played our local youth club and a couple of working men's clubs, places where the "act" plays second fiddle

to the Roto-Thro Automatic Bingo Machine (in wood-effect laminate and black vinyl). The idea of a proper concert in a music venue seemed completely out of reach, a world away from Thursday night social at Burnley's Central Methodist Youth Club.

The MMC meeting was down the stairs at the back of the North West Arts building in the stone heart of the city, down down down into a windowless room with plastic chairs arranged in a circle. There were around fifteen or sixteen people there, most of them smoking like chimneys and one or two recognisable from local bands we'd been to see—Kay and Mark from The Fall, Mick from Frantic Elevators, Ian from the recently renamed Joy Division (we hadn't heard them yet, but the lad looked properly glum). What struck us was this: At home we saw "the music business" as something run by people with skillsets, power, authority, from record labels right down to working men's club secretaries. But here in this basement it was the musicians doing the organising, talking about who could borrow a PA, who had a van they could use, which venue would host a Collective concert, who would design and print the posters. Sage and me sat there quietly, drinking in our first look at how collectives can work, filling our

heads with ideas that we could take home with us.

Which is exactly what happened—a group of teenagers working with Mid-Pennine Arts in Burnley ("That place on Hammerton Street, they've got a photocopier! And a van!"), finding venues, organising gigs, designing posters, writing fanzines, arranging coaches to concerts, gathering, congregating, forming, rallying and mustering, coming together in our twos and threes to make a mass of sparking, bouncing energy that spread right across the region. Rats crawling out of the basements and bedrooms, flocking to the town centres, drawn by that youthful impulse.

And did Dick Witts up in Manchester know this? Of course not. And that's why I'm here with my hot chocolate saying thank you to this softly-spoken person who seems a little puzzled that I'm labelling him "a disrupter"…

—Picture starts to shimmer and becomes wavy lines, a harp plays a long, arpeggiated ascending scale, and all of this indicates a digression—

And then I'm sitting in a busy little café in Didsbury, Manchester, with a different cup of hot chocolate,

at a window table and opposite Louise Alderman, who I'm meeting for the first time since the late 1970s. This meeting is, I should mention, a digression that may or may not find its way back to the coffee shop in Brighton with Dick Witts. A digression that begins with Dick saying to me, "You know, you should talk to Louise. She'll know a lot more than me, she was really instrumental in the Manchester Musicians' Collective. Talk to Louise."

When Dick says this, I realise that, back then, it simply wouldn't have occurred to me that a woman was the lynchpin of that series of meetings. I was a teenage lad listening to music by teenage lads. My world of bands, school and football was all lads, lads, lads. Of course there were girls, but in my closed-off closed-down world they weren't the ones doing the organising. Except that Louise was doing exactly that.

She puts down her cup and speaks, despite the forty-five-year gap, with an enthusiasm and a passion for the Collective that says how much it meant to her. She's the unofficial keeper of the flame, running social media linked to the Musicians' Collective and gathering, collating and ordering its wayward history through local archivists. What I remember of Louise from the late 1970s was that she had tightly curled hair, wore a black leather jacket, played bass guitar and rode a motorbike (and if that doesn't conjure up a picture then I don't know what will). But what I'd missed was that she was an organisational heart beating at the centre of the Collective, spending chunks of her day at work using the office phone to organise concerts, book venues and liaise with bands. I say my thank you, explain how much of a part she had played in inspiring the creation and flowering of our own collective in small-town Burnley, and wonder about what disruption might have brought her to set up the Manchester Musicians' Collective.

"I moved into this flat where Dick Witts lived. He was on the phone in the hallway, he was arranging to go to Paris with a group of musicians, for a performance. And I walked past him in the hall, and said, joking, 'Oh, can I come too?!' And he goes, 'Yeah, sure.' So I went. And that completely changed my life. I started participating in music theatre, everything from performance to doing the slides, the lighting.... and then we went on, with Trevor Wishart, to set up the collective."

Trevor Wishart was composer-in-residence at North West Arts in Manchester, and, says Dick, he decided to use part of his annual budget to help this fledgling

Collective find its feet. Wishart, like Witts, was immersed in the world of experimental jazz, and he was surprised to find that the Collective was rapidly taken over by people in punk and post-punk bands looking to play gigs. Following Sex Pistols' appearance at Manchester Free Trade Hall, the cat was out of the bag: as Joy Division bassist Peter Hook said, he didn't particularly like the band, but the very next day he went and bought his first bass guitar in a spirit of "I can do that."

Lives are changed in these tiny moments. Not just through luck, chance and coincidence—being in the right place at the right time can be a matter of purpose, ambition, persistence and being prepared to hang around. Researcher Christian Busch calls it "the serendipity mindset." In other words, active luck. Luck you create. He explains: "Unforeseen events, chance meetings and bizarre coincidences aren't just minor distractions or specks of grit in our well-oiled lives. The unexpected is often the critical factor—it's often the force that makes the greatest difference in our lives." Busch maintains that welcoming the unexpected, rather than fearing it, is a huge factor in making our own luck. Let go of planning everything, be open to possibilities.

And although I'm in a Manchester café to talk about the Manchester Musicians' Collective, Louise's little story about the phone call in the hallway says everything about life's disruptions—the story isn't about chance, it's about Louise's "serendipity mindset." For coupled with the cheek of saying "Can I come?" is having the bottle to drop everything and take the chance once it's been offered.

Sage and me spent a lot of time in our teenage years on the X43 bus from Burnley to Manchester. Every time we went, it seemed like an education built around tatty record and book shops. Not long after that first Collective meeting at North West Arts, Sage's band Notsensibles got their first gig with the Collective at the city's famous Band on the Wall venue. At the same time, a musicians' collective had now started up in our part of Lancashire, a gathering of the region's creative teens forming bands, writing fanzines, finding venues and printing posters.

*

I finish my hot chocolates, both of them, one in Brighton, one in Manchester. I still feel a little awkward meeting these people to *a)* say thank you and *b)* call them Disrupters, but I do enjoy asking if they have their own disrupters (mainly because, basically, everybody has). Often these aren't people but books, films, music. Dick sticks with a teacher (a popular choice), but not from school—"There was an ambulance driver in Cleethorpes offering lessons in drumming, for sixpence a lesson. There was me, and all the rest were girls. He taught me a snare drum roll. A wonderful man. Those drum lessons got me my first appearance with the Hallé orchestra, in front of two thousand people…" I half expect Dick to relive the moment by tapping out a snare roll on the table between us. Here's to the ambulance driver from Cleethorpes, then, a link in the chain that somehow winds its way between a basement meeting and a bus back to Burnley. Oh, can I come too?!

Hmmm
Talking to Danbert

Danbert is weird, and he wouldn't mind me telling you that. I first met him on a street outside a bakery in south Burnley, halfway between Bob's corner shop where I had a newspaper delivery round and that bus stop on Manchester Road where we spray-painted **MIDGE IS A CHIMP**. He was wearing a home-made straitjacket. With his mum's help he'd turned an old parka into a prisoner's restraining uniform, arms around the back and buckles tied up. The next time I saw him he was wearing trousers he'd made himself entirely from old Burnley football scarves. How could I not fall in love with this quiet kid with his bizarre sense of fashion?

Fast-forward to the late 1980s, and by now living in Leeds in a huge squatted gothic redbrick house in the west of the city, Danbert declared that he was going to "do a turn" at a city-centre comedy club. These places were suddenly all the rage in that decade, following the meteoric rise of the "alternative" comics, Ben Elton, Rik Mayall, Alexei Sayle and that mixed-up gaggle of entertainers whose mission was to sweep away the established and traditional (and often institutionally racist, sexist and homophobic) comics who'd held sway since forever. Or at least since Jim Davidson first trod the boards.

None of us who lived at the house had seen Danbert ever have the slightest inclination towards being a comic performer, so this came as something of a shock.

You're going to get a spot at one of the comedy clubs?
I am, aye.
Doing what?
Telling jokes.
I've never heard you tell a joke in your life, Dan.

Well I'm not actually going to … tell jokes.
So you're not telling jokes?
I'm telling punchlines.
What?
Punchlines. Punchlines to jokes. I'm not going to tell the joke, I'm going to tell the punchline. Then if people know the joke, they'll laugh.
And if they've never heard the joke?
I haven't thought that far.

This was Danbert. He was fearless. He had an idea and decided he'd just DO iT. And he did. He got himself booked onto a comedy show for a Friday night, a fifteen-minute slot in front of a paying audience—people who'd paid to laugh, essentially. Go on Danbert, I dare you.

The club was small but busy, everyone seated around small tables. Most of the audience looked and sounded like they were on post-work outings, the quick-fire on-and-off roll-call of local comedians apparently getting funnier as the drinks wore on. Myself and the handful of people I was sitting with, we could barely breathe waiting to see what the audience would make of Danbert's surreal show. We all knew for a fact that we were more nervous than Dan—he takes this sort of thing with a pinch of salt.

"Ladies and gentlemen, hurry back from the bar, next on tonight we have a feller from Armley, it's his first time doing stand-up, can you welcome please … Danbert Nobacon!"

Danbert came on and fumbled for the microphone, squinting into the spotlights.

"Ah … hello. Here we go."

He paused. Left a silence hanging for five, six seconds. Then—

"Because he had a square bum!"

Pause.

We few laughed, nobody else did.

More silence.

"I only shagged one sheep!"

We laughed again. We knew the jokes. Nobody else in the room laughed.

Pause.

[117]

"We don't serve breakfast."

The awkwardness in the room was such that our group around the table gradually stopped spluttering and sniggering, and, as the punchlines kept on coming, we joined the rest of the club in an uneasy shuffle and cough.

"So he looks up and says, 'Oh, I thought you meant today.'"

"Oh, it's just the Mormons. They think they're the only ones here."

"I said I wish I had a giant orange spherical head."

"Tea break over. Back on your heads."

◎◉

Danbert and me met when we were about fifteen years old. That's a long time ago. But despite sharing decades of experiences, we now tell the stories of those experiences differently, as memory (and loss of memory) work to slowly change truth into story. We're both, the pair of us, like those Italian craftspeople who, every fifty years or so, have to touch up the great Renaissance paintings, subtly changing the shapes of faces, the size of a nose, the rosiness of a cherub's cheek…we drag out our stories, see if they're the same as the last outing.

On a visit to England from his home in Twisp, USA—a tiny place tucked away up in the northwest of the States—we sit down to compare our versions of events we shared, like the first time we met each other. You've heard my story: it starts this chapter. The boy in the home-made straitjacket, how could I not remember it?

"So, Danbert. Let's talk about the first time we met, you and me. Can you describe what you think was the first time we met?"

"Hmmm, that's a really good question. Aaaah, Jeez. I'd have to guess, I think, that it was at a Notsensibles gig?"

"No. Not there. I have a really vivid memory of it. It may not be correct, but it's vivid! It was when Midge said to me that I should go and meet you with him on Manchester Road. Outside the bakery. You were wearing that home-made straitjacket."

"Oh yeah. Hmmm. Sheesh. Yeah. Maybe."

I think I'm allowed to remember that one more accurately than Danbert because he was weirder than me. He was wearing something completely out of the ordinary, so that gave me a handle to form a good and lasting memory. I probably looked much like any other Burnley punk rocker. I was just Midge's mate.

We go through a few other significant events that we share (how we formed our first band, what we remember about busking in Paris), and it's clear really quickly that we have different versions of almost all of our shared story. And that the things we remember are the parts that were strange or unusual to us as individuals—of our first live gig together, Danbert remembers the bright lights in his face while I remember not knowing where to plug in a guitar lead.

We both remember rehearsing for our first big Parisian busking trip by playing the set in the disused bandstand at Scott Park. We share that memory in all its little details—because Tomi took a photograph of us rehearsing. We're not sharing a memory, we're just sharing a still black-and-white frame that we've seen many times down the years.

The great Italian writer Primo Levi said:

"Human memory is a marvellous but fallacious instrument. The memories which lie within us are not carved in stone; not only do they tend to become erased as the years go by, but often they change, or even increase by incorporating extraneous features."

It's been said that history is simply our collective memory, which, if true, is worrying—memory is unreliable and changeable. One person's precise recollection of events is another person's "Hmmm."

I love meeting up with Danbert, not only because of our shared history but to see the growing space between our lives being filled with new adventures and new people, things we don't share. Relationships, children, work, travels, and now, increasingly, illnesses. Dan changed his name sometime in the mid-1980s from Nigel Hunter to Danbert Nobacon—he'd always been Dan since being a schoolboy and he'd recently become a vegetarian and thought the play on the old joke was amusing…

Knock knock
Who's there?
Egbert
Egbert who?
Egbert Nobacon

But somewhere along the way there was an ironic turn of events; a decade or so ago, Danbert, the genetic inheritor of a faulty valve in his heart, was informed by surgeons that he would at some point have to have an operation. Not just any operation, but full-scale, invasive, get-in-there-and-rummage-around open-heart surgery. The irony was that the operational replacement valve that would be inserted into Danbert's heart would be from a pig. Mr Nobacon and his hammy heart! Telling you this wouldn't be funny unless I add that, since finding out this news, many years have passed, and that by the time Danbert was required to actually have the surgery, a new, improved and synthetic valve had been developed. The operation was successful,

and

Danbert

continues

to be

Nobacon.

May his

story

be a

very

long

one,

which-

ever

version

of it

he

decides

to

remember.

An Activist's First Duty Is to Have Fun

The only honest art form is laughter, comedy. You can't fake it… try to fake three laughs in an hour—ha ha ha ha ha—they'll take you away, man. You can't.
—Lenny Bruce

Ian Curtis of Joy Division, the rest of his band have consistently told us in interviews, was a good laugh. That's as maybe, but in all the publicity shots he looked beautifully, strikingly joyless. Huddled against the Manchester rain in an overcoat, cupping the remains of a cigarette, Curtis exemplified an austere Northernness that stood against the glitzy pomp of the New Romantics and the Blitz Kids in the London style magazines. I saw Joy Division several times, and I never saw Ian smile. This meant, I realised, that he wasn't messing around, this wasn't an act—*he meant it*. Whatever the truth, the story as told in grainy monochrome photographs was the story we wanted.

So, sucked in by po-faced leafleteers at various punk concerts, I became a vegetarian and an animal rights activist. And I *meant it*. I wore a home-made shirt at our family Xmas meal that depicted a dead turkey and the slogan "10 MILLION TURKEYS ARE SLAUGHTERED FOR YOUR CHRISTMAS DINNER." I went on demonstrations and hunt sabs, broke into laboratories and factory farms. I wasn't messing around. I was a dickhead though.

For the first couple of years, our band played concerts wearing stern, serious faces. The songs were angry and bleak. We became pacifists, then vegans. Handed out pamphlets at Leeds train station, went to peace camps, smashed the windows in the local KFC, and wore black, all the time.

Keep fighting for freedom and justice, beloveds, but don't forget to have fun doin' it. Lord, let your laughter ring forth.
—Molly Ivins

That level of seriousness was never going to last—I wasn't very good at being po-faced, I couldn't pull off that grim Ian Curtis cool and I got bored of handing out leaflets. The miners' strike of 1984–85 was a signpost—a bunch of us having set up a local miners' support group in Leeds went down to join the strikers on a picket line at Frickley pit, staying the night before the early morning picket in various houses around the village. We were taken to the local miners' welfare, where, against a background of crushing poverty and media victimisation, the place was packed for an evening of cheap beer, cabaret turns, bingo and laughter. A fantastic, joyful night out. In the morning we were up before dawn, down at the pit gates to push and shove as the scabs— strike-breakers—under heavy police protection, were driven in to work; all memorable stuff but nothing more so than the idea that, yes, this strike is a serious business—but this community under the cosh was determined to have fun an' all.

Plato the po-faced philosopher (that could be his *Viz Comics* name), in discussing "civilised society" back in 400 BC, grumpily denounced laughter as "an emotion that overrides rational self-control." I can't imagine he had a lot of friends.

No composer of comedy, iambic or lyric verse shall be permitted to hold any citizen up to laughter, by word or gesture, with passion or otherwise.
—Plato

Activism can be like that—the passion is too often just anger and cynicism, with the result that it can come across as preachy, hectoring, holier-than-thou. There's a quote in a recycling shop window in Otley: "We don't need a handful of people doing [activism] perfectly. We need millions of people doing it imperfectly."

My favourite activists are funny. A while ago I got to know author and climate activist Jay Griffiths (John Berger says, "If bravery itself could write, it would write like she does") and was heartened to discover that she spends a good deal of her time telling jokes. The author of *Why Rebel* writes powerfully on the existential challenge of the global emergency and also likes a good fart gag.

Humour, fun, laughter, what-you-will, it gives us humanity. It connects, it's inclusive. Jay Griffiths often writes about our shared past, a history where we marked our connection to the earth with seasonal celebrations and pageants. These pre-Christian carnivals were rebellious and joyous, poking fun at lords and rulers, singing of a world "turned upside down." Fast-forward to the late 1980s and see how all the Leeds city centre nightclubs switched almost overnight from being ugly, violent cockwalks of machismo to being open, friendly and welcoming. Why? Because ecstasy pills made people happy, turning the nastiest thugs into instant bosom buddies. It's true, I was there, getting hugged by blokes who would previously have wanted to punch me in the face.

My version of the ecstasy revolution was punk. It was unexpected, new, clever, social fun. It came with chances to learn too— learning how to organise a gig, how to make and print a fanzine, how to travel around the country watching bands for free, how to play a musical instrument, how to use a sewing machine. I learned how not to be racist and homophobic, realising that discarding the nasty bigotry made everything more fun. And I wore a badge— loads of people had this badge—that said NAZIS are No Fun

So by implication, I learned that anti-Nazis were probably Fun.

> We cannot have a meaningful revolution without humour.
> Every time we see the left or any group trying to move
> forward politically in a radical way, when they're humour-
> less, they fail. Humour is essential to the integrative
> balance that we need to deal with diversity and difference
> and the building of community.
> —Bell Hooks

As I grew older it became clear that fun was essential, necessary. Smiling and laughing together with someone—a friend, an enemy, an audience—creates a space that you've shared, a starting point for something more. If we really believe that "we've more in common than divides us" then it's good to start with what those "in common" things are. Humour is a basic, shared experience. Perhaps this explains why there are currently very few right-wing comics, because in times of austerity and hardship, people need to punch up, not down.

And so to today, where the daily news is a nonstop litany of utter awfulness. It would make a lot of sense right now to simply bawl and shout about the mess we're in, but that's not very helpful. Anger is good; if it comes with a plan, and if it offers hope.

> By jettisoning the conditions necessary for happiness via
> decently funded healthcare, education, and culture, what
> [the government] have left us with is fun, and we had
> better have fun while we can.
> —Joanna Walsh

Have fun! By having fun we're giving lie to the right wing's culture-war version of activists as killjoys. You know, the so-called "ultra-woke snowflakes who just want to spoil everybody's fun." What's the headline I saw recently—

Piers Morgan claims Woke Brigade have sucked all the joy out of life

Which perhaps explains why the old TV commentator/ complainer always looks like he's been weaned on a pickle. What activists want is a world where everyone gets the opportunities and freedoms to have fun, so by having fun with our activism we're simply being the change we want to see. I'm going to end this chapter with a joke. Because it's funny:

Maybe Hitler wouldn't have been so grumpy if people hadn't left him hanging for high fives all the time.

So It Goes

I always feel more comfortable in chaotic surroundings.
I don't know why that is. I think order is dull. There is
something about this kind of desire for order, particularly
in Anglo Saxon cultures, that drive out this ability for the
streets to become a really exotic, amorphous, chaotic,
organic place where ideas can, basically, develop.
—Malcolm McLaren

September 4, 1976. A local TV pop show hosted by Tony Wilson, him with the floppy hair and the wide lapels on his suit jacket. He does his link: "Our final live band tonight has a warning on them. One of the most reviewed and most reviled rock phenomenon of recent weeks—Sex Pistols. You can hear them warming up in the background even now. Take it away!"

Rotten in a ripped pink jacket, a mess of a haircut, and is that a print of Karl Marx on his shirt? It's hard to tell, the camera is zooming right in on his face as he looks into it, menacing, shouting, "Get off your *aaaaaaarrrrrsssse!*"

This is on the TV in my parents' living room in small-town Lancashire.

I don't understand what's going on, and I can't decipher any of the words.

But the next day, at school, some of us talk about it: Did you see that band? What did you think? Weren't they weird? And a month later, I swear we've all cut our hair and we've altered our flared school trousers so they're now drainpipes and we're embarrassed by our record collections.

Sex Pistols drummer Paul Cook later said, "The Sex Pistols were an accident that caught fire." And to Cook, maybe this felt true. But look at anything manager Malcolm McLaren was doing and

saying in the two years leading up to that TV appearance and you'll see that, to him, as the band's devious and devilish puppeteer, *none* of it was an accident. Even the rubbish bits—Sid's bass-playing, Sid's drug-taking, Sid's girlfriend, Sid's suicide—were all part of McLaren's outrageous glorification of chaos.

It's hard to overestimate the number of kids who, like me, saw this cartoonish band as a call to action, who completely changed the way they looked and thought in response to the latest rock 'n'roll roll-call of what Stanley Cohen called "folk devils and moral panics." It's fair to say most of those kids wouldn't describe that moment as "an accident," in fact they'd say they were already looking for something, or at least open to the idea of something exciting and new, searching for an escape route, a community, a vision of an unknown that was more interesting than technical colleges, unemployment statistics, grey politicians and the new Pink Floyd album. Other than being born in the right place and time, this sort of thing isn't just down to chance or luck. US proto-punk Richard Hell had already written his anthem for bored youth, "Blank Generation," a year before Sex Pistols were recording their own first single; The Adverts, meanwhile, punks whose lyrics sparked of the outsider poetry of the Beats, were singing:

> We're talking into corners
> Finding ways to fill the vacuum
> And though our mouths are dry
> We talk in hope to hit on something new
>
> We're just bored teenagers!

This was no accident. The punks weren't lost souls, they were stray animals on street corners sniffing out the next meal, eager for something new that might cross their path. In his fascinating book *The Age of Wonder*, writer Richard Holmes describes how the main players of the Romantic Generation in the first half of the nineteenth century came to make incredible and world-changing

discoveries and innovations in science, literature, art and social change. Inspired by the French Revolution and its spirit of change and challenge, creative minds across all these disciplines came together to inspire each other to further discoveries. Holmes describes dinner parties where poets, painters, scientists and inventors gathered to eat, drink and experiment with drugs, their search for new ideas causing them to sometimes make "accidental" discoveries—such as anaesthetic. As these free-thinkers in places as disparate as Boston and London were trying ether as a recreational drug, they began to realise that it had, like opium (Coleridge's drug of choice), anaesthetic qualities which could be applied in medicine. Countless retellings from these times describe this as an accidental discovery. It wasn't—it was the result of enquiry, exploration and adventure.

Samuel Taylor Coleridge, it is said, "accidentally" made the first recorded ascent of Sca Fell Pike, England's highest mountain, in 1802. Again, this was no accident! Setting off from his home at Greta Hall in Keswick, in the English Lake District, Coleridge spent nine days exploring the Western Lakes mountains wearing a pair of ordinary shoes and a knapsack containing little more than spare socks, a shirt and a book in which to record his travels. His descent of the notorious crag called Broad Stand is something that nowadays is completed by climbers using ropes, helmets and safety equipment. None of this was an accident; it was the result of a kind of poet's delirium—an overwhelming love of adventure. As he writes in his journal, on being stuck on a small ledge during that mad descent of Broad Stand:

"I'm calm, God! I am blessed, even though I don't know how to get off or how to get back up! The soul swims in the air like a flight of starlings!"

It's this bird-like soul—a swooping, soaring, fluttering thing—that propels Coleridge to keep going, to somehow clamber and slither down the sheer rock face (and it is sheer, I've climbed it with a rope and felt the deep, breathless fear of it).

"Curiosity" seems like too benign a word to describe the fire in the poet's belly, or the kid's urge to remake a life upon seeing a

rock'n'roll band on the TV. It's more like an alchemical, magic sense of wonder. An attraction to what might be. And if the attraction turns out to be fool's gold, then that's perfectly all right—just roll up your sleeves and start digging somewhere else. As the great writer and activist Audre Lorde tells us (and I think she knows she is addressing the people who don't give up easily):

"Revolution is not a one-time event."

Comic Sans Walks into a Bar.
The Barman Says,
We Don't Serve Your Type.

Whenever a new information technology comes along,
and this includes the printing press, among the very first
groups to be "loud" in it are the people who were silenced
in the earlier system, which means radical voices.
 —Ada Palmer

Shortly after returning from touring Europe in a knackered
yellow-and-blue hippie bus (with its Sex Pistols destination sign
reading "NOWHERE"), limping from town to town busking for
petrol money and scavenging at the fruit markets, we decided
to start a band, properly this time. This was in 1982, or there-
abouts. We'd had several attempts before, but now we had a
different vision—it wasn't to be just a band, it would be a
collective, squatting in an old house, sharing money and inviting
friends to join us. We commandeered a Victorian tumble-down
mansion in West Leeds, planted a garden of vegetables, built
furniture out of discarded wooden pallets, and blagged and
borrowed amplifiers and microphones.

But there was something missing, and we found it in a skip
round the back of the Leeds University buildings one night,
where perfectly good stuff seemed to be routinely thrown out.
What we found was a Roneo Rotary Stencil Duplicator. Basically,
a crude desktop printer. It was as big as a kitchen bin and
incredibly heavy, with a single circular drum housed in a steel
frame, a large cranking handle at the side and the smudge and
stink of old printing ink all over it. It was rudimentary (oh the

hours we spent fixing the thing, with its adjustable springs and catches) but it altered what we could do as a band—before this we played guitars and sang, now we wrote stories and articles that sat alongside the songs, handed out mass-produced (is five hundred copies "mass"?) leaflets and pamphlets at gigs, and with that one small step we became, er, multimedia.

What was exciting was that, suddenly, we had the means of production. Instead of passing round CND and anti-Nazi leaflets, we could make our own, we could write and design them not to fit the generally accepted political-pamphlet template, but according to our own ideas and style, no matter how weird and singular they were. Even now, when I turn up to a demonstration and see ranks of Socialist Worker placards in their heavy, formal design, part of me dies inside...until I see a sign made from an old cardboard box, hand-painted and full of individuality and care and passion.

When Johannes Gutenberg perfected mechanical movable type in 1448, he opened the door not only to the mass production of books but to the idea that the church and the state didn't hold a monopoly on words—suddenly people had their own information, their own songsheets and calls-to-arms, cheaply printed and passed around. This incredible cultural upheaval changed the way we communicated and learned, forever. It empowered us. Power to the people, in fact.

Some years ago I spent some time reading and researching the history and effect of the invention of the printing press for a performance and exhibition at Leeds Central Library. A journey that threads through letters, words, sentences, paragraphs, chapters, books and libraries. Celebrating the outward explosion of knowledge that came from that mechanical wooden frame and a block of reusable metal type. It's a beautiful and inspiring story.

I first came across a stencil duplicator a few years before that night at the back of Leeds University, when I was at secondary school in Burnley—my dad had brought a huge old Gestetner printer home from the primary school where he

worked, and I learned how to draw into the waxy sheets and create a template that could be attached to the drum. Overnight I produced scores of copies of a cartoon ridiculing one of my teachers and, first thing next morning, distributed them at school. Within minutes of the first lesson, the printed sheets were up on noticeboards and being passed around classrooms. Someone snitched, and I ended up with a week of staying behind at home-time and missing football training. I was never cut out to be a footballer anyway.

Gutenberg's invention freed us. It took power from above and spread it around—in addition to books, the cheaply printed ballads and rallying cries, sold for ha'pennies on street corners, helped to democratise knowledge. Within just fifty years of the building of that first printing press, a thousand printing presses were in operation throughout Western Europe and had produced 20 million books, rising in the sixteenth century to between 150 and 200 million books.

One of the things I loved about that big old Roneo printer was the smell, the mess, the physicality of the machine. It's what computers lack—a sense of tactility and immersion in the process. As a post-digital revolution begins to take shape, with people actively seeking time away from 24/7 digital communication, there's a move towards the physical and the face-to-face. We're searching for "authenticity" by getting grubby on allotments, by walking, cycling, baking, singing, dancing.

One of the most evocative smells is the fusty reek of a second-hand bookshop.

Most research now confirms the fact that paper is still the best medium for storing information. Look at those boxes of old floppy disks and SCSII hard drives, think about all those photographs and articles you carefully stored on formats that your latest computer can't recognise. Then go and wander up and down the five-storey building that is Scrivener's Books on Buxton's High Street, a building that feels like it's practically held up by its forty thousand books, papers, annuals and maps on slanting, sloping higgledy-piggledy shelves. There's a whole world

of history and ideas there, some of it hundreds of years old, waiting to be discovered.

The original Gutenberg press was a rudimentary design, a wooden frame with a lever that allowed a plate to be pressed down onto sheets of paper. It looks, now, not unlike an ornate high-backed chair, or a guillotine. But within this construction of wood and steel, joints and brackets, lay a universe of ideas and knowledge. The eighteenth-century iron-monger and book-collector Joseph Ames put it beautifully when he wrote, simply:

Souls dwell in a printer's type.

Upside Down

Love sometimes wants to do us a great favour:
hold us upside down and shake all the nonsense out.

—Hafez

On the Bus

To hell with facts! We need stories!
—Ken Kesey

In 1964, after the success in the United States of his book *One Flew over the Cuckoo's Nest*, author Ken Kesey, counterculture freak and leader of the "Merry Pranksters," purchased a yellow school bus. Kesey and friends gathered with huge tins of coloured paints and turned the 1939 International Harvester bus into a swirling mess of psychedelic ridiculousness, its destination panel overpainted to read, simply, "**FURTHUR.**" (Erm, yes, with a second *u*. That's what happens when you drop out of school, kids!) This bus they took on a trip across the States from California to New York. Remember, this was 1964—our generally accepted version of the hippie counterculture explosion places it around 1967; here, three years earlier, a bunch of self-styled freaks were cruising through downtown America, tripping, laughing and singing.

My wife, Casey, tells me a story of being a kid in 1970s USA, in Wilmington, Delaware, of the everyday school bus turning up on a wintry, snowy day. Having collected all the kids from their road-sides and bus stops, the driver suddenly announced—

"Who doesn't want to go to school today?!"

And all the kids yelled, "Me!"

So the driver said, "Who wants to go to the Old Market Car Park instead and play in the snow?!"

And all the kids yelled, "Me!"

The bus driver drove the big old yellow bus to the vacant parking lot and chugged it through the snow. Pausing for a moment, he shouted, "Now, who wants to see a bus doing doughnuts in the parking lot?!"

And all the kids yelled, "Me!"

And that's what the bus driver did, he crunched the bus into

first gear, turned the steering wheel right across, floored the accelerator and, after a second or two of ploughing through the deep snow, he released the clutch and handbrake and sent the bus into a glorious spin. The kids, including Casey, couldn't believe their luck. They all screamed, "Wheeeeeeeeeeeeeeee!"

Next they jumped off the bus and had an almighty snowball fight, with the driver joining in. When everyone was exhausted, they all clambered back onto the bus and set off not for school but to drop everyone back at home.

This was the best not-school lesson ever: when you're not driving, you can never be sure where the bus will go.

Malcolm McLaren, architect of Sex Pistols and general all-round maverick, said:

"The thought of ever getting on a bus was the thought of never getting off. That in itself was the romantic trip. For it never to end. You didn't ever want to arrive. If you arrived, it was a conclusion— you didn't want the conclusion, the conclusion was irrelevant, it was nothing, it was not important. It was the living event that you wanted to continue to live in."

Here's my bus story. In 1983 I'd dropped out of college in Leeds for the second time and seemed committed to a life of—well, a life that was defined only by what I didn't want to do (scarred by a short stint as a postal worker where I was promised that if I kept my nose clean I could get a job in the Dead Letter Office, the cramped and airless room where you spend every day trying to decipher badly addressed envelopes). Me and my mates—our small gang of headless chickens—somehow blundered into a friendship with some older Leeds musicians and artists who had squatted a huge Victorian house in Armley, across the city, away from the student and ex-student areas. They had a band that defied categorisation called Mirror Boys, and were mostly ex-art students (*fine* art, at that). They were clever and weird and had seen Sex Pistols play at Leeds Polytechnic in 1976—this indicated that, despite the dope-smoking, they weren't hippies. Like us, they were

headless chickens. We threw in our lot with them and within a few months had taken a decision to buy a bus that we would drive around Europe, busking for petrol money and spending some months being utterly directionless.

The bus we found was advertised in the *Auto Exchange & Mart*:

> **Bedford VAL**
> **Plaxton Panorama,**
> **needs work.**
> **Ring Tring 666.**

It was the phone number that convinced us we should go and have a look at it. Off we went to find the old Bedford (the same model that was used by The Beatles in the *Magical Mystery Tour* film) sitting in a farmyard somewhere in Hertfordshire. After a few turns of the engine, it started. We paid in cash and somehow got it back to Leeds and into the scruffy garden surrounding the huge squatted redbrick house. The next few weeks were spent scrubbing, dismantling, sawing and building, putting bunks and a table into the bus. Mirror Boys had one important date in the diary, towards the end of July: a jazz festival in Ghent, Belgium. We aimed for that. Basically we were a bunch of people who didn't know what we were doing, but we were doing it. This was an adventure—open-ended, barely planned, a blunder into the unknown.

Several days before the opening date of the Belgian festival, we sat in the parked-up bus in Leeds, ready to go. There were Ian and Barbara, who planned to chalk the pavements of Europe; Malcolm, a clown and children's entertainer who came with specially made oversized clown shoes which had to live on his bunk; Julian, Sarah and Graham, Mirror Boys without a lead singer; and three of us with our acoustic guitar, snare drum and cymbal. A friend of Mirror Boys called Jasper, wanting a lift to London, climbed on board as we were about to leave. He took off his watch and placed it on the table, telling us, "In exactly an hour, wake me up. I have to meditate." Then he closed his eyes and switched off.

The entire journey was an unpredictable and unforgettable

[137]

experience. We gathered at continental street markets each day as the food stalls were closing, living off boxes of bruised fruit and vegetables. I had my very first avocado—so green! We busked and chalked and clowned, performed a few hastily arranged gigs at tiny clubs and picked grapes for a while on the south coast of France. We swam in a sea of bioluminescence, a night-time ocean of tiny glowing (and harmless) creatures. We discovered the practical concept of the siesta and, somewhere along the way, decided that when we eventually returned to England we would put all our efforts into being a proper, functioning band. It was all an exercise in exploring and adventuring, learning not to worry when we didn't have a plan. Going somewhere, anywhere, *furthur*.

> At worst, one is in motion; and at best,
> Reaching no absolute, in which to rest,
> One is always nearer by not keeping still.
> —Thom Gunn

Ken Kesey's psychedelic bus trip is reputed to have kick-started the Sixties; Rosa Parks's bus trip on December 1, 1955, in Montgomery, Alabama, kick-started a movement. Taking a seat towards the back of the bus—designated and labelled as "coloured seating"—Rosa was then asked by a white passenger to move, since the "white seating" area was full. She refused, and remained firmly in place until police officers took her from the bus and placed her in custody. On the day of the trial against Rosa (she was given a fine and a suspended sentence), a boycott of the bus service began and a young man named Martin Luther King was elected as president of the newly formed Montgomery Improvement Association.

That particular bus took the entire country into a world of change, a journey it's still making.

Single fare, please.

Where are you going?

Furthur.

Erm, with a *u*?

Definitely with a u.

Lieteller

I read Sam Harris's book *Lying*—a compelling book-length argument for being brutally (and pragmatically) honest. I didn't agree with it. Harris says that children learn to tell so-called white lies around the age of four, a habit that probably protects them from losing all their playground friends. I've known people who live by the credo of being completely honest, and they come across as overconfident and even arrogant. Yes, by simply telling the truth.

Does my bum look big in this?

Yes, it looks massive.

That's no way to make friends, is it?

We pick and choose when to lie and when to tell the truth, and there don't appear to be any collectively agreed-upon guidelines on the line between good lies and bad lies. The morality surrounding truth and lies is a big old mess, compounded by all the deception that goes into selling capitalism, selling it like soap powder that washes whiter-than-white, selling it like the missionaries sold Christianity to Africa:

> When the Missionaries came to Africa they had the bible
> and we had the land. They said "Let us pray," we closed our
> eyes. When we opened them, we had the bible and they
> had the land.
> —Desmond Tutu

Sam Harris's clear line on lying is frustrating, if only because it refuses to accept the subjective, irregular and messy nature of when and why we lie. If the truth is a story that everyone tells differently, then lies are the disrupters that change the story in odd and un-

expected ways (which is perhaps why this writing is

<div style="text-align:right">meandering</div>

in an

[139] almost
slapdash manner

<div style="text-align:right">down</div>

<div style="text-align:right">the</div>

<div style="text-align:right">page).</div>

Jazz pioneer Buddy Bolden is a legend of almost mythical proportions. A cornet player in New Orleans in the first years of the twentieth century, he formed a band that, for the very first time, mixed ragtime with the blues, and had it played on brass instruments. This looser, wilder playing also incorporated gospel and marching music, creating a unique sound. His tune "Funky Butt" was perhaps the first mention of "funk" in music, and it took its meaning from the funk (smell) of tightly packed bodies dancing to the live music. Bolden led his band for several years before ending up alcoholic and half mad in the Louisiana State Insane Asylum. There are stories—truths, lies, who knows? They're stories, passed down and around—of Buddy attacking his mother and sister, of wild nights and cop fights. Bolden was as wild a character as the music he passed down, and the shame was that only once in those years of live concerts did his band commit to recording onto wax cylinder; that recording became the stuff of legends.

The recording was lost (presumably forever) until a German author and musicologist, Bruno Leicht, was unceremoniously handed the old and fragile wax cylinder by somebody-who-knew-somebody-who-knew-somebody going right back in time through various aunts and nephews and in and out of several cardboard boxes kept in New Orleans attics and basements until, there it was, an 1894 recording titled simply "Bud Bolton Blues."

Not having the means to play the cylinder, Leicht took it to the New Orleans Jazz Museum, where he was able to listen through the hiss and crackle of time to the Buddy Bolden band blowing and swinging. This was a revelation: being at last able to hear that primitive, defining sound from the man commonly thought to be the father of jazz.

Hearing this story from my friend Kenny, I looked up Leicht's tale of discovery, which includes a defunct link to that infamous audio recording, stating simply:

(Link will be renewed soon)

And then, as Kenny had advised me, I read the accompanying article explaining the recording's provenance and checked the

date at the top of the article: April Fool's Day, 2014. It was all a lie. That's German humour for you.

Or not. Myth has it that German people are humourless, which is another lie, this time disguised as a stereotype—Germans have a fondness for satire and irony and love a good *antiwitz* (anti-joke). Here's my favourite:

"What's yellow and is a banana?"

The problem with the Buddy Bolden lie is that it disappoints. The best lies work the opposite way around: you tell a lie which disappoints but then follow it with a truth which gives relief, which satisfies. I use this form all the time, possibly to the point of annoyance. It disrupts the story.

"What happened to the last piece of cake?"

"Our cat Little Betty came down in the night and ate it."

"Nooooo! That's so disappointing. Now I'm sad, and cakeless."

Pause.

"No, I'm lying, Little Betty doesn't even like chocolate cake. The last piece is in the fridge waiting for you to eat it."

"Oh! Now I'm half annoyed at you for catching me out, but doubly happy about the cake. My relative sense of expectation for eating a piece of cake is higher now than it was before you lied to me. Thank you."

As the fly caught in flypaper said, this is my story and I'm sticking to it.

And then there are lies that are sold as truth. Some of these lies are huge and ongoing—German people have no sense of humour, for instance. But no, bigger lies than that:

If you work hard enough, you can achieve your dreams

This is what we're all told, continuously, from as soon as we are able to read those large-print motivational posters and badly type-

set memes, pithy sentences set against a backdrop of a snowy dawn-lit mountain. We're told this in every sports winner's interview or in every successful person's autobiography. It's a lie. If you're born without the innate talent of kicking a football accurately, then no matter how hard you try you won't make it as a footballer. Less than 0.5 percent of people attempting to be professional footballers are successful. Of the ones who make it through the English Premier League's academy system, 97 percent never make a single Premier League appearance. Of the 250 million football players in the world, only 130,000 are officially professional-level footballers. Should I keep going? The numbers get worse. Only 0.018 percent of children attempting to make a career out of football become professionals, a percentage equal to winning the lottery. But winning the lottery entails simply buying a ticket; trying to become a professional footballer involves many, many years of hard work and dedication, and a lifetime of believing that meme about achieving your dreams.

Most US presidents enter the White House as millionaires (yes, including Barack Obama). The UK's government is stuffed with privately educated sons and daughters of wealthy families; recent former Prime Minister Rishi Sunak, together with his wife, is valued at around £730 million. By contrast, boys in Britain who grew up in families in the bottom tenth of the income distribution are about twenty times more likely to be in prison in their thirties than boys born into families in the top tenth. In the US the disparity is worse:

> The United States currently incarcerates 2.2 million people, nearly half of whom are non-violent drug offenders, accused people held pre-trial because they cannot afford their bail, and others who have been arrested for failure to pay debts or fines for minor infractions.
> Poverty and excessive legal punishments contribute significantly to the United States' high rate of imprisonment, which has disproportionately affected low-income and minority populations.
> —Tara O'Neill Hayes, American Action Forum

Let's have a look at some of these feel-good quotes that prop up the universal myth of meritocracy:

> The difference between Try and Triumph is just a little
> Umph!
> —Marvin Phillips, basketball player

> With hard work, there are no limits.
> —Michael Phelps, swimmer

> There is no magic to achievement. It's really about hard
> work, choices, and persistence.
> —Michelle Obama, First Lady

I know these people are unaware that they are spinning a big lie, and that for the most part their hearts are in the right place. Part of their job, they've been told, is to motivate people, make people feel good about themselves. But what they're also saying is, look at me, I'm successful, but you know what? It wasn't by being lucky, or by accident of birth (being really tall, having huge feet, being married to a popular politician), or by being friends with other famous people, or by taking performance-enhancing drugs. No, I'm successful because I worked hard, and with the right amount of inspirational quotes from us successful folks, you can achieve it too.

It's telling that in Sam Harris's book, he recounts a tale of passing through a customs checkpoint on his way home from India. The customs officer asks where Harris has come from as he searches his luggage, and then asks if he took any drugs while he was there. Harris tells the truth: "Yes, some pot and opium." The officer concludes the search, exchanges pleasantries and sends Sam on his way. This leads Harris to restate his argument that telling the truth is always the best option. He can't see that by accident of birth and upbringing he is white, well-educated, well-spoken and wealthy, and that these privileges absolutely affect the possible outcome of the story. At the UK's airports and ports, you are 11 times more likely to be stopped, searched or detained if you

are Asian than if you are white. Narrowing it down further, Pakistani people are 52 times more likely to be stopped than white people, 135 times more likely to be questioned and examined for more than an hour, and 154 times more likely to be detained.

Here's a popular motivational quote:

Pain is temporary.
Quitting lasts forever.

That's a good one—inspiration, desire and a dollop of shame. It's by Lance Armstrong, the cyclist who realised that dishing out these quotes (his various autobiographies are full of them) effectively acted as a sort of shield to criticism. Famously, during a 2005 speech delivered from the podium at the end of another Tour de France victory, Armstrong attacked "the cynics and the skeptics," saying, "I'm sorry you don't believe in miracles. There are no secrets. This is a hard sporting event and hard work wins it."

Lying, the great disrupter, pro-social and anti-social, twisting and turning from place to place and time to time. David Wolnerman, a Polish Jew, was thirteen years old when he was taken to Auschwitz. He stood in a parade of prisoners and watched as the infamous Nazi "Angel of Death" Josef Mengele walked in front of each of them, signalling with a stick whether the prisoner should join a line to the left or the right. Wolnerman saw that the frail, the young and old went one way, the healthy adults the other. "What is your age?" said Mengele. Wolnerman puffed out his chest and declared, "Eighteen." He joined the line that went to the work camps and not the gas chambers. The lie saved his life.

What the Folk?

Nobody, to my knowledge, has been around the mines and the mills and among the fettlers and the professional footballers, collecting the stories and sayings which must abound in such jobs...a folklore anthology should be a great funny tragic heroic lusty tender brutal and essentially everyday affair. So much an everyday affair, indeed, that it strikes one, if some people would put their anthropological books away for a moment, and take a walk round Woolworth's, say, they might learn a bit more about folkways than they'd bargained for. Comrade Cleverdick might tag along.

—A. L. Lloyd, "This 'Folk' Business: Review of 'The American People' by B. A. Botkin," *Our Time*, 1946

Let me start to unravel the slippery story of folk music by wilfully (and shamefully) ignoring the ongoing and ubiquitous folk cultures of places and people across the globe and reducing my scope to England and its folk music—simply because this is where I grew up singing "Green Grow the Rushes O" in the school hall at Lowerhouse Primary as an eight-year-old, tying bells around my ankles and dancing with wooden swords.

Every Monday morning at 11 a.m. our headteacher would switch on the weekly BBC radio programme *Singing Together*—a show that began as part of children's home education during the war years—and we'd learn and sing along to the folk songs they played. This breezy singalong session was an antidote to the stuffy music lessons where we'd dissect the instruments of the orchestra or (even worse) learn extracts from Gilbert and Sullivan.

The folk songs we sang originated from across the country and,

in the face of mannered and upright BBC Queen's English, felt like a history we all shared, whether you were from the Highlands of Scotland ("The Skye Boat Song") or the Yorkshire coast ("Scarborough Fair"). So, growing up, that was folk music, that was our music—music that came from our communities and was sung not just by "professionals" but by us, with battered guitars and (much later) with a pint of dark beer in your hand. Not only that, but folk music wasn't like the pop charts, in that the songs were often about things-other-than-love. They were about pregnancy and war, about rigging sails and drinking ales.

This tradition inspired a generation of acoustic singer-songwriters who took the form and gave it contemporary meaning, who didn't just copy the old stuff but created their own version of this community-based music—I learned about a folk "scene" that was incredibly diverse and interconnected; Martin Carthy and Martin Simpson seemed to take as much from American blues as from English tradition, and "folk" covered everything from Dylan, Joni Mitchell and Joan Baez (following in the footsteps of Guthrie and Seeger) to the Watersons belting out fishermen's songs, from Nick Drake and Roy Harper and John Martyn with all their fey and faltering beauty to Davey Graham nicking ideas from all over the world to create something shockingly, strangely beautiful, to Leon Rosselson and Roy Bailey and Frankie Armstrong singing about nuclear war and apartheid South Africa...

It just seemed incredibly eclectic, basically.

But as I grew to love and sing English folk music, I was also becoming aware of how much it stuck doggedly to a notion of "tradition" that seemed narrowly rural; my completely underresearched theory was that the sons and daughters of the first wave of English folk musicians grew up in a rarified atmosphere of folk club fiddle sessions and singarounds and somehow missed that connection to a vibrant and important English urban tradition. It was all very pretty, this constant wandering out early on May mornings, but where was the dust and grime of the mills and

factories that were my childhood landscape? They'd somehow been mostly written out of the story.

So I went and found out why there was this huge bias towards the rural tradition, and discovered that it was all a well-planned heist of our nation's cultural heritage—the wholesale robbery of our history, basically, that happened right under our noses. It seems that the urban tradition wasn't of much use to most of the people who made it their life's work in the early twentieth century to collect the songs from around the country in order to preserve and pass them on—those enthusiasts armed with notebooks and pencils (and occasionally antiquated recording devices) who scoured the land for people who sang their old songs in pubs, kitchens and backyards.

Cecil Sharp was the most famous of these—a man who is synonymous with the back catalogue of traditional folk songs, pictured as racing around country lanes on his bicycle in the early part of the twentieth century to meet up with the ageing grandmother who, he'd heard, remembered all the words to "Widecombe Fair." He was also notoriously sniffy about the working classes and their factory songs, despite the historical significance and importance of music hall, industrial working songs, songs made up and brought back by serving soldiers in both world wars and all the popular pub songs. He was also, without doubt, motivated by a patriotism that leant heavily into racism. Cecil wanted a "Merrie England," a middle-class bowdlerized version of tradition which ran scared of urban grime and sought to popularise a clean and wholesome national culture. Morris dancing on the village green, good; Lancashire clog dancing, bad.

Cecil Sharp's haranguing of England's Board of Education—which set the generally accepted curriculum across the country's schools—eventually paid off. His sort-of manifesto for "educating" the peasants (his term, not mine) began thus:

LET THE BOARD OF EDUCATION INTRODUCE THE GENUINE TRADITIONAL SONG INTO THE SCHOOLS AND I PROPHESY THAT WITHIN THE YEAR THE SLUMS OF LONDON AND OTHER LARGE CITIES WILL BE FLOODED WITH BEAUTIFUL MELODIES, BEFORE WHICH THE RAUCOUS, UNLOVELY AND VULGARISING MUSIC HALL SONG WILL FLEE AS FLEES THE NIGHT MIST BEFORE THE RAYS OF THE MORNING SUN. ¶ WE MAY LOOK THEREFORE, TO THE INTRODUCTION OF FOLK-SONGS IN THE ELEMENTARY SCHOOLS TO EFFECT AN IMPROVEMENT IN THE MUSICAL TASTE OF THE PEOPLE, AND TO REFINE AND STRENGTHEN THE NATIONAL CHARACTER. THE STUDY OF THE FOLK-SONG WILL ALSO STIMULATE THE GROWTH OF THE FEELING OF PATRIOTISM. ¶ THERE ARE MANY WAYS OF STIMULATING THE FEELING OF PATRIOTISM. EDUCATION IS ONE OF THEM. OUR SYSTEM OF EDUCATION IS, AT PRESENT, TOO COSMOPOLITAN; IT IS CALCULATED TO PRODUCE CITIZENS OF THE WORLD RATHER THAN ENGLISHMEN. AND IT IS ENGLISHMEN, ENGLISH CITIZENS THAT WE WANT. ¶ THE DISCOVERY OF THE ENGLISH FOLK-SONG, THEREFORE, PLACES IN THE HANDS OF THE PATRIOT, AS WELL AS THE EDUCATIONALIST, AN INSTRUMENT OF GREAT VALUE. THE INTRODUCTION OF FOLK-SONGS INTO OUR SCHOOLS WILL NOT ONLY AFFECT THE MUSICAL LIFE OF ENGLAND; IT WILL TEND ALSO TO AROUSE THAT LOVE OF COUNTRY AND PRIDE OF RACE, THE ABSENCE OF WHICH WE NOW DEPLORE.

✝

This was Cecil Sharp's story: a fictional history that could be taught to primary school children and which would help to banish the working-class songs of the music halls and fight the good fight against music from other cultures. Sharp's success with this scheme was such that his version of our folk music history is still the dominant one. His skill and dedication as a collector isn't in any doubt, but his strangulation of a collective history is unforgivable. The story, as it stands, is so narrow in scope as to effectively condemn a big chunk of folk history to a sort of slow strangulation, whereby the folk clubs would be in danger of ending up with the same few hundred basic songs going round and round. The story that Sharp told drew two definite lines: between high and low art (rural idyll versus music hall) and between civilised and uncivilised (English heritage versus the entire rest of the world).

Of the first of those separations, Sharp demanded that we "distinguish between the instinctive music of the common people and the debased street-music of the vulgar." On the second, Sharp's visit to the USA in 1916 to hear the music of the Appalachians was preceded by a decision not to collect songs from black people. On a trip to Winston-Salem, he declared: "The place is stuffed full with negroes—I presume they work in the factories whether they are attracted to the tobacco industry by their similarity in colour or not I do not know!…This is a noisy place and the air impregnated with tobacco, molasses and N—!"*

It's fair to say that English folk music would have done itself a service over a century ago by dismissing Sharp's narrow defini-

* Yes I know times were different and all that, but the use of the word here is both hateful and ugly. Although the outright taboo on using the N-word is relatively recent, its meaning as a racial slur was current at the time Sharp was writing. As early as 1837, Hosea Easton wrote that (the word) "is an opprobrious term, employed to impose contempt upon [blacks] as an inferior race…. The term in itself would be perfectly harmless were it used only to distinguish one class of society from another; but it is not used with that intent…. It flows from the fountain of purpose to injure."

tions and instead opening itself up to that "vulgar and debased street music," which would sit perfectly well alongside "John Barleycorn" and the rest. Of course, in the past few decades musicians have made efforts to tip the balance away from the predominance of *Merrie England*, though there's a long way to go before the BBC Radio 2 Folk Awards "Best Traditional Song" list includes songs from the Jarrow Marchers, the Greenham Peace Women, the prisoners and the countless unsung factory workers.

All praise to legendary English folk musician Martin Carthy on this one. He was around (in fact was instrumental) at the start of the English folk revival but has refused to be pigeonholed merely as a keeper of the tradition; his willingness to mess with the form and to introduce other types of English music is peerless. I saw him several years ago in concert in Leeds, along with his daughter Eliza, Simon Emmerson and an eclectic onstage ensemble as *The Imagined Village*. What they were doing was basically taking the patriotic, narrow definition of folk as handed down by Sharp and allying it to a global version of folk—mixing fiddles and accordions with dub beats, sitars and tablas. Exploring our history and culture and making it clear that it's a changing culture, an expansive and varied culture. Even "Scarborough Fair" was given a dusting-down and updated with African drums and sitar. Brilliant.

Folk music. Music of the folk, all of 'em, not just the educated white ones. When we were sitting cross-legged in the school hall singing along to "Green Grow the Rushes O" we weren't to know that within a few years we'd be giggling as we sang our own version of the song, which began—

"*I'll give you one—O*"

Which was replied with a heartily sung, "*Oh no, you won't you know!*"

That's folk music.

*

> I must say this: folk music has no border checkpoints. In
> the end, it has—it can have—no country.
> —Martin Carthy

This is the beauty of traditional folk music, music tied into the history and culture of particular peoples and places: it refuses to toe the party line, refuses to tell a singular, narrow story of that place. When British National Party leader Nick Griffin tried unsuccessfully to hitch his wagon to traditional English folk music, he was shouted down beautifully by both a pop-up organisation calling itself *Folk Against Fascism* and through the wise words of scores of folk musicians. Music is notorious for spreading like wildfires across boundary lines—and with England being traditionally a maritime country, it's always been part of our Englishness to be constantly importing and exporting songs from around the world.

I have in my cellar a shruti box, bought ages ago online from India. The shruti box is basically a squeeze-box harmonium without keys, played by hand-pumping air through a sort of bellows and pushing small wooden stops which cover and uncover holes that play chords. It's a beautiful thing and is, to my ears, a recognisable sound of Indian traditional music. That's its heritage, its story.

And then I chased the instrument's genealogy and traced its family tree, and this is what I found:

First came the Chinese sheng, a mouth-blown instrument consisting of pipes and reeds, then the German harmonium, which used a similar reed system but introduced foot-operated bellows and keys. The German harmonium travelled to India during British colonisation, but was unwieldy and impractical (and the keys kept gumming up in the dry heat). So the keys were stripped out, retaining just the essential box for creating a drone. Beat poet Allen Ginsberg brought one of the first shruti boxes (*shruti* means "that which is heard" in Sanskrit) to the USA in the early 1960s, playing it himself as he recited his epic counterculture poem

"Howl," adding yet another layer to this globe-crossing mixed bag of traditions.

That's folk music—"that which is heard," travelling around the world reinventing itself to suit time and place. As Martin Carthy says, "Folk is the intuitive nature... of people who love messing about with stuff and coming up with something else to keep the continuity going; people who aren't intimidated by how venerable it is."

disrupt

No.4
Crass

Art requires philosophy, just as philosophy requires art.
Otherwise, what would become of beauty?

—Paul Gauguin

Labelled "punk's heavy thinkers," Penny Rimbaud and Gee Vaucher live in an isolated house with a sprawl of a garden somewhere near Epping in Essex. It's a bugger to find, stuck out on the end of a dirt track that winds through a farmyard before coming to a halt at the well-hidden home of two of England's most influential (and yet mostly unknown) artists. Gee is a painter and filmmaker, exhibiting around the world, and two of her current paintings hang in her studio at the house: huge, gloriously huge, canvases of bulls, their eyes fixed on the viewer. Penny is a writer and composer, author of a series of books and an avid collaborator. Both are founders of Crass, the legendary anarchist punk collective and band who regularly troubled the authorities and spawned a generation of young activists in the early 1980s.

We turn up—Casey, myself and our thirteen-year-old son, Johnny—in a sudden downpour, dashing to the front door, met by Gee, who ushers us into the kitchen and offers us home-made bread and tea in a pot. It might all be delightfully quaint if this wasn't the infamous "centre for radical activity" and home to

[153]

several decades' worth of revolutionary political ideas.

This is the first time I've made it out to Dial House, with its various self-built extensions and additions, plus a couple of large, beautifully appointed sheds out in the garden. While Johnny and Casey head out to explore the garden and surrounding fields, I'm led into what must be Penny's shed, a cosy retreat warmed by a log-burning stove and lined with prints, photographs and books. It doesn't take a lot to get Penny talking— I'd already known this from having watched and read various interviews with him over the years. His talking is nothing if not an illustration of his winding, wondering thoughts, with words and ideas playing out along arcs and spirals. He is still—at eighty years old—eloquent, sharp and knowledgeable. He has a fantastic way with language, and a philosopher's ability to probe and question that conjures an image of a 1950s Beat poet jumping onto moving trains of thought and heading wherever the line might be going.

I tell him my story about Welfare State International, about the surprising spectacle of their big mad procession and bonfire, and I tell it partially because I know that, before starting a punk band with Steve Ignorant in the 1970s, Penny had been part of a

performance art group called Exit. I tell him that the first time I saw Crass, in a tiny church hall somewhere in Kent, I'd clocked that they looked as much like a theatre troupe as a rock'n'roll band, that they seemed to be about so much more than music. Penny thinks, and thinks, and thinks, and then sets off:

"Everything was totally considered. And it was, absolutely, a piece of theatre. And it was designed as such. The common thread was, trying to help. Nothing more and nothing less. My intent, since I was very young, was to help. I didn't have to ask what was the meaning of life. There is only one meaning of life, and that is to help. That was a common thread…using the potential of any situation to help; everything is simply a response to what is happening, all the time. Allowing it to find its own crystallisation…and fragmentation, which is what happened to Crass."

I wonder if Penny's home life since he was writing songs and playing drums in a punk band all those years ago—they split up in 1984—has been peppered with visits from people saying, in their own various ways, their own thank-yous for those handful of years when Crass were probably the most fascinating, thoughtful and inspiring band that came out of that subculture.

This is what the band did to me, at that church hall back in the late 1970s: they taught me that the ideas in punk that I was drawn towards—stuff that was clever, poetic, and socially conscious—didn't end with the music. When Crass finished their set that first gig, they didn't head off triumphantly to the side of the stage and into a dressing room, they stepped off the front, straight into the crowd, and started talking to their audience. That was a *boom!* moment. Yes, it was theatre, and it was planned and organised. But it said, these big ideas, we don't just sing about them within the accepted and traditional framework, we take them into the real world. We live them. We're not railing against the system as an art form, we're doing it as a lifestyle. An everyday, morning-till-night, fully committed lifestyle. *There is only one meaning of life, and that is to help.*

Dial House was the central pivot of that lifestyle, a house that Rimbaud had set up with an open-door policy, where people could come and go as they pleased, where ideas grew and were shared along with the communal meals. I didn't imagine any other band at the time doing this. Even from a distance, it was incredibly inspiring.

"Thanks," I say, knowing that this small and easily passed-off word could never convey the impact of Rimbaud and Friends' particular disruptive act on this scruffy-haired kid from Lancashire. Rimbaud, like most of the other Disrupters, batted it away quickly, already moving on to answer what my next question would be—talking about a singularly disruptive moment that had changed the course of his own life:

"I was somewhere between four and seven years old. I had one of those effects in my life, where the whole thing just changed irrevocably, when I took a book out of my parents' library…and it was pictures of Auschwitz. And I thought, 'Fucking hell! That's what my dad had been doing in the war.' And then I started trying to inform myself, in a rather naive way. But even then, as a very young child, I just thought, this really is not for me, I'm not having this. And since then I haven't really altered my stance."

The idea that Rimbaud cites the disrupting influence of a book, rather than a person, makes sense: he seems utterly sure of himself, admirably comfortable in his own beliefs, locked into this beautiful mantra of "there is only one meaning of life, and that is to help." There's something else at play here though; Rimbaud is made up of more than just altruism—there's a bloody-

mindedness, a sense of belligerence. Somewhere on YouTube there's a short and fascinating clip from the British pop show *Ready Steady Go* (look up "Lennon Meets Penny"); it's 1964 and the show has previously held a competition for its audience to send in drawings and paintings of The Beatles. The winner would be presented with two LPs of their choice by The Beatles themselves. And here we see a young, suited Penny Rimbaud—answering to his real name, Jeremy Ratter—being presented to the audience as the competition winner. Along comes John Lennon, having been hastily given Rimbaud's two chosen records, all smiles and exaggerated accent, shaking hands and looking to see what the two records might be; surely he will have chosen Beatles records...

Presenter: Jeremy Ratter...your prizes.
Lennon: Hello, Jeremy lad. Pleased to meet yer. Good old Jerry! May I present you with these, er—
Presenter: You tell us which LPs you chose.
Rimbaud: Well, I chose Shostakovich's *Violin Concerto* and *Mingus* by Charlie Mingus.
Lennon: Each to his own! [*Under his breath:*] Rocker!

This, I realise, isn't just contrariness on the part of Rimbaud, it's also self-confidence, an adamant "why should I compromise or pretend in this world that is full-to-bursting with pretence?"

Gee Vaucher is very much like Penny; she has an almost scary sense of what she wants. She doesn't like being recorded, and her reluctance to talk about Crass is about wanting to live and work in the present, here, today, where she has artworks to finish and exhibitions to organise. She's in demand around the world, her eclectic work always in some way commenting on the world's power imbalances, whether that be at the level of family, corporation or state. Nevertheless, Gee shrugs off any inference of mine that her work is an essential part of Crass's "disrupting influence," wanting to bring the conversation back round to what she's working on now.

Having accepted that we're hanging around for a little while though, she produces home-made cake, makes more tea and ushers us into her studio to see the magnificent bull paintings. Gee has been painting cows and bulls for years now, alongside a lifetime of incredibly varied work, from huge, harrowing close-up portraits of children (*Children That Have Seen Too Much Too Soon*),

to a walk-in greenhouse, its glass embossed with the names of all the countries where the USA has instigated or taken part in war (*The Sound of Stones in the Glasshouse*, a collaboration with Christian Brett). Even as we leave, Gee is giving us beautifully produced booklets of her work along with the hugs and waves.

Back in the 1980s I was determined not to visit Dial House. At the time I thought it would have felt too much like a pilgrimage, like paying homage. I wanted to savour the influence Crass had had on me but not be a slave to it—they exerted such an overwhelming pull for so many people, to the extent that people mimicked their music, their style, their record sleeve design…so I hadn't ever called in. I'm glad, to be honest. There's so much happened, so many roads travelled and so many choices made, that I can look back now on each of the people who changed the course of my life and see them in context with all the others, all of them spinning me off in different directions, all of them helping to create a looping, twisting, unholy mess of a life-map.

We drive off from Dial House and head into more rain on the journey back up north. After a while, Johnny pipes up from the back seat:

"Dad, I thought you said they were, like, punk rockers?"

"That's right. A long time ago. When I was a teenager."

"Thing is, though, Dad, because you said they were punks, I expected these really old people still wearing leather jackets and with mohawks and chains and stuff."

"Ha ha!"

"Anyway, I've texted my mates to say I met some famous punks."

"Good. I think Penny and Gee would like that."

Gimme Some Truth

> You don't win any trophy for the truest story you've ever told. As professionals we can embellish and embroider and make it better...rather than just tell what happened. The only thing that matters to me is "is it entertaining?" And if it's entertaining it means it's ticked all the boxes, so I've believed it, it's got a point, it's well crafted. I'm not that bothered about whether it actually happened.
> —Sarah Kendall, comedian

We crave authenticity, even in a joke. Something funny is so much funnier if we think it actually happened—and every time a stand-up comedian begins a tale with "This is a true story," we really, really want to believe it. When we read an adventure story—the man forced to cut his own arm off to free himself from where it was trapped between rocks in the desert, say—we need to believe it's true. If that man turns up for a book reading, the first thing you'll do is check the number of arms he has.

Nobody wants to find out that a really good story that they've believed for half their life is untrue. Here's one: peeing on a jellyfish sting to make it better is an old wives' tale. I don't know which old wife started the myth, but believe me, it isn't true. Believe me.

I read Keith Richards's (ghost-written) autobiography a while ago and made a discovery: The chunk of life lived by someone famous before they were famous—in Keith's case, growing up in Dartford, getting his first guitar, everything up to the point where he bumped into Mick Jagger on a train station platform—is probably authentic. And everything after that fabled meeting, it's all mythology. What Keith got up to as a kid doesn't need to feed into rock'n'roll lore, but the stuff of the remaining four hundred pages of Richards's life—concerts, hit songs, arrests, fights, deaths and lovers—that's a saleable commodity. That's the stuff that

oozes from the Gibson fuzzbox opening riff of "Satisfaction," the simplest of three-note melodies that contains a Pandora's box of charms and spells. We know it's all exaggerated, fluffed-up fables and fictions, but still we love it and still we want so much for it to be true.

Punk laid a claim to truth that was purposefully designed to pour scorn on the Keith Richards version of rock'n'roll rebellion. In doing so, of course, it created its own mythologies. When The Clash were photographed wearing their leather jackets and combat boots on Belfast street corners, they were both placing themselves in a harsh and everyday reality (Keith wouldn't be caught swaggering along Belfast's Falls Road in his pirate outfit) and at the same time honouring the street-fighting pose of the Stones. We mean it, man. Then along came bands like The Fall, wearing Oxfam jumpers and ambling onstage as if they were shuffling into the unemployment office—dressing down becoming the new dressing up.

Before my time there'd been all sorts of musicians, from poor black bluesmen to train-hopping folksingers, whose authenticity was without question. Music born of struggle, music that told stories that just couldn't, ever, have been works of fiction. Struggle you could hear in the recordings. But "my time" began with pomp and glitter, with artists hidden behind so much make-up it was hard to tell what was real and what wasn't. I loved it, but never quite *believed* it.

When I was eighteen, in 1979, I left home and ran off to college in Maidstone, Kent, armed with a bag of punk badges and my dad's old bike. Ridiculously, I went there because I thought it was close to London (I couldn't get into any of the London colleges). I only lasted three months on Maidstone's graphic design course, but halfway through that time I found out that the anarchist punk band Crass were playing in a village hall somewhere a couple of stops along the railway line. I'd heard a lot about this obscure group from my mates Spider and Pepe from Burnley, who'd been to see them in London. Apparently they were "sort of like The Clash, but more extreme, more political, more committed." I bought their first record, which started with a minute's silence

(called "The Sound of Free Speech"), and I loved it. It was punk, but not punk rock. It didn't rock, it barked and stuttered. It was strange and extreme, and, crucially, it sounded like *they meant it*.

So I got the train to the gig, suddenly seeing all sorts of disenfranchised punks appearing out of the Kent woodwork. When I walked into the wood-and-peeling-paint village hall (wherever it was), the stage was surrounded by home-made banners and painted slogans. The band were chatting to people as they arrived, and their pre-gig ritual seemed to be drinking cups of tea. The only stage lighting was from small, home-made wooden boxes on the floor, household bulbs throwing dark shadows against the ceiling. The band wandered around handing out hand-duplicated leaflets and lyric sheets, showed a couple of short films and then, boom, launched into an hourlong *aaaaaaaagggghhhhh* shriek against the world. A nonstop, full-throttle yelp that, despite the noise, was clearly literate and clever (the lyric sheets helped). It was rooted in rock'n'roll, but it hated rock'n'roll. The bastard child that fights its parents. It was as close as I'd seen rock'n'roll get to being authentic, and I loved it.

As soon as the music stopped, the band put down their instruments and—shock!—stepped off the front of the stage and resumed chatting to the audience. Crass made rock'n'roll seem like just a story, a well-constructed fiction. This wasn't Mick Jagger singing "Street Fighting Man." It wasn't a ninety-minute pantomime where performers wear costumes, learn their lines and put on an act. What Crass did was suggest that this practise and performance of rock'n'roll could be truly, excitingly honest.

> Every day, to earn my daily bread I go to the market where lies are bought. Hopefully I take up my place among the sellers.
> —Bertolt Brecht

Brecht spent a lifetime making theatre that spoke the truth. He created a form he called "epic theatre," which did away with the artifice and heightened emotion of traditional theatre. He wanted

the audience to be aware at all times that this was a play, these are actors, this is a script, we are the audience. The idea was that theatre could avoid illusion, be explicitly political, and could be less a performance and more a set of instructions for action. He wrote plays where characters regularly "broke the fourth wall" by directly addressing the audience—just as Crass broke it by stepping off the stage instead of scurrying off to a backstage dressing room.

How far can these writers, rock'n'rollers, directors, comedians —storytellers all—go in trying to convince their audiences that they are telling the truth? It isn't enough anymore (was it ever enough?) to start a joke with "A funny thing happened to me on the way to the theatre..."

A short while ago I drove up to Fort William to stay for a few days, and on the way I was able to see the infamous Russian feminist band Pussy Riot performing at the art school in Glasgow. The Glasgow School of Art is an amazing building designed by Charles Rennie Mackintosh, an innovative designer and architect, and just to tie all this together, here's a quote from Mackintosh:

"You must be independent, independent, independent—don't talk so much but do more—go your own way and let your neighbour go his.... Shake off all the props—the props tradition and authority give you—and go alone—crawl—stumble—stagger—but go alone."

Earlier that year I'd seen one member of Pussy Riot (Maria Alyokhina) in a show in Manchester presented by the ground-breaking underground theatre group Belarus Free Theatre. That show had shocked me with its incredible, raw brutality; the band's performance in Glasgow took that same energy and doubled it. From the moment they took the stage, they demanded attention. Their one-hour show reminded me, again and again, that they were *for real*. A projection screen told the story, in English subtitles, of their formation, arrest, trial, imprisonment in Russian jail and eventual release, while two original Pussy Rioters narrated (or actually, sang, declaimed and shouted) a story that swung from fist-raised defiance to tearful loneliness. Digital dance beats kept the

whole thing sounding urgent and uplifting; the performers danced, yelled and cried. It was Crass all over again, only this time it told the story of imprisonment and hunger strikes. Of being away from your young children, locked in solitary cells, sent to far-flung prison camps, fighting for justice. It reminded me of what punk could be, at best—not a form of 4/4 rock'n'roll but a way of shouting about the world.

Considering the way they have suffered for their art, Pussy Riot are the most authentic version of rock'n'roll I have seen, or will see. They reminded me of being a teenager heading off to college, wide-eyed and on the search for a coming-together of theatre, art, rock'n'roll and politics. While I was there I spent a lot of evenings and weekends at Maidstone Library, catching up on all the stuff I thought I needed to read—so along with *Catcher in the Rye* and *The Bell Jar* I read Aleksandr Solzhenitsyn's *Gulag Archipelago*. And that spotty, spiky eighteen-year-old in a small-town library reading about the Russian labour camps, about totalitarianism and impris-onment, was still looking for Pussy Riot to demonstrate that art and music wasn't all about playing with words, style and culture—this was people's lives being put on the line.

I could have left Crass's little gig in Kent behind as a distant memory, but somehow it stuck. It became part of how I think about music and the world. It became an introduction to art being part of real change, for real people in really crap situations. Hearing the Pussy Riot audience—mainly spotty, spiky teenagers like I'd once been—roaring their denouncement of the Putin dictator-ship and yelling their approval of the band's direct action tactics reminded me that, yes, the world is capable of learning, bit by bit, especially with people like Pussy Riot to provide the soundtrack.

ANYBODY CAN BE PUSSY RIOT

YOU JUST NEED TO PUT ON A MASK
AND STAGE AN ACTIVE PROTEST OF SOMETHING
IN YOUR PARTICULAR COUNTRY, WHEREVER THAT MAY BE,
THAT YOU CONSIDER UNJUST.

Marginalia

I used to always read with a pen in my hand, as
if the author and I were in a conversation.
—Tara Bray Smith

THERE'S that
story about
someone going to
see a particularly
dreary theatrical
version of *The Diary
of Anne Frank*.
About halfway
through the show,
tiring of the
monotony, an
audience member
reacts to the onstage
arrival of German
soldiers with a cry
of "She's in the
attic!" It's such
an unfair and
destructive act, but
it's a memorable
story. That act of
vandalism comes to
mind when I think
about *marginalia*,
the act of writing in
the margins of
books: a desire to
change a book from
monologue to
dialogue. To make it
a conversation,
active and not
passive. Writing in
the margins means
you're not "getting
lost" in a book,
you're participating
in it. Bringing
yourself to it.

Marginalia has
been going on
practically since the
invention of the
printing press. The
first Gutenberg
Bible was printed in
the 1450s, and from
that moment on
books were there to
have their margins
doodled in
(including the
medieval period's
statutory
hand-drawn
genitalia). Before
the printing press,
the monks and
scholars employed
to copy entire
books by hand
would often insert
their own cheeky
comments and
complaints—one
famously added, at
the conclusion of a
book, *"Now I've
written the whole
thing: for Christ's
sake give me a drink."*
As the practise of
scrawling in the
margins became
widespread, it
became common to
publish books with
blank pages
inserted, specifically
for marginalia. In
other cases, book
buyers would take a
copy of a book to
be rebound to
include blank pages
for notes, a process
called interleaving.
None of this was
considered
disrespectful or
destructive—it
wasn't until the

1800s that people
began to see
marginalia as
defacing the book.
 Even then, the
practise persisted
(as it does today,
or at least until
Kindles came along
and spoiled the
fun). Lots of
famous writers
were themselves
marginalians—
from Samuel Taylor
Coleridge to Sylvia
Plath, not forgetting
the prolific
margin-scribbler
Mark Twain, whose
scrawls could be
particularly critical.
His personal copy
of *Plutarch's Lives*
has the following
interjections added
by Twain on its
title page:

PLUTARCH'S LIVES

OF

ILLUSTRIOUS MEN.

into rotten English

TRANSLATED FROM THE GREEK BY JOHN DRYDEN
AND OTHERS. ^

THE WHOLE CAREFULLY REVISED AND CORRECTED.

by an ass.

[165]

I grew up in a
Mormon family,
attending church at
least three times a
week and holding
various home
prayer meetings.
From the
perspective of an
outsider, I can now
see how seriously
the Mormon
congregation took
their religion, with
firmly held
strictures and
guidelines covering
every aspect of daily
life. We all had our
own Bibles, usually
presented to us
when we were
baptised by being
fully submerged in
a specially built
baptismal font at
the age of eight.
Those Bibles—
along with the
accompanying
scriptures *The Book
of Mormon* and *The
Pearl of Great Price*
(and even now I
have no idea what
exactly that third
book was about)—
were carried with us
to every meeting;
we held on to them
as if they were a
badge of honour, a
mark of our faith.
Then as young
teenagers we were
encouraged to read
these scriptures by
engaging in
competitive
scripture-memory
competitions firstly
with each other and
then in teams

against other Mormon church congregations. These competitions —called scripture chases—became incredibly combative and important. Four of us from our branch of the church in Burnley would travel to Preston and Blackburn to sit opposite four teens wanting nothing more than to do battle with our knowledge of the scriptures. This happened in front of large audiences of the Mormon faithful, clapping and cheering. One of the sections of the competition involved a quizmaster saying a single word, upon which the hyped-up participants on both teams would frantically, desperately rifle through their Bibles to find the scriptural quote that included that word.

Such was our desire to win that we began to find ways of annotating our holy books with highlighter pens around relevant pages, colour-coded short-cuts to key scriptures. Whole pages of what we truly believed to be

God's word would
be ringed in
fluorescent yellow
and shocking pink.
Then another
solution—some-
body on the team
discovered that by
carefully scrunching
up a page of the
Bible and then
flattening it back
again, the page
would more easily
present itself as we
flipped furiously
through the book.
As the competition
continued over
months and years,
our scriptures
began to gradually
grow with each
scrunched-up page
adding up until the
book was around
twice its original
size, becoming a
bloated series of
ringed and
underlined quotes.
This was marginalia
gone mad.
The funny thing
is, while we were
defeating other
branches of the
church in these (at
first regional, then
national)
competitions,
nobody (not our
parents, or the
church teachers or
the bishops) said
anything about the
state of our Bibles,
possibly taking
their appearance
as proof that we
must be avidly
reading them.
Journalist Ian

Frazier is a bona fide detective of marginalia, a collector of scrawls and scribbles by various authors and writers. On a trawl through books at the New York Public Library, he discovered a copy of Henry David Thoreau's *A Week on the Concord and Merrimack Rivers* that had been owned and annotated by a young Jack Kerouac—when I say owned, I'm being disingenuous: Kerouac had borrowed the book from his local library and never returned it. On page 227 of the book, one sentence in particular had been underlined by Kerouac along with a small tick mark. The sentence was:

"The traveler must be born again on the road."

Maria Popova is (and this is her own description) "a human-powered discovery engine for interestingness." She collects and curates sections and snippets of writing from anywhere and everywhere and collates it, regularly and irregularly, into an online resource called *The Marginalian*.

She annotates her
collections with her
own thoughts and
discussions, making
a sort of life's work
of writing in the
margins—she refers
to literature as "the
original internet—
every footnote,
every citation,
every allusion …
essentially a
hyperlink to
another text, to
another mind."
There's a great
photograph of
Popova that
accompanies a
New York Times
article about her
work—great
because it shows
her flicking through
a book which looks
like it's been
attacked by Post-It
notes. There they
are, scores of slivers
of paper in all the
fluorescent colours,
poking out of every
edge of the book
like dragon's teeth,
each one a
reminder and
a pointer.
And in an art
gallery in San
Francisco there's a
small, framed
drawing by the
artist Willem de
Kooning. Except
you can't see it,
because in
1953 Robert
Rauschenberg,
having acquired the
drawing from de
Kooning, erased it.
It is now called

Erased de Kooning Drawing, and well over half a century later it still has shock value. But the artwork isn't about the act of defacing at all, it's about collaboration; it suggests to us that we can be more than passive consumers of somebody else's artistic vision, that we can find ways to play an active part in the process.

Of course, there's an element of wilful vandalism in all of this. And I admit to thinking there's just something *not right* about the idea of scrawling across a beautifully set block of printed type. But that's often a good place to go to, that *not right* place where you're doing what you've been told not to do. So I'm giving you the chance here to collaborate and coauthor this page, this section, this book, in whatever way you think makes it yours as well as mine. I've made sure there's plenty of space on the pages in this section, giving you plenty of scope to doodle and scrawl and argue your point.

And if you don't like this final sentence, feel free to cross it out.

[1 7 1]

Pissing It Down
(In Praise of English Rain)

Vexed sailors cursed the rain, for which poor shepherds
prayed in vain.
—Edmund Waller

I look outside my window. It's pissing it down. Bucketing.
Depending on where you come from, it might be luttering, tip-
pling, siling or plothering. And subject to how heavy it is, it could
be blirting, plouting, driffling or mizzling. It's raining stair rods,
chair legs, cats and dogs, pitchforks and hammer handles. Whatever
it's doing—turn up the radiators, close the curtains—I'm not
going out.

 Like everyone else in England, I get sick of the seemingly end-
less downpouring of all this wetness, fed up of the greasy pave-
ments and churned mud, tired of heaving on cagoules and boots
every time I want to nip out, wondering where the umbrella*
went, blind behind spectacles slaked with the stuff. But this,
essentially, is our story. My story. Round here, tradition and history,
however heroic or important, is damp. The problem is that story-
tellers use rain as a device, as a way of expressing disappointment
and failure. But those are stories; in reality, the rain doesn't just
come along to illustrate an emotional hit. It does what it wants,
irrelevant of how we want to construct a narrative. Rain, it's just
there.

* I hear the typesetter mutter under his breath, "You've changed!"...
In the autumn of 2012, a ban on the public use of umbrellas was
introduced in my hometown of Burnley, then adopted across whole
swathes of Northern England by the end of that year. Some of us
though...*once a rebel, always a—*

And it's getting heavier and more persistent, the forecasters tell us. The 1990s ecological buzzwords that we bandy around changed slyly and slowly over the last two decades from *global warming* to *climate change*, as it gradually dawned on us that it wasn't getting any warmer—just wetter. Rivers around the country break their banks every year, trench foot at rock festivals is on the rise and Doctor Foster steps into puddles right up his middle with increasing regularity.

Nobody really likes getting rain-soaked, every day. It's uncomfortable, time-consuming and tedious. We all crave the sun, not only because it helps us to produce health-giving chemicals (serotonin, endorphins and melatonin) but because, in England, it's almost always a welcome break from the rain. A relief from ill-fitting Wellingtons and sweat-inducing anoraks. A chance to wear a T-shirt and shorts.

Rain, rain, go away,
Come again another day.
Rain, rain, go to Spain,
Never show your face again!

This is the prevalent story—that, yes, the rain is essential and life-giving, but at the end of the sodden day it's a sodding nuisance. But imagine if England were sunny all year round. If some blip in the climate disaster forecasts meant that the tiny Cumbrian hamlet of Seascale—consistently and officially the wettest place in England—was drenched in Californian warmth. If we woke up every morning knowing exactly what to expect; if our wardrobes were reduced to swimwear, sunglasses and linen. If, as the nursery rhyme suggests, the rain had gone on a permanent holiday to Spain.

For starters, imagine a country without The Beatles, without *Wuthering Heights*, without Richard III's "My country for a horse!" Imagine a country without rainbows, imagine the rolling Peak District moorland being a desolate, sandy scrub. Hot tea replaced by iced tea. No sou-westers, no Glastonbury mud-sliding. Wimbledon without its retractable roof, schoolkids' football without those hardy, embattled, do-or-die parents on the touchline gritting their teeth against a windswept lashing.

Imagine looking out of an aeroplane window as you come into land, seeing not the familiar patchwork of vivid greens, but a vast burnt-yellow uniformity. Imagine us all, standing at our front doors before we embark on our journeys into the day, having nothing to huddle against, nothing to moan about, nothing to blame.

So much of our culture—historical, social and political—has sprung from our weather. The Smiths were The Smiths and not The Beach Boys because they were born into a land of dripping raincoats and street corners that you huddle into—you could argue that since Morrissey moved to Los Angeles he hasn't written a good song (and all that sun has certainly done something nasty to his opinions). Ted Hughes thrived on the bleak grey swirl of Yorkshire uplands and soggy Devon moors. Our favourite fiction, from Shakespeare to Ken Loach, is peppered with the drama of rain. Turner's paintings are suffused with rains, mists and fogs; English films—from *Brighton Rock* to *Saturday Night and Sunday Morning*, *Billy Elliot* to *The Full Monty*—are drenched in

the melancholy of rain. Every story needs opposition, something to fight against, and if nothing else comes to hand there's always the rain.

My friend Alice Nutter wrote a script for a TV drama some years ago—an episode of a series created by writer Jimmy McGovern called *The Street*. It was a story of a postman whose wife had left him, taking the kids with her. The downhill spiral of the postman's life culminated in a night-time visit to the semi-detached house where his wife and children had moved in with her new partner. It was a desperate, desperate scene. But Alice remembers that when the editors read the script, they had one adjustment to make: the late-night gloom of the scene needed one addition—rain. Heavy rain. Rain that at first dampens, and then drenches, your hopes. Because we've allowed rain to become a metaphor for sadness and melancholy.

It doesn't rain all the time in England, despite what we like to think. It rains, on average, roughly 133 days in a year. That's a little more than one day in three. But that one day, whether we admit it or not, defines us. It bore us, it cradled us, followed us as we grew. Seeped right through our skins and became an absolute and essential part of us. All those 1980s post-punk bands from Manchester, Liverpool and Leeds (Echo & The Bunnymen, Gang of Four, Joy Division) wore raincoats to define their attachment to a post-industrial urbanity; their greyness was definitively cool. So why do we allow rain to be a signifier of gloom and despondence?

Here are some pointers that the *pluviophiles* (people who love rain) can use as its defence in the weather court—in New York, according to a study carried out in 2009, homicide rates drop significantly when it rains. Rain dampens and reduces air pollution. And Charlie Chaplin said, "No-one can see you cry in the rain."

I'm talking in particular about English rain, because I believe that our peculiar attachment to it—part resentment, part sulking love—has spawned our character, made us into what we are. We wake up in the morning not knowing what the weather will be doing, not knowing how we'll dress or how we'll face the day

beyond the bedroom curtains. The *not knowing*, always a good place to start. So it's not fair that the rain is storytelling shorthand for melancholy, it's not fair that BBC weather reporters refer to rain as "bad weather," and it's not fair that the rain we watch in films and read about in novels keeps us from appreciating the rain outside our front door. Toiling across Dartmoor in a heaving rainstorm, battered by the stuff, feeling the wet soaking through waterproofs (no such thing!), at the very least what you're getting is a taste of the stuff that keeps us all alive. Being pissed off at the rain is like being angry at the sun for shining.

I look through the window. It's still pissing it down. Grab my coat, pull on some boots; I'm going out.

Shhh

I, A.B., of my own free will and accord do hereby promise and swear that I will never reveal any of the names of any one of this secret Committee, under the penalty of being sent out of this world by the first Brother that may meet me.

—Luddite oath, 1812

Just before midnight on an April evening in 1812, on the edge of industrial Huddersfield and adjacent to the old Three Nuns Inn, several hundred Yorkshire Luddites set off to march across the moors to attack Rawfolds Mill, or more specifically to attack and break the mill's shearing frames. The route followed rough paths towards the almost-indiscernible summit of Hartshead Moor, scene of several Luddite attacks upon the hated frames. Before the enforced enclosure of the land, this open moor, criss-crossed with goods routes, would have been a relatively wild place, exposed and in common daily usage. More than once, the new machinery bound for the local mills, carried on horse and cart after dark and accompanied by men hired to protect it from ambush, would be attacked and overpowered by masked Luddites. After tying up the men and wrecking the machines, the Luddites would alert the servants of the local magistrates and gentry to their actions, adding threats to be passed on from General Ludd himself.

It all started in 1779 with a young labourer in Leicester. Frequently told off at work for not operating his spinning machine fast enough, he was ordered by a magistrate to be whipped. His impetuous reaction to the punishment was to take up a hammer, return to his place of work and smash the knitting-frame to pieces. Nothing else is known of him, other than that his name was Ned Ludd. Later, when people began to plot and plan

against the introduction of machines that were threatening their livelihoods, they didn't declare their allegiance to recognised leaders or figureheads; they invented one. Ned Ludd, *aka* General Snipshears, mythical redresser of wrongs, a man who could be everywhere at once (and nowhere if needs be too), taking the fight to the employers throughout Lancashire, Nottinghamshire and Yorkshire. Sometimes Ludd would be physically depicted by means of a life-sized straw puppet to be hoisted high at the front of Luddite gatherings. Sometimes Ludd would sign proclamations, transcribe oaths, send threatening letters. *Yours truly, Ned Ludd. All of us and none of us.*

We live (and we've always lived) in a world of evolving language, where words are twisted and shaped according to changing culture, changing times. The pattern and rhythm of our speech is up for grabs in a developing society. But sometimes a word is misused and misconstrued so spectacularly and so often that it forces us to stop and take stock.

Luddites were not "against technology" or "against progress." Luddites were against a ruthless alliance of bosses, landowners and politicians who were eager to bring in new cropping frames resulting in thousands of men being thrown out of work, their families forced to choose between begging and the workhouse. The Luddites were against enforced starvation, against grinding poverty. Had the introduction of the new cropping machinery opened up a wealth of work that demanded more skilled operators, there would have been no gathering, no plotting and no oath-taking. It's significant that countless other technologies introduced during that time of incredible expansion—including transport, communication and science—were left wholly free of the attentions of the Luddites.

The chronology of Luddism spans little more than a decade, from the Combination Acts at the very end of the eighteenth century to the conviction and murder of seventeen Luddites in 1813. The Combination Acts prevented any union between workers, resulting in thousands of countrywide gatherings of working people, in secrecy, going about their business away from the eyes

of the mill owners and politicians, in the closed-off sanctuary of the inns and alehouses; workers turned suddenly into all of us and none of us. *Shhh.*

It was recently predicted in the American *Smithsonian* magazine that almost half of all US jobs will be automated within the next two decades. That's because artificial intelligence and robotics are being produced with a sophistication that means they can carry out many of the routine tasks that typify the modern workplace— it isn't hard to imagine Amazon's huge shipping warehouses (unironically called *fulfilment centres*) being run by order-picking, box-folding robots. It's tempting to envisage the rise of a new Luddism as idle workers are thrown into poverty and are unable to afford to travel in their driverless cars.

The trail from the Three Nuns Inn to Rawfolds passes the Shears Inn, infamous home of Luddite gatherings. The rear of the inn looks out across open fields, and this was a good incentive for the rebellious croppers to gather there—the Shears offered various escape routes at a time when the area was crawling with hundreds of local militia. It's here in the Shears where Luddites "twisted" an oath to the cause, a secret testimony of loyalty and community that would stay with almost all of them until death. On this oath of secrecy was built an entire community of Luddites across the North of England.

From the Shears the men had only a further mile to reach the old mill owned by the ruthless industrialist William Cartwright. The attack on Rawfolds that night resulted in the deaths of two Luddites, shot by militiamen hired to defend the mill and its machinery. The mill was fortified with trapdoors, spikes and burning oil, along with a small regiment of soldiers armed with muskets. Despite breaking hundreds of panes of glass, the Luddites failed to gain entrance to the mill.

When the battle at Rawfolds was over, two badly injured Luddites—John Booth and Samuel Hartley—were taken to the nearby Star Inn by local militia to be either treated or tortured (depending on whose side of the story you wish to believe). What wasn't disputed was that nitric acid was found soaked into the

bedsheets and that this was the authorities' perfect chance to force the men to snitch. Both men, literally on their deathbeds, kept their mouths shut. It was reported that one of the men, wracked with pain and bleeding heavily, responded to the request for information on fellow Luddites by drawing the questioner near and asking, "Can you keep a secret?"

"Aye, I can," replied the constable.

"Well," whispered the dying Luddite, "so can I."

The Guitar

Guitars are infused with stories and histories. Beautiful, practical objects that somehow embody the creative urge, both artistic and practical, solid and ethereal at the same time.

But.

I was listening to BBC Radio 4 while making toast for my daughter. People were discussing "precious things," and a man whose name I didn't catch—but was presumably a famous guitarist—talked about walking into a used guitar shop in New York and the store owner informing him that a guitar had just come in that had belonged to some fabled 1930s jazz musician, an authentic piece of musical history.

So our man asks if he can play it and is shown into a private room where he sits and plays the precious guitar for a while, explaining to the interviewer how he could feel the "resonance of history" in its shape and sound, and he could practically sense the original guitarist's presence embodied and alive in the worn fretboard. Then the shop assistant came in and said, "Oh, sorry, no, it wasn't that guitar; it was the one next to it."

Despite being the guitarist in a band for umpteen years, I decided sometime in the mid-1980s that I wasn't a guitarist, that I wasn't even a musician; I was in a band, I wrote songs. There's such rich history and mythology around guitars, such a wealth of stories, that my realisation that I wasn't a guitarist felt like a betrayal. And for the record, I think guitars are beautiful. I love the folklore surrounding guitars, Brian May and his dad making one from an old wooden fireplace, B. B. King calling his "Lucille," Joni Mitchell's Martin acoustic that survived a tour of duty in Vietnam, Jimi Hendrix setting them on fire ("You sacrifice the things you love," he said)...I mean, the stories are great. But for me the guitar was just a means to an end: it got me in a band.

Occasionally people would find it hard to understand that I

could play guitar in a band but not be a guitarist. People want the lore and tradition of guitar-playing, not some idiot who doesn't know the difference between a Fender Mustang and a Fender Jaguar. My first guitar was a Spanish nylon-stringed thing that I acquired when my mum's decision to learn classical guitar ended after two or three lessons. That guitar (which went with me busking around Europe on various summer-long jaunts, strumming "Career Opportunities" and "Teenage Kicks" in the stretching shadow of the Pompidou Centre in Paris) eventually gave way to an electric guitar I bought on Maidstone Market. That cost £10 and the electrics were knackered after I spray-painted it in black-and-white stripes and the paint got into the switches.

I spent a year struggling with that useless piece of wood in my first punk band, and then took a trip to JSG in Bingley, which despite being in a basement was a cavernous cathedral of a place, bristling floor-to-ceiling with electric guitars and always soundtracked by long-haired hopefuls playing riffs and licks. I didn't do licks and riffs. I bought an unknown-brand guitar based on its size and shape—I was more interested in how I'd paint it than what it sounded like.

At this point my mate Sage, guitarist in Notsensibles, loaned me a yellow plastic fuzz box, which had one setting (fuzz). I took the strings off the guitar, got some masking tape and acrylics, painted a Mondrian onto the instrument body and took this and the fuzz pedal into my (yet another) attempt at being in a band (when we were a sort of cross between The Fall and Tracey Thorn's all-girl group The Marine Girls). The Mondrian I copied onto the guitar was *Composition with Large Red Plane, Yellow, Black, Gray and Blue*.

Things changed when we played an early concert with American post-hardcore legends Fugazi towards the end of the 1980s, where I was eyeing up Ian MacKaye's Gibson SG. I asked him if he played that guitar because it was the guitar played by Angus Young of AC/DC and he said no, he played it because it was light. He looked me in the eye—he was always wonderfully intense—and gave me his sales pitch.

"Have you played a Gibson Les Paul?"

"No."

"You should. Just once. One show. Man, that motherfucker is so heavy, you'll come off stage thinking you've just carried a big bag of cement up a mountain. Those guitars break your back, man. But look at this, here, hold it—"

He practically threw a battered white Gibson SG into my arms. I awkwardly strapped it on. He was off now, I'd given him permission to get poetic on my ass about his guitar.

"That's a Standard Alpine White. The SG stands for Solid Guitar. You can have that hanging off your shoulders all night and forget it's there."

I'd seen how Ian would sometimes, mid-show, swing his guitar around his back or throw it into his amplifier, how at the end of a set he'd simply drop the guitar onto the stage while feedback howled out of his amp.

We were about to set off on a tour of European countries, so after Ian's pep talk I sheepishly asked the band if we could afford to buy a better guitar. They agreed. We collectively bought all our instruments, so effectively the guitar would only be one-eighth mine. The band had probably been wondering for years why I was still playing a no-brand guitar that sounded like a bee's distracting buzz. I found a cherry-red Gibson SG second-hand in Leeds and took it home to strip off the strings and paint it. By now I'd discovered that by using acrylics and stencils I could decorate the guitar with handy and up-to-date slogans, changing them for each tour using some white spirit and a rubbing cloth. And I didn't tell the rest of the band that, in truth, the reason I wanted to play an SG was because it was light.

That's the guitar I stuck with until the band stopped using electric guitars; I had two, since one had its neck snapped when someone stepped on it at a concert in Norwich. Notwithstanding all this talk of guitar brands, by the 1990s I'd given up playing guitar on any of our records. I'd discovered that our recording engineer, Neil Ferguson, was an alarmingly brilliant guitarist and I could simply explain to him what sort of thing we wanted—there seemed little point in me playing it not-quite-as-well, and frankly I didn't care who played it: like I said, I wasn't a guitarist.

Actually, I did play guitar on recordings if we needed some wah-

[183]

wah effect. For some reason Neil couldn't quite coordinate the *wakka-wakka-wakka-wakka-wakka-wakka-wakka-wakka-wakka* foot-pedal, so I still merited the job title "guitarist" on our records. When the band did our first tour of the USA, in 1990, we didn't have the necessary work permits, and so, flying into Los Angeles as tourists, we'd been promised a handful of instruments for the tour up and down the West Coast, Seattle to San Diego. We turned up on the morning we were due to set off driving to our first concert, and I discovered to my horror that the guitar I'd been loaned was a white Flying V. Originally made by Gibson, this particular Flying V was a cheap copy that came with—to add insult to injury—a big furry guitar strap. I couldn't play a Flying V. I know they have a real rock'n'roll pedigree. Jimi Hendrix famously played one. It wasn't the guitar he set alight at the end of his sets, though—that was a Fender Stratocaster—but it should have been. I'd be more than happy to watch every Flying V guitar go up in smoke. The V-shaped guitar had become an easy signifier of heavy metal, of one-foot-on-the-amp guitar god soloing, of hair and denim and all the stuff Joe Strummer had revolted against. ("Like trousers, like brain" was his maxim.) I couldn't play that onstage. I asked the tour manager if there was an alternative, and friends were dispatched across the city to borrow something less Metallica and more Mick Jones, less LA and more Lancashire. I have no memory of what I ended up playing on that tour—I've even watched some concert footage from the famous Gilman club in Berkeley and can't make out what the guitar is that I'm playing. All I know is that it wasn't a white Flying V.*

I still play a guitar—a semi-acoustic, f-hole something-or-other, because it looks good and it's handy for writing. It does a job. I still feel awkward about not being a guitarist while nonetheless

* I didn't know the make of the guitar, but Christian Brett, who typeset and designed this book, does. Christian worked in a guitar shop called The Twang's the Thang for ten years, and for eight of those he part-owned and ran it. This means he has a deep-seated understanding and love of guitars, a love that has to be balanced by a cynical and dismissive

playing guitar most days. When people ask me what kind of guitar I have, I'm a little embarrassed that I can't remember the make and model. But at least by not even knowing what it's called, I know the conversation won't move on to twin humbucker pick-ups and adjustable truss rods.

Lots of guitarists—real guitarists, who love and adore the instrument—have names for their favourite guitars, did you know that? I mean, lots of them. Here's a short list:

ERIC CLAPTON	"Blackie"
WILLIE NELSON	"Trigger"
PRINCE	"Cloud"
GEORGE HARRISON	"Lucy"
NEIL YOUNG	"Old Black"
JERRY GARCIA	"Tiger"
JIMI HENDRIX	"Betty Jean"
KEITH RICHARDS	"Micawber"

These people (yes, they're all men. I couldn't find a single example of a woman giving her guitar a name) love their instruments—they really, really love them. And love stories are beautiful, aren't they? Me, though, I've spent a lifetime with guitars, and I just don't have that story. All I have is a muttered "We aren't in a relationship.

view of obsessive guitar enthusiasts. The ones who will buy an amplifier "just like Clapton's" and a guitar "just like Clapton's" and even use a plectrum "just like Clapton's" and then return them to the shop complaining that when they played it, it "didn't sound like Clapton."

So Christian thinks that the guitar I used on that first US tour was an Ibanez, and specifically a Bob Weir signature model, identified by the specific narrowing of its distinctive bridge and tailpiece. He is also desperate to get members of the Grateful Dead mentioned in this book, so I'm taking that information with a pinch of salt. Christian likes to tell stories about his eccentric older partner in the guitar shop, "as mad as a box of frogs with his own lingo—a cross between Jerry Garcia and Austin Powers…he once smashed up a customer's guitar in front of him and threw it in a skip out the back."

We're just friends." I imagine I'll get to a point when I'll walk away from guitars altogether, and then I'll be able to look my guitar in the neck and declare, honestly, "... It's not you. It's me."

A little kid goes to his mum and says,
"When I grow up I'm going to be a guitarist."
His mum smiles and shakes her head.
"Well, honey, you can't do both."

No. 5

Lou Watts and Alice Nutter

Every woman knows what I'm talking about when I say girls grow up with a desire to please, to cede their power to other people.... Everyone knows about the sometimes aggressive and manipulative ways men often exert power in the world, and how by using the word empowered to describe women, men are simply maintaining their own power and control.

—Kim Gordon, *Girl in a Band*

Kim's right—that word *empower* is a slippery word that makes us think it's about taking power, being powerful, when what it really means is to be given power. Here, I'll allow you to be powerful (because I am more powerful than you). It's a bit early for semantics and etymology

on a freezing winter's day in Wortley, a nondescript area of west Leeds full of tightly packed housing estates and rush-hour rat runs. It's where Alice Nutter lives, in an old Yorkshire stone manor house that's been divided into three separate houses, an anomaly in the middle of the semi-detached street, with a view out of the back window right across the valley to Leeds United's stadium Elland Road. On match days you can work out the score from the crowd noise that reaches Alice's back garden.

Alice puts on the kettle in the same movement as she's just opened the door, as if it's a nonnegotiable part of entering the house. Lou is there already, keeping her distance due to an ongoing serious illness that means staying out of the way of people with coughs and colds. She seems to be taking it all in her stride, though,

[187]

swapping questions and stories about partners and friends and (grown-up) kids. I've known these two (and yes, a lot of the time they come as a pair) for my entire adult life, so a cup of tea and a catch-up isn't unusual, but now I'm here on a mission to label them as Disrupters and consequently they're curious and faintly amused. Which makes sense, since our relationship is one of those deeply embedded friendships that doesn't need working on and doesn't need working out, it just is. It's habitual, perpetual, a coat or a scarf you've had forever, that old wind-up clock that sits on the mantlepiece and chimes on the hour. I can't imagine these two not being there.

I met Alice when I went to Burnley Technical College for a year to take a foundation course in art. It was the best year of education I ever had—seventeen years old, given a year to have a go at all sorts of creative challenges, a year of playing—sculpture, life-drawing, textiles, printing, graphic design, stripping naked and singing songs around a piano as some sort of conceptual idea. One day, a couple of lasses (they were lasses then. Not girls, not women) came into our classroom, poking around and somehow being overtly superior; they'd already been at the college for a year and saw us lot as cowering freshers. My makeshift

working cubicle was decorated with a woodwork apron pinned up in the shape of a crucifix with a newspaper cutting next to it, by way of explanation:

DRUGS
KILL
PUNK
SID

Alice and her mate started asking me questions, mostly variations of *Are you a punk?*, before sauntering away. I can't say I liked her. I was alarmed by her self-confidence, her gobby assertiveness. I was young, I didn't know lasses like Alice. Over the next year I kept

seeing her around, and we ended up in the same social circles, talking at local punk gigs. It was another two years before we were thrown closer together when she started a relationship with one of my best friends, Midge. She was still assertive, still gobby, but as well she was really funny and she cared about people, with an instinctive urge to skip the small talk and ask about how you were feeling. Feeling? I was nineteen, I was in a band, I'd dropped out of college, my only feeling was that I felt great.

Lou, I'd seen at the Railway Workers' Club in Nelson, Lancashire, our weekly punk rock hang-out. It was at the Railway Workers' that we learned how to craft and grow an organic community, a big bunch of people who loved to gather and put on gigs and make zines, a buzz of shifting and spreading activity that splintered and grew into a "scene." Hundreds of young people clumsily building a do-it-yourself world we could live in. Lou belonged to one of those shifting subgroups within that scene, but (like everyone else, it seemed) I fell in love with her and wanted to find out more about her. What most of us shared, away from the music and all that malarky, was a sense of our place—a shared history of terraced houses on post-industrial Lancashire streets, horizons full of fells and moorland, colour TV with three channels, new-build estates with neatly mowed postage-stamp gardens, struggling football teams and a belief that somehow, someday soon, we could escape what we saw as the small-mindedness of our parents' generation.

After a summer spent travelling around continental Europe on an old bus and busking Undertones songs, some of us (me and my mates, all *lads*) returned to move into an empty and near-derelict house in the west of Leeds, took a deep breath, and invited Lou and Alice to move in. Up until that point, music for me—or at least, pop music, rock'n'roll music—had been boy music. Yes, there were girls in bands. There were even a handful of all-girl bands, which I loved. But the bands I was in, they were for boys, and they came with a boy's eye view of the world. It was the same with the house—I'd lived with four other boys in a shared student mid-terrace in the heart of Leeds 6, the city's student ghetto. We lived on endless bowls of cornflakes and catering packs of frozen beefburgers, all kept separately and marked with our names.

And this move, from boyworld to realworld, is where the Disruption came. This was where our band,

Chumbawamba, became something more than a group of lads with crap guitars, this was where our hopes and dreams ("Maybe one day we'll get to make a record!") were suddenly mixed, beautifully, with a sense of shared commitment to something better and more long-lasting. What Alice and Lou brought to our huge-but-rickety squat wasn't simple "femininity" but organisation and purpose—as Lou put it, "If you're going to do something, do it properly."

We sit in Alice's back room (or front room, I'm never sure with Alice's house), walls literally lined floor to ceiling with bookshelves, along with one of those sliding ladders you can use to get to a book on the top shelf. It's all frighteningly neat and tidy. I imagine the books are ordered according to the standardised Dewey method as fetishised by librarians everywhere. My thank you for Alice and Lou's disruptive intrusion into my young lad's story goes almost unnoticed as the pair of them trade anecdotes like an old couple (which I suppose they are, in a sense). This particular disruption happened in a tumble of changes, all based around the simple fact of having a huge empty house and realising this was our "project", as Alice calls it:

"I don't think we would have lasted long without Southview House and communal living as a project.

We were trying to see what happens when we pool our resources...that took up most of our time. Not being a band, just living. And I think that was the making of us."

Out went the frozen beefburgers and in came nightly shared cooking for nine or ten people gathered around a large kitchen table that Dunst built from stolen scaffolding planks. Out went scrimping around for cash to pay the landlord and in came shared responsibility for rewiring the electrics, clearing the drains and fixing the shared van. Alice and Lou were absolutely central to all of this (to the extent that Lou studied to be a mechanic and worked in a local garage. The feet sticking out from under the van's engine were hers):

"Nothing was beneath us.
I didn't enjoy fixing the van, but it needed doing.
Somebody had to."

It quickly became obvious that rock'n'roll, even at the more untypical gender-skewing punky end of it, was run and populated by men, and that our level of familial domesticity looked weird. That probably helped us too—helped us to be weird and interesting and not like everyone else. Alice says, "The fact that I didn't have a lot of musical talent was in a way a good thing, because

it made me think, what else can I do that needs doing? Because I wasn't musical, I wasn't indispensable, so a bit of me was like, well, to fit in with this group of people I have to do things that aren't musical."

Once, years later, we were on a tour of Europe—a monthlong trawl around the medium-sized concert halls of Switzerland, Germany, Austria, Italy, everywhere, nowhere and somewhere *Further*. We bumped into legendary thrash-metal band Napalm Death in a forgettable city where we were both playing that night. They were hungover but friendly, and we arranged to meet up the following day. Alice was asking the members of the band about how they "got on" after weeks on the road (you just knew that within half an hour she'd have one of them tearfully confessing a heartbreak...) and she cheekily asked to check out their tour bus. (Tour bus envy. It's a thing.) Five minutes later she returned, horrified at the sights, sounds and smells of your average all-male tour bus, seats strewn with discarded cans, pizza boxes and underpants. "I asked them if there were any females on the bus. They just sniggered and said, 'Ha, yeah, some nights there are...'" What we'd taken from this was how freakishly organised we were, as a band and as a bunch of people. That had

happened when Lou and Alice came along. They stopped us thinking that being in a band was an excuse to be irresponsible. Blimey, we were the band who, instead of scrawling graffiti across dressing-room walls, once bought a can of white paint and decorated a German backstage area—as a cross between some kind of silly art prank and a desire to confront the cock-and-balls sexist crap that seemed to dominate every band room.

None of this communal thinking fitted into the rock'n'roll story that I grew up with and loved. I picture The Clash onstage, legs wide apart, Strummer hollering into the void like a mad dog, Simenon's bass slung loooooow. And I put that iconic image next to the memory of Lou's feet sticking out from under the band van, in our muddy back garden, with only an occasional swearword for a soundtrack.

As I leave Alice's house, edging yard by yard towards the door, the conversation carries on. I imagine Lou and Alice are still sitting in that room now, talking not about who sang which harmony or who played the bassline, but about how we used to live, who fed the dog, who mended the broken toilet, who planted the potatoes. Well, it needed doing. Somebody had to.

But I Digress

Everything's going along as usual and then all shit breaks loose.
 —Joan Didion

British comedian Ronnie Corbett was five-foot-zero and fitted with oversized spectacles. He was more a comic actor than a comic —he didn't write his own material, and a fair amount of his comedy was based on his stature. But at some point in his TV career—while playing opposite Ronnie Barker in *The Two Ronnies* —his scriptwriters hit on the idea of sitting him in an oversized chair and allowing him to tell a single joke with a five-minute deadline, within which he could digress as much as he wanted. His catchphrases were any linguistic expression used to divert the story somewhere else—

> Incidentally
> Which reminds me
> Speaking of which
> By the way

—after which, and approaching the five-minute limit, Corbett would bring the joke back to its patiently waiting punchline.

What Corbett was doing unwittingly imitated great satirist stand-up Lenny Bruce, in making digression into a story in itself. There are recordings of Bruce onstage towards the end of his (short) life, drunken ramblings that veer between jokes and analyses of the law. The recordings show how Bruce became so entangled in his continuing drug use and the ever-present threat of arrest and imprisonment under obscenity laws that he forgot that

being a stand-up comedian meant telling jokes and making the audience laugh. Instead of delivering punchlines, Bruce allowed himself to say just what was going around in his head, tortured sentences tumbling out along with Yiddish exclamations, snorts of laughter and snatches of impersonations (often of judges). And here's the thing: what made Lenny Bruce's multiple digressions more powerful than Corbett's was that Bruce often didn't return to his original, opening point, whereas Corbett always satisfied that audience yearning for the punchline.

Bruce's punchline was, sadly, being found dead on his bathroom floor after a heroin overdose; the cops allowed New York press photographers to come in and get shots of his naked body splayed on the floor. His onstage dope-fuelled digressions would no longer have to be monitored, registered, assessed and held up in court as an assault on decency. But what he gave the world was an insight into how comedy could be in and of the world outside the theatre, could tell the truth, and could stand up to hypocrisy and bigotry.

Digression can act as a sort of soft disruption, a gentle stroll away from the expected path. There's that lovely old joke (in song form) that is sung by John Gorman, one-third of comedy band The Scaffold, which begins with the familiar acoustic picking of Ralph McTell's famous "Streets of London":

Let me take you by the hand
And lead you through the streets of
Llanfairpwllgwyngyllgogerychwyrndrobwllllantysiliogogogoch

That's the name of a town in Anglesey, Wales, a town known almost solely for its name, which was stretched, added to and
e l o n g a t e d
in the nineteenth century as a way to develop the area as a tourist attraction. The most popular attraction for the two hundred thousand visitors who make a detour to the town each year is the local railway station with its track-side sign.

For the Situationists in 1950s Paris, digression became a revolu-

tionary act. Walking the streets of Paris aimlessly, without a map or a plan, became a technique to combat the dreary everyday routines of the modern world. This wandering became known as the *dérive* (meaning simply "drift") and became part of Situationist theory alongside a critique of life as "the society of the spectacle"—a world where everything was commodified, including our lives. The *dérive* was a direct descendant of an earlier Parisian idea developed by the poet Charles Baudelaire in the nineteenth century. Known as the original *flâneur*—French for "roamer"—Baudelaire wandered the avenues of the capital as an observer rather than a participant, celebrating the art of going nowhere in particular.

Today we have the similar concept of psychogeography, wandering the city in an attempt to understand the psychology of urban space—that is, refusing to follow the rules of navigating around the modern city, by following your nose and not the signs. At this point we can picture three figures in a grey urban landscape, the derivist, the flaneur and the psychogeographer, ambling separately along back streets and across city squares, hands in pockets, whistling, until they unexpectedly bump into each other where their three unplanned paths meet, atoms bouncing off each other with electromagnetic force, heading off on their new trajectories.

Reading set texts at school, children mistrust the English teacher's obsession with finding meaning in every line. *Sir, why do we have to "dissect" Wilfred Owen? Why can't we just read it?* But then we persevere (because we have to, because we have exams, because blah blah blah) and we can see that in each line of text there's a discussion to be had, inside your head, a series of digressions that lead outwards from the page and then back again. We read the short opening stanza of Owen's "Anthem for Doomed Youth" and we conjure up a worldful of images, we find out what *passing-bells* are, we hear the rifles rattling as all the *t*'s zing around our brains (or between teeth and tongue if we're reading out loud), we puzzle over *hasty orisons*. And all of this, hopefully, eventually, sooner or later, in the course of time, someday, ultimately, we come to see as the best kind of digression, all of it making the journey through the text as important as the arriving at the end.

What we get from these digressions, whether by poets, artists, novelists or pint-sized comedians on TV, is a sense of our lives, because that's what happens to us all. Walking up through the early-morning woods behind my house, heading for the summit of the hill, I see a deer before it sees me. I stop dead in my tracks. The deer sniffs and looks around. Five seconds of silent alertness, then it senses I'm here and Usain Bolts through the trees and leaps effortlessly over a high stone wall and out of sight. The walk was about me, and then suddenly it was about the deer, and even when I get home it will still be about the deer...that's the part of the story I'll want to tell people. The beautiful digression.

From A to

> Digression is the sunshine of narrative. When we start to
> talk, things fall out of our pockets. We talk, and the sheer
> power of continuity and serendipity enlivens a conversa-
> tion. You go by many roads to arrive at some point. The
> side road and the back road are often so much more
> interesting than just straight on.
> —Paul Holdengraber

In the world before everything was available, all the time, right now, there was a new thing called *The World Wide Web*. It came with its own in-built digression system we called "surfing." Every page on the web came with a series of links, jumping-off points to related or similar pages, creating a network of websites that meant you were encouraged to hop from site to site with no particular endpoint. For a while, this felt like

This was the digital equivalent of the French flâneurs and the Situationist wanderers, a loose and aimless series of twists and turns that could throw up new ideas, new dis-coveries, revelations or dead ends.

And then, over the years, the dreaded algorithms took hold, and the peculiar joy of "surfing the web" became an exercise in following the trail that led to the sale. I'm not sure how long that period lasted, that time where we believed that the internet could somehow be dem-ocratic, open, free of market forces…

DOM!

it was probably a handful of years, if that. And then the digital technology corporations rolled out their plans for our future, and we all sold our souls to Google Maps and online shopping.

But—

Sales of books in the UK and US—actual books with actual pages, like this one—are now increasing dramatically. A younger, smartphone generation are buying books, going back to the old-school idea of turning pages, and to the physical connection of having a well-thumbed book lying around the house waiting to be picked up and loved. And I quote, from somewhere:

> As of 2022, over 788 million copies of print books are sold in the US in one year. While this figure presents a drop from a record-breaking 2021, print book sales are still well over pre-pandemic levels.

Mark Hodkinson is a writer and friend who we'll meet here briefly, in his neat-and-tidy house in Littleborough, near Rochdale, before digressing to somewhere else. We'll rejoin him later in the chapter, after we've briefly visited Primo Levi and *The Very Hungry Caterpillar*. Mark invited me round to his house to talk about books. Mark is an obsessive collector of books. His sort-of autobiography is called *No One Round Here Reads Tolstoy* and is both a story of growing up in a place where no-one reads and also a beautifully written love letter to his own collection of books. He has, according to what I read in *Tolstoy*, around 3,500 books. Mark's house is near enough to Rochdale FC's ground that he can still feel attached to it by an invisible but taut elastic band. And it's also far enough from the ground that he can, sometimes, see the world beyond his upbringing. I say this about seeing the world because the story of *Tolstoy* is a story of escape. Books as a way of adventuring, discovering, navigating, finding places that weren't *here*.

I sit in Mark's cosy living room drinking tea and chatting easily about bands and football and writing, when I suddenly, secretly, realise that there couldn't possibly be 3,500 books in this house. It isn't big enough, surely? Admittedly I've only seen the downstairs. Actually, only this room, the kitchen and the toilet. But unless his partner, Kellie, has given up the entire upstairs of the house to

such a huge collection, I suspect Mark has them all stashed like bodies in storage units. I won't show Mark this passage before this book goes to print, because he'll have a good explanation that will destroy my next book idea: *The Mystery of the Missing Books* (Faber & Faber, £14.99 hardback).

Primo Levi, the inspirational Italian writer and Auschwitz survivor, had a way with books. He kept a large collection which he constantly lent out to people. Visitors were encouraged to take books, read them and replace them with other books. It was an ad hoc library, a sort of worldwide web of book borrowers, a circulation of ideas. When I started to read Levi's books, I realised that here was a writer who was informing the way I thought about life. This man survived the most inhumane of ordeals but came out with a sense of dignity and purpose—and a view of humanity that wasn't crushed by the horrors he had seen and endured. Levi grew up in Mussolini's Italy, with the growing threat of fascism that threatened his knowledge of the world as a scientist, a chemist:

> Dissension, diversity, the grain of salt and mustard are needed: Fascism does not want them, forbids them, and that's why you're not a Fascist; it wants everybody to be the same, and you are not.

Levi's opposition to fascism was an opposition not just to its systematic brutality but to a regime that despised diversity, despised it to the point of wanting to physically eliminate it, person by person. The opposite of fascism isn't socialism—it's *difference*. Being different, being other. Comedian Lenny Bruce shouted and screamed it from the stage every night: **"YOU NEED THE DEVIANT! DON'T SHUT HIM UP! YOU NEED THAT MADMAN TO STAND UP, TELL YOU WHEN YOU'RE BLOWING IT! THE HARDER YOU COME DOWN ON THE DEVIANT, THE MORE YOU NEED HIM!"** The deviant is the one who interrupts the story. Any parent will know what it's like trying to read a bedtime story to your wide-

awake child who won't allow you to simply read the damn book, flip over the pages and get to the end so you can slam it shut and say, "Right! Time for lights out!"

"One Sunday morning the warm sun came up and—pop!—out of the egg came a tiny and very hungry caterpillar. He started to—"

"Pop."

"Yes, pop. He popped out of the egg."

"Pop like a balloon."

"Like a balloon, yes. So he started to look for—"

"Pop like a balloon at a party, a big red balloon."

"A big red balloon, yes. He started to look for some—"

"I had all colours of balloons at my party."

"You did."

"Red, blue, yellow, green."

"So he started to look for some food—"

"Orange. Purple. And some long ones. Can we have balloons even when it's not a party?"

As the adult you're thinking, I'm tired and I just need to get to the end of *this* story, the story about the caterpillar—but to the wide-awake child, the caterpillar story has been joined by another story, a side story, a story that's bigger and more colourful and full of more balloons than the original story could ever blow up. Because a child's imagination is perfectly capable of following a story to somewhere the author hasn't written, a somewhere that mingles with memory and dreams, a structureless, meandering somewhere without an ending. The holy mother of all digressions. And the child has had this book read to them many, many times, and maybe they're thinking that this time the caterpillar might possibly—just possibly—*not* turn into a butterfly…

Tommy Ward was convicted in 1984 in Ada, Oklahoma, of a murder he didn't commit. Despite several appeals and retrials, Ward has consistently been knocked back, and he remains in prison while the Oklahoma criminal justice system does everything in its power to keep him locked up. Ward's transparently unsafe conviction has become well known through a book by author John Grisham, who continues to publicise the miscarriage

of justice. Grisham is a writer of fictional legal thrillers and has had thirty-seven (and counting) consecutive number-one best-sellers—his book about Tommy Ward's case is his only nonfiction book to date. Ironically, Grisham's fictional crime novels follow an accepted pattern of beginning, middle and end, yet his 2006 book about Tommy's case—*The Innocent Man*—is singularly devoid of an ending. Ward remains in prison. It's an awful reminder that real life refuses the standard narrative.

Tommy Ward, in a phone call from prison in Hominy, Oklahoma, tells the story perfectly:

"You know, whenever you see a movie on television, they always get the right guy. And if they've mistakenly got the wrong guy, it winds up at the end, y'know—they get the right guy...

"It's not like in the movies, you know. In this field, y'know, they get the wrong guy, and it's just never-ending."

•

Liminal space — and I only found out what it meant a handful of years ago, as one of those terms people toss around in academic arts circles — is non-place, the space between things. A corridor, a waiting room, a lift. Liminal spaces are the spaces that bridge places. Physical, hollow erms. Spaces measured in physical distance. There are theorists who will tell you that liminal spaces are disorientating, that they trigger our fear of the unknown. That as humans dependent on predictability and security, we find their nothingness unsettling.

There is also the idea that these spaces can be emotional voids. Like the space between having a problem and solving it, or between sending an email and getting a response, or the space between pregnancy and birth — spaces measured in time.

The trick is to give liminal space meaning, to make non-place into a space to pause, breathe and relax. To stop being constantly busy busy busy. I know a bit about this because I had to adjust my life after my one and only panic attack several years ago, which happened at a point where I was juggling so many jobs and ideas that there was literally no space to think straight and I thought I was Superman and could do everything but couldn't really which is a problem I've always had and in this case it was something to do with ordering a specific colour of chalk from the internet for a project I was doing at Somerset House in London where we were gathering people to sing from all across the country and I had the song to finish writing and it was when Maisy was doing her A levels and I remembered I had to

send a new draft of a play to be proofed but there were some amendments to make on it and I hate missing deadlines I always try to make sure to hit them even if it means staying up all night to get it done and that's when it all began to get fuzzy around the edges and everything was overlapping and parts of my life and work were fighting for territory with other parts of my life and work and the whole thing became a tangled garden of weeds and suddenly I was driving along the road from Phil's house somewhere up near Ilkley Moor near to Dick Hudson's and gasp gasp gasp what's this what's going on and had to pull over. And stop. And then I sat and panted breathlessly for ten minutes.

That's what happened, and I asked around and found out what a panic attack was and that it wasn't unusual. And so I had some tiny insight into what people feel when they're stressed out and worrying and panicking. It was a long time coming, and it took a while (and some prescription drugs) to sort out. The solution for me was to rebuild my nervous system, gradually over the next few months, not slowing down but instead polka-dotting my calendar with spaces. Organised spaces, time-out spaces and chanced-upon spaces. I won't list them, everyone has to find their own. But I imagine a lot of you will know what I'm talking about.

So here's some space. Have a cup of tea, take time, and treat your own liminal space as the blank pages between chapters.

B

Little black marks on wood pulp.
—Ursula K. Le Guin

Back to Littleborough, and to Mark Hodkinson, who apart from writing books about books also knows about ghostwriting. Before getting the train over to meet up with Mark, I looked up how much it would cost to have someone ghostwrite my own autobiography. A twenty-thousand-word book by "a premium writer," based on ten hours of interviews, costs around £6,500. (By comparison, the book you are reading right now has around ninety thousand words.) Let's face it, that's a short book. But it sounds relatively cheap to me—the task of listening back to, and annotating, ten hours of interviews alone sounds like hell. And for all that work, the writer doesn't even get their name on the cover. Top ghostwriters who author bestsellers by famous politicians, sportspeople and royals earn more like £100,000 per book—but still struggle to negotiate their name onto the cover. The front sleeve of the book *Spare* is filled with a close-up of Prince Harry's face, below the words "Prince Harry." Nobody wants to see the name J. R. Moehringer on there—least of all the publishers, who paid Moehringer around £1 million to write the thing.

Dale Hibbert was the original bass player for The Smiths, a man whose story is told in the book *Boy, Interrupted*, an autobiography of a fascinating up-and-down life mixed with tantalising tales of growing up at the heart of a Manchester music scene that spawned (among others) Buzzcocks, The Fall and Stone Roses. And yes, The Smiths—who wouldn't want to read about someone who one week was in a rehearsal room with Morrissey and Marr, the next out on his ear? What must that feel like? A five-star review on Amazon says:

Written from the heart and a very difficult book to put down. The writing pulls you in and Dale does not pull any punches, he writes it as it happened.

Which is all well and good, except that Dale didn't write the book, Mark Hodkinson did. He made a good job of "being" Dale though, clearly; Mark writes it as it happened (to Dale). Mark started out as a local newspaper journalist before starting his own book publishing company, all the while writing, writing, writing. He's a passionate music fan and has played in several bands. So when the idea came up to write Dale's story, Mark knew he could bring an honesty to it that's uncommon in ghostwritten books.

"Dale has Asperger's, which we write about in the book. He couldn't have written that book. Because, with the Asperger's, the grammatical and mechanical accuracy is beyond his reach. I've created a framework, as ghostwriter, and I've sat Dale in it. I would never use a word that Dale wouldn't use in speech. He would never use a word like 'profligate' when he could say 'wasting money.' So it was like … fabricated, but in authenticity. My safety net was always, 'Well, he's going to read it and [has to] approve it.' But you do always impose your own sensibilities."

Ghostwriting is still publishing's big secret—sources claim that at least 60 percent of nonfiction is written by ghostwriters, most of whom won't even get a mention in small print on the flyleaf. Emma Donnan, a professional ghostwriter, claims that the "ultimate compliment" is when the reader believes the book is written by its subject. I've already discussed Keith Richards's so-called autobiography, how its main purpose is to retell the myth. And as with most autobiographies, if you read closely and carefully, you can begin to hear that writerly style, you can hear the way the taped interviews have been decorated, fluffed up and aggrandised.

Many years ago I managed to acquire a VHS copy of the infamous (and permanently banned) Rolling Stones film *Cocksucker Blues*. The film was made by the legendary American photographer Robert Frank, and it captures the Stones on their mammoth

1972 tour of the USA. Seeing through the badly copied fuzz of my video copy, it's obvious why the Stones had refused to give permission for the film's release; it's just too real. A rock band completely divorced from everyday restraints, a study of outrageous indulgence. In many ways it's quite beautiful, even with all the privileged sexist ugliness of a bunch of young men being pampered. The time between concerts (and of course the concerts have their own overplayed indulgences) is an ongoing haze of groupie sex on private planes and buses, backstage cocaine (lots and lots of it) and wasted time in recording studios. There also seems to be a hell of a lot of lying around nodding out on hotel beds, with or without heroin needles. Of course, in hindsight, the Stones were never going to allow the film to be released—because, apart from the numerous illegalities on display, it captures not the rock mythology but the dirty, scuzzy, ridiculous banalities of drug use and overindulgence. These outlaw rock'n'rollers, when they're on drugs they're as dull as the rest of us.

Instead, the band rush-released a concert film called *Ladies and Gentlemen: The Rolling Stones*, a record of the same tour shorn of any context. And I mean, *any* context: even the audience aren't shown, this was simply a document of a live stage show, which in itself is remarkable as a document of a rock band playing at their peak. Which is all a roundabout way of saying that the ghostwriter's job is all too often to retell the myth, print the legend, maintain the fiction. There are notable exceptions, but the indefinite shelving of *Cocksucker Blues* is a reminder of what happens when those outside the subject want to get too near to the truth.

R.L. Stein, author of the *Goosebumps* series of children's books (and subsequently the long-running TV show, seventy-four episodes and counting), wrote the first collection of stories but became overwhelmed by trying to keep up with the popular reaction to them, so he hired a team of ghostwriters to churn out story after story, all under his name.

Most scholars of ancient literature acknowledge now that the Bible is a collection of ghostwritten stories, and point to the fact that the New Testament apostles, not being part of an educated,

upper-class elite, would not have been able to write. Literate, scholarly ghostwriters created the Gospels many years after the deaths of the illiterate fishermen that were Jesus's disciples. This, of course, is disputed—not least by political leaders who know that invoking the Bible is a good way to keep a steady hold on those who profess to be Christians. Donald Trump, for example, surely a man who exemplifies the idea of myth-over-reality. Here's an extract from an interview Trump did with the TV show *Bloomberg* in 2020:

> Interviewer: You mention the Bible, you've been talking about how it's your favourite book ... I'm wondering what one or two of your most favoured Bible verses are?
>
> Trump: I wouldn't want to get into it because that's very personal. You know when I talk about the Bible it's very personal. I don't want to get into specifics.
>
> Interviewer: Even to cite a verse you like?
>
> Trump: No. I don't want to get into it.
>
> Interviewer: Are you an Old Testament guy or a New Testament guy?
>
> Trump: Erm ... probably ... equal. I think the whole Bible is incredible.

When Trump reacted to the ongoing riots and disturbances following the murder of George Floyd by standing defiantly for a photo-op outside St John's Episcopal Church with a Bible in his raised hand, he was simply reinforcing a myth that, to his support-ers, was a mixture of righteousness, faith and deep-seated conserva-tism. He didn't need to be able to quote a single verse of the book he finds so "incredible." The book as a symbol was enough.

Personally, I think any book—and especially autobiographies—that are ghostwritten should come with a front-cover declaration of such. Can you imagine the Bible coming with a **BOLD-TYPE NOTICE** that **"the authorship of this book is disputed"**? Part of

ghostwriting is, of course, to keep the second-hand writing a secret. If you knew that Michelle Obama didn't *actually* write her number-one best-selling memoir, you might not hold its inspirational messages quite as dearly. The blurb that accompanied Obama's book says it is "a work of deep reflection and mesmerizing storytelling." It even says, "telling her full story as she has lived it—in her own words."

When he was just twenty-six, Mark Hodkinson was commissioned to write a biography of Marianne Faithful, titled *As Years Go By*.

"I think people skipped the more mundane chapters. It wasn't ghostwritten, it was a biography. But the only thing people ever asked me about were the drugs, Mick Jagger and the Mars bar. It's really reductive. And I say that I tried to provide an insight, talked to the kids she was at acting school with, her youth club…but despite all your efforts, when it's boiled down, you look at the blurb on the back [of the book], and you see that the publishers reinforced the stereotypes."

Mark is a huge fan of The Fall, and we briefly discuss the book *Renegade*, an autobiography by the band's lead singer, Mark E. Smith, that is ghostwritten by Austin Collings. The book is fascinating, not so much as a straight autobiography but as an exercise in working out where Smith's voice ends and Collings's begins. There's a routine involved in ghostwriting an autobiography where the writer sits down with the book's subject and records a dozen or so interviews, gleaning as much as they can of both the facts and chronologies along with some sense of character, attitude, emotional connections—the *voice* of the subject. With 2008's *Renegade* it becomes clear quite quickly that Smith (as was his wont, any time of day) was interviewed in the pub (uh-oh) and that his rambling gets steadily less coherent and more belligerent. Turning the reminiscences of a drunk, grouchy old man into a readable book must have been a job and a half.

Not long after the book came out, Mark E. Smith wrote to a friend:

So glad you enjoyed the book, 'Rubbish,' by me
+ ghost writer. Funnily enough, six hours
after I saw you I hit him — poured beer
over him. I'm not really designed for this
literary world. I mean — have you seen
the chapter where he invokes
the Tarot??? Not my idea!!'

Perhaps the lesson there is that it's better to tell the truth than to
second-guess what "the public" want. The press and cover blurb
that accompanied Victoria Beckham's 528-page autobiography
Learning to Fly talked of how Victoria saw the film *Fame* at an early
age, a film that inspired her to seek stardom. The book's PR spin
said:

"A line from the film's theme song stayed with her—'I'm gonna
live forever, I'm gonna learn how to fly.' With this amazing book
she gives us the chance to fly alongside her on her journey from
lonely teenager to international star."

In an interview with a Spanish magazine not long after the pub-
lication of her book, she admitted that "I've never read a book in
my life. I just don't have the time."

●

Storyboard

Football is a game of mistakes.
—Alan Hansen

Some time ago a friend, Burnley Pete (he's called Pete. And he's from Burnley), rang me up to let me know that the TV quiz show *Mastermind* that evening was to feature a contestant answering questions on Burnley FC. I watched it and could only answer four or five of the twenty questions asked on the club. My club. My score confirmed what I already knew: that my love for football might be avid, or dedicated, even loyal—and it's certainly passionate—but it isn't obsessive. It isn't just that I have a bad memory for football's vital statistics—opponents, scorelines and league positions—either. It's that I remember other stuff instead, stuff about football that they wouldn't ask me, should I ever end up on *Mastermind*.

I remember games where things happen that transcend football's accepted narrative. In the late 1980s my favourite player at Burnley was a quick, popular, Manchester-born striker called George Oghani. So much so that when Burnley played in the (illustrious, renowned, esteemed) Sherpa Van Trophy final at Wembley, me and my mate Dunstan (who used to come on some of the matches with me) painted a huge banner with the lyrics to the Burnley fans' George-specific chant: it read simply, in claret-and-blue paint, "OOH! GEORGE OGHANI!"

A season after that Wembley final in which we lost to Fourth Division rivals Wolves, George was caught in a department store in Manchester allegedly trying to steal some shower curtain fittings. He had under his arm an ironing board, which he'd paid for. When accosted by a security guard, George apparently pushed him aside and scarpered down Deansgate with the ironing board under his

arm. Unfortunately for George, he'd paid for the board with a cheque, and so was traced, charged and fined. This incident endeared him even more to me and to the Burnley fans—T-shirts were produced featuring a cartoon of Oghani in full Burnley kit, taking a shot at goal with the ironing board held tight.

Not long after that, local newspapers reported a training-ground bust-up which involved goalkeeper Chris Pearce suffering a fractured jaw after being punched by George, who was summarily sacked. At which the point this story might end with a shrug and a whimper, had George not gone on to sign for coastal town Scarborough FC, who Burnley played in the 1991 season. Dunstan and me travelled to watch Burnley at the away game at the McCain Stadium—McCain's were a local manufacturer of frozen chips and the team's sponsor, so the ground was known to many as *The Theatre of Chips*. A wind-blasted shell of a place plonked well away from Scarborough's seaside attractions, the stadium was typical of a time when football was trying to modernise itself, awkwardly, with plastic pitches, bans on away fans and football grounds sited next to DIY stores and ring-road junctions.

I remember it was freezing. Still full of early-season optimism, several hundred Burnley fans made the trip to the Yorkshire coast and took up noisy residence behind the goal, where we discovered that George Oghani would be leading the line for Scarborough. Cue a series of songs featuring ironing boards, courts, broken jaws and shower curtain rings. As the teams took to the pitch, the songs got louder and funnier, dying down gradually through a first half that saw Scarborough take an early lead. Oghani then made a cross for the home side's second goal before giving a defiant wave towards the travelling Burnley fans. He might have assumed he'd shut everyone up; but no, a few fans continued to sing until just before half-time, when, halfway through a rendition of "Does your ironing board know you're here?," Scarborough scored a third.

The smile on Oghani's face was unforgettable. As the whistle went for the break, around half of the Burnley fans grunted their disgust at being 0–3 down and left the ground, off to play in the seafront amusement arcades and eat fish and chips.

A sense of schadenfreude hung heavily on the hunched, freezing shoulders of the remaining fans. Now there weren't even enough of us to afford any shelter from the gale, and since the most vocal rump of the fans had disappeared down to the promenade, we were left to shiver silently.

The second half saw a change in Burnley's fortunes, with striker Ron Futcher grabbing two Burnley goals. But no, this isn't a story of a great heroic comeback; George Oghani sealed victory for Scarborough with a headed goal, which he celebrated by running, arms out wide and wearing a huge grin, towards the travelling Burnley fans. Which would be memorable enough without the final peculiar surprise minutes later of Oghani lashing out at an opposing defender and being promptly sent off by the referee. The few remaining Burnley fans took what little comfort we could muster by serenading the departing Oghani with a rousing chorus of "Ooh! George Oghani!" as he trudged, dejected and ejected, from the pitch. Dunst and me drove away from the ground in our rusting brown Vauxhall Chevette as discombobulated as, well, kids returning from the seaside trying to balance sugar high with disappointment. Yes, our team had been comprehensively beaten, we'd stood for two hours on an open terrace in the chilling sea-breeze, and we'd not even had a glimpse of the beach. But what we had was a great story.

•

Alastair Campbell was Tony Blair's spokesman and campaign organiser, a man who came to embody the essential quality needed for that role: being a master storyteller. And Campbell's biggest story was, without doubt, the story of the Iraq arms dossier. Here, briefly, is how it went down: Prime Minister Tony Blair and US President George W. Bush, after several meetings (at which, we later discovered, they prayed together for guidance on policy decisions), jointly prepared for war against Iraq by making public statements about that country's ability to not only manufacture nuclear weapons but to give them the capability of striking the UK.

The "evidence" was prepared by foreign office experts in a top secret dossier, nominally under the guidance of Alastair Campbell. The original version of the dossier stated clearly that it would take "at least two years" for Iraq to acquire a bomb with nuclear capability. However, George W. Bush then gave a keynote speech to the United Nations declaring, "Should Iraq acquire fissile material, it would be able to build a nuclear weapon within a year." So Campbell then amended the UK dossier to read "within a year."

In a similar fixing of the facts, US Vice President Dick Cheney gave a speech stating that he had proof that Iraq had acquired special aluminium tubes for a nuclear programme. Again, the "proof" was retrospectively added to Campbell's UK dossier. What was happening here was that a dossier that amounted to a justification for going to war was being written on the hoof to fit whatever cock-and-bull story the Americans were spinning. The dossier, which played a crucial part in convincing the UK Parliament to launch an attack on Iraq, was later discredited; most of the claims in the "Dodgy Dossier" were later found to be completely false.

The war in Iraq dragged on from 2003 to 2011; calls for Campbell and Blair to face justice over the way they took the country into that war remain today. Sometime shortly after the end of the war, the popular TV political discussion show *Question Time* took place in a college in Burnley's Towneley Park. On the panel, apart from the usual spread of politicians and pundits, was then Burnley Football Club defender Clarke Carlisle and Alastair Campbell. Campbell, as a long-time supporter of Burnley FC, was only too happy to be appearing alongside a player who he regularly applauded from the stands at Turf Moor, home of the club. Happy, that is, until Carlisle was asked his opinion on Campbell's role in setting out the preconditions for war in the Dodgy Dossier. Clarke, soft-spoken and erudite, said, "I have a cousin serving in the armed forces. I honestly believe that the people responsible for sending our brave men and women to war should be held accountable if that war is found to be illegal."

•

One Saturday morning, [presenter] Adrian [Chiles] had someone in the chair who professed an addiction similar to his own: Alastair Campbell, the spin king, who loved Burnley FC. At the time, Burnley were doing well and looked as though they might get into the play-offs for a Premiership place. Everything went swimmingly until Adrian sprang a little surprise. While the sound was away playing news and weather, he told Campbell that he proposed to do a miniature version of the Mastermind [quiz show] specialist subject, and ask him three obscure questions about Burnley FC. Campbell went bananas and threatened to walk out, so Adrian quickly read him the questions [in advance, off-air]. Campbell answered them all swiftly and correctly. When they came back on air, Adrian announced the Great Fan Test and asked three "very difficult" posers, which Campbell, playing to the audience, laboured over but got right in the end. As he would.

—Henry Lightfoot, *Presenting Adrian Chiles and Christine Bleakley: The True Story of the Hottest Team on Television*

When Two Lads Meet

Once upon a time there was what there was, and if
nothing had happened there would be nothing to tell.
 —Charles de Lint

Liverpool, 2017
The lonely all-too-regular at the bar, seventy-seven years old
and counting down, is broken, drink-sodden and phlegmy.
He has a pint in front of him and the world behind him, and
he's only vaguely aware of the band in the next room playing
a more than competent version of "Ferry Cross the Mersey."
The pub's barely half full and there aren't enough bodies to
swallow up the annoying thump of the bass drum. He un-
slouches and walks through the dark-panelled pub to see
who's playing, catching sight of himself in the unpolished
mirrors, stumbling against a chair, unnerved by the ruthless
flashing of a fruit machine. He's wearing an old bootlace tie
and a dirty old teddy boy jacket. Not many of them left nowa-
days. Not originals anyway. Remembering his drink, he walks
uneasily back to the bar to get it, mistimes the sweep of his
arm and knocks the drink across the bar towels and pumps
and onto the floor with a shrill shudder of cracking glass.

Shit! he slurs.

The bar staff gather and fuss over the broken glass, pointedly
ignoring the old drunk to make sure he doesn't start begging
for a free replacement pint. He doesn't. Instead he wipes his
mouth with his cuff and orders another bitter and black.

Who's the band? he asks.

The girl behind the bar grabs a glass and shrugs, looking in
his direction without making eye contact. She's a student
working someone else's hours; they call it the Morgue Shift.

Sunday afternoon, a backdrop of fading daylight after the last of the morning Catholics has drifted away. *Some local blokes from up Stockton Road way,* she answers. *Well, that's what it says on the poster. Been doing the clubs for forty years by the look of 'em.* She pushes the fresh pint across the bar and collects his warm coins. He nods and says thanks; some days it's the only conversation he has. The band are playing an old Fats Domino song now, he can tell even before the vocal comes in. A *rat-tat-tat-tat-tat-tat-tat* piano riff over a walking bassline. He wanders over to the doorway of the music room, with its semi-circular bandstand and a smattering of people in the gloom paying scant attention. Hardened drinkers like himself who probably worked out that this was cheaper than feeding the jukebox. He begrudgingly pays a man on the door £2.50 (*Bleedin' rip-off, mate*) and sits at the back, alone. Everyone in here is alone. Except for the band, obviously.

The pub's band room is dimly lit and he has trouble picking out who's playing what. Drummer, bass player, saxophone, guitar. All blokes in their fifties, he reckons. Old pros who can crank out the old show tunes in their sleep. And over to the left of the tiny circular platform at an upright piano sits a neat, boy-faced bloke who's obviously a good couple of decades older than the rest. He's the one singing, setting the tempo, looking around at the band and flashing smiles at the audience, stomping his feet to keep everyone in time. The band leader: white hair, white jacket and white winklepicker shoes with horseshoe buckles.

Liverpool, 1957

The precocious sixteen-year-old in the checked shirt and boot-lace tie carries a cheap acoustic guitar strung around his shoulders with knotted household string. He has a gang of lads with him, and is clearly the leader. He tells them to look sharp, they're onstage in five minutes. Stage is the back of a flatbed lorry at the village fete, a lorry strung up with home-made bunting, its engine idling to provide electricity for a

small amplifier rigged up to a single microphone. The group tease and comb their greased-back hair and pick up their instruments—skiffle snare, tea-chest bass, harmonica and that plywood guitar—and clamber onto the back of the wagon. A few people gather to watch, slouching teenagers holding their bubblegum in their palms while they lick ice creams. Most don't even turn and look towards the music, tracing paths across the village green towards the tombolas, jumble sale, coconut shy or kiddies' swings. He doesn't care, the kid with the quiff and the guitar. His band, named after the school he and his mates spend their lives playing truant from, launch into Buddy Holly's "Crying, Waiting, Hoping," and he strums his guitar ferociously even though it's barely audible. The strings—old piano wires cut to length—bite into his fingers like an egg-slicer as he makes the most of his opportunity in front of a crowd. He eyes up the girls, one in particular.

She's blonde, pretty, and catches his eye. There's a connection. When the band have finished playing, their thirty minutes of rock 'n' roll songs picked to avoid any hard-to-play chords, the band leader swings his acoustic guitar around to his back, jumps down from the wagon and marches straight over to the girl who's been watching him.

"What's a nice lookin' place like you doin' in a girl like this?"

He's charming and witty, funny and clever. They hit it off. Talking about music, about art. She's called Cynthia ("Sin, for short?" he quips) and she'll be going to the city art college soon—so is he, he tells her, after the summer. Two more months and he'll be down Hope Street at the big front gates of the college with all the rest of them, wondering what he's doing there, reminding himself that he's only doing art 'cos he thinks it's a way to avoid getting a real job. He's about to invite Cynthia around to his place to "see his latest work" when a mate of his, Ivan, turns up and interrupts them.

"What is it now, Ivan? Can't you see I've got business to attend to?" This followed by a dirty laugh that makes Cynthia feel uneasy.

Ivan is tall and blonde, too clean-cut to be one of the gang. But he's funny, is Ivan. Funny and interesting. He's with a friend of his, a smart-looking lad in a modern-cut jacket, a handful of grease in his slicked-back hair and some smart white winklepicker shoes with a distinctive horseshoe buckle. Ivan says that this lad he's brought along, he plays guitar too. Just watched the band. Loved 'em.

The lad pipes up. "Great that. You were smart."

"Yeah, we were, weren't we." Deadpan.

Ivan breaks the awkwardness.

"John, this is the lad I was telling you about. This is Paul."

Paul holds out a hand.

"Paul, this is John."

John clocks the shoes. Asks where he got them. Nice.

Ivan's mate Paul—all arched eyebrows and easy manner—tells John he thinks his guitar-playing is "great, different." John looks at him slyly, sensing the danger of being patronised. Paul's eyes widen; John's narrow. The two talk, coyly, wary of each other. Then John offers Paul his guitar, flashes a smile, asking him to show what he can do. Paul tells John that, well, the guitar is right-handed, and he's left-handed, so he'll have to play it upside down, shaping the chords back-to-front with his right hand.

John is fascinated, but more fascinated in the blonde art student he's been talking to, keeping an eye on her over Paul's shoulder. Cynthia is standing waiting, fidgeting, looking around while this exchange between the two lads takes place. As Paul takes John's guitar and twists it upside down, figuring out its unfamiliarity, shaping chords with his fingers on the sharp metal strings, Cynthia and John lock eyes. He looks at her pale, slim neck. She's wearing a small pendant with the letter *C* fashioned in cheap silver. Paul plays an open G and sings, "We-ell…" He can play. And sing. He's good. Cynthia wears mascara that makes every half glance look like a come-on, and twirls her hair with the tips of her fingers. The pendant shifts across her neck.

Paul lurches confidently into Eddie Cochran's "Twenty Flight

Rock." It's a note-perfect performance, he knows all the words, and John looks impressed. He *is* impressed. "Yeah, nice one, pal. Lovely. We should keep in touch, eh?" He's not sure if he means it or not, as he takes back his guitar, holds it closely to him as if someone had defiled it, and walks over to Cynthia, putting an arm around her and kissing her neck. Just like that. Affronted by his forwardness, she shrugs him off. She's going to art school, the city art school. She's not some cheap kid fancying the lead singer. John tries again, putting an arm around her waist. This time she pulls his hand away and walks off, shooting him angry glances. Him going to art school? Liar.

John lets out a slow hiss between his uneven teeth. Paul is out of earshot now, chatting to the band's drummer, forming chord shapes with his right hand. John, smarting from the girl's reaction, sidles up to Ivan and puts an arm around him, talking into his ear, angry.

"Who's the prat with the white winklepickers then? Big-headed git. Too cocky by half, mate."

Ivan looks upset as John slaps him on the back and tells him he'll see him next week at school, walking off pointedly in the opposite direction to where Paul is holding court with the group, with *his* group, *his* gang. Ivan walks over to Paul. Paul pulls away from the band and towards Ivan, glancing over his shoulder to make sure John isn't around before mouthing off.

"What d'you want me to meet him for? Arrogant bastard. Too big for his boots. And a bloody shite singer an' all."

Ivan just shrugs diplomatically. They walk off together.

Liverpool, 2017

The old man is watching the band through the gloom, listening past the bass boom, the drink blurring his vision and dulling his hearing. He remembers the songs and half mouths the words. Used to be a bit of a singer himself. A long time ago. The piano player counts them in and the band swing unsteadily into the Del-Vikings' "Come Go with Me." Too slow. Should be rockin', this one, should be getting up a head of

steam. Not swinging politely, all suited and shoepolished and smiling. He catches sight of a bleached blonde older woman sitting with a friend, or a daughter, three or four tables away. Same age as he is, probably. He might be getting on, but he still has an eye for the ladies. She looks over at him. She's clutching her small glass, fidgeting, fingering a silver necklace, uneasy.

The band finish their tune. *Ladies and gentlemen, thank you!* In the back room of the pub there's light applause from the dozen people watching. The band leader isn't fazed, and talks as if playing to hundreds, thousands even. The consummate professional. *Our next number*, he declares spritely, *is a little tune by the late great Mr Eddie Cochran. Ey up, fellas … one, two, three, four!*

The band strike up. The old man drinks the dregs of his pint and lets out a loud belch aimed at the old bottle-blonde, as if to impress her. Feels like he's seen her before. Probably has. He's seen enough women around here, or maybe they all start to look the same after a few pints. She looks away, shaking her head. Onstage the piano player smiles at the audience. The old man gets to his feet and leaves, muttering, *Too cocky by half.*

HOWEVER

YET

NEVERTHELESS

NONETHELESS

EXCEPTING

SAVE

4'33"

Never miss a good chance to shut up.
—Will Rogers

In an effort to come to a better understanding of John Cage's infamous piece, I downloaded and printed off the music for what is simply called *4'33"*. It's in three parts and comprises just the instruction, three times, once for each movement—"*Tacet*," a musical term for simply not playing. It's a gap, a nothingness, usually between two played sections, but in this case not.

It clearly isn't liminal space, space-between. It's anything but—in the context of the history of musical composition it's *fortissimo*, as loud as possible, Motörhead-loud. Silence can be like that, can't it?

But *4'33"* isn't about silence—Cage himself commented repeatedly that it's about the noises we hear within that musical tacet. The shuffling and coughing, even the breathing. John Cage was delighted to note, after several performances, that the piece is also about the noise "of people walking out."

Sometime before he composed *4'33"* Cage decided that he'd like to experience silence by visiting Harvard University's anechoic chamber, a room that is completely soundproofed. Not egg-boxes-on-walls and a towel along the bottom of the door—this is a room filled floor-to-ceiling with hundreds of spiked foam wedges, designed to absorb any sound. The quietest-recorded chamber—and thus the world's quietest place—is in Redmond, Washington, where noise levels are at −20dBA (it's estimated that true silence is around −23dBA).

The disorientating effect of spending time in an anechoic chamber means that people are rarely allowed to spend more than an hour in the room. Nevertheless, Cage was eager to experience the

chamber, so in 1951 he went to Harvard in search of silence. What he discovered after spending just a few minutes in the chamber was that the noises of the human body are continuous, varied and surprisingly loud. Blood circulating, heart pumping, stomach digesting—it all makes a noise.

People are surprisingly derisive of Cage's *4'33"*, seeing it as some kind of prank played on the music-loving audience. Even having sheet music of the piece seems daft.

I talk to my friend Emma Adams, a friend and writer and dramaturg of theatre, TV and radio plays. Emma has read all the books on dramatic structure (though she reminds me that she forgets them very quickly) and has a deep understanding of how story structure is used across all dramatic forms. She isn't without criticism of the rigidity of storytelling, but she takes issue with my contention that John Cage's *4'33"* is an example of breaking and challenging the form.

Me: To me it's a piece of music without the normal structure of beginning, middle and end. Cage throws out every other structure that exists in music, except for time. That's all he keeps in. That's a great story, but there are no rises and falls and twists and turns. Just time passing.

Emma: But it does have a beginning, middle and end. Because if the musician has a clock on the piano—or whichever instrument they sit down to play—and they hit the timer, then at some point there is a mid-point...

Boff: But what we call "the middle" in a story is when something happens. To take you on a journey from the beginning to the end.

Emma: But if it was being performed in a music hall, then there would be the sounds of people breathing—there would be things that you would experience.

Boff: But there's no structure to that. The only story here is that we move from one moment in time to another moment in time, and within that anything is possible.

Emma: But the sounds of the audience are the story.

[232]

Emma is right. But still, that "middle"—that coughing, shuffling, squeaky-chair middle—disrupts everything we've been taught about how music works, and that's what makes it an incredible piece of, er, music.

My favourite record right now is an album that comes via the good people at Scarfolk and is a rare copy of a recording that was withdrawn from libraries across the country when sound effects records on vinyl were deemed to be "a thing of the past." It's called, simply, *Sound Effects No.2: Uncomfortable Silences*. It's a collection of silences, mostly (as it says on the cover) uncomfortable but sometimes awkward and occasionally embarrassing. Significantly, what we get apart from the shuffle of feet and the quietly smothered coughs is the crackle and hiss of the vinyl. This surface noise can't be underestimated—it takes us back to those years of scouring second-hand record shops for that vinyl copy of the first The Who album, a record you know has been battered by old needles at parties (and at home). The pops and jumps are part of the record. We don't want these *Uncomfortable Silences* digitally cleaned up, compressed and noise-gated to within an inch of their lives. We want our silences to make a noise.

John Cage's most celebrated work isn't about silence at all, it's about noise. Noise that isn't notated or scored—Cage's score for the piece is just a short list of instructions for the players (any instrument) to not play, which is very different to an instruction to be silent. Here it is, broken into its three "movements":

I

Tacet

II

Tacet

III

Tacet

So with this score in mind, I sit down with a guitar and prepare to play Cage's *4'33"*. I'm aware of what Emma Adams said as I set the timer on my phone, so instead of having the digital numbers clicking down in front of me and unwittingly giving the piece a definite mid-point (a place where I stop heading away from the start and heading towards the end), I set an alarm for *4'33"*, turn away from the clock and begin.

<div align="center">

I clutch

the guitar

as quietly

as possible.

I can

hear

continuous

low traffic noise,

an aeroplane passing overhead

(I live on

a flight path

from Leeds

Bradford

Airport.

When we

first

moved here

a decade

ago,

I heard the aeroplanes

all the time.

Now I never

hear them,

I've

filtered

them

out)

and at one point there's a gate on the back street

being slammed shut.

</div>

<div align="center">

[234]

</div>

My stomach
rumbles, a low
growl. Just once.
My ears begin
to ring. Or
rather, they
probably always
ring but now I
am listening to
the continuing
high-pitched
frequency. It
isn't unpleasant,
but I'm
surprised how
loud it becomes.
I feel like I can
hear myself
thinking.
It's hard to
not strum
a chord
when you're
holding a guitar.

Tacet.

I'm surprised
there are no
children's voices
from the street,
no dogs
barking,
no crows
cawing and
croaking.

I start to hear
a low note to
accompany the
higher, and try
to work out if
they're attached,
and if they're
the same note
in different
octaves.
I scratch my
arm, and listen
to the scratch.
Another
aeroplane.
And just as the
plane engine
noise begins to
fade,

peep peep peep peep peep peep
goes
the
alarm,
brittle and
shocking.

I put the guitar down and switch off the timer.

My next-door neighbour Carl meditates. I've never meditated. When I asked him recently what he was going to do with all his time when he retires, he answered simply: "*Meditate.*" The word *meditate* originates from the Latin, meaning "to think or reflect upon, consider, design, purpose, intend." Those words are all surprisingly active words for an act that I always assumed was about emptying out your mind. I've clearly listened to too many George Harrison songs. The one thing that "playing" John Cage's *4'33"* did was get me thinking, intently thinking. Thinking about listening, thinking about sound, thinking about how such a quiet piece

could be so loudly disruptive. I read somewhere that $4'33"$ wasn't actually a piece of music, it was "a piece *about* music."

Frank Zappa, composer and guitarist, had a fascination for sticking dynamite under classical music's straight-laced (and straight-faced) conventions. As a rock guitarist who performed theatrical live shows, he understood that he and his band the Mothers of Invention had a place within rock'n'roll's counterculture: much as he lambasted the hippies, he and his band claimed a direct lineage from Ken Kesey's Merry Pranksters and every long-haired weirdly dressed beat-freak on the California block. But the way he gatecrashed the world of classical music was another thing entirely —he saw in that world of uptight orchestras and reverential audiences a chance to play out (and play the fool). His incredible arrangements for orchestras included instructions—on carefully annotated musical scores—including that for the piano in his piece *Penis Dimension*, where the musical notation suddenly appears (at bar 47, just before a sudden tempo lurch from a waltz to a single bar of 5/8) as a thick black block of print spread right across the staves of the score. Underneath the block is the instruction, in a beautiful italic:

Stand. Turn around. Sit on keyboard and
jump back to normal
position without los-
ing the tempo.

And above the stave is written, in parentheses:

(Both buttocks)

These Hills Are—

These Hills Are Ours, which I wrote about briefly back there in "Ziggy Visits Sabden," was a two-man stage show that myself and Dan Bye toured for a couple of years coming out of the Covid pandemic. We'd first had the idea while on a run, aptly—we'd started talking about how off-road running is a physical metaphor for escaping your class. About how runners ought to be more attentive to the great history of mass trespassing, which has won us the right to run through these formerly forbidden landscapes. And about escaping the tyranny of twenty-first-century digital technology.

While running, we agreed to meet sometime to come up with ideas, and several weeks later we were in Dan's living room in Lancaster surrounded by Post-It notes. The Post-Its were in various different colours, which meant they could be classified and grouped. Being Post-Its, they could be unstuck and rearranged, shuffled along, taken out and screwed up. This was Dan's accepted method of starting a new project—find the Post-It notes.

I tried it with this book. I scribbled lots of chapter headings and ideas onto Post-Its and stuck them on a huge sheet of paper in my basement. I looked at them for a long time, then realised that all I was doing was confusing myself and procrastinating the actual writing. The big sheet of paper and the Post-Its are still there, rolled up now, next to a tall shelfful of CDs (also, to all intents and purposes, ignored).

So we came up with a plan, which was essentially to do a theatre show telling stories about running from town and city centres, along ginnels and through parks and along canal towpaths, to find the nearest hill, or wild place. A place where you feel like you've escaped the city. And that during each show we would invite the audience to join us in a run the following morning, along such an escape route, from the front doors of the theatre.

To test out our idea, we did several runs—we ran from Burnley's town centre canal to the summit of Pendle Hill, barely touching a road. We ran from the ARC theatre in the centre of Stockton-on-Tees to the top of Roseberry Topping, eleven miles away. We ran from Bradford city square to the high open wilds of Baildon Moor. We ran these routes while talking about what form our project would take. I'm sure you can guess: two middle-aged white blokes sitting on a stage talking about running. Insert sarcastic comment here about audiences flooding in, etc.

We needed more. So we added the idea of seven or eight songs that would punctuate the stories, and planned how we'd pay attention to all the requisite narrative arcs and came up with pencil sketches of a stage set complete with barbed wire fence and a cairn. But it still wasn't quite enough.

What we needed was a story, a single story, that could form a sort of backbone to all our higgledy-piggledy ideas about freedom, class, technology and land ownership. What we needed was a story of a journey—a long, running journey that we had undertaken. Yes! Now the story made sense … a run from where Dan lives close to the Bowland hills, scene of many right-to-roam disputes—all the way to the summit of Kinder Scout, home to the original mass trespass in 1932 where five ramblers were arrested and jailed for simply wanting to walk across the Peak District moors.

This journey would be just over eighty miles long, and so as a run it would take, at the very least, two night-times and one looooooooooooooooooong day of constant moving. An epic run that reconnected us to our history, that paid homage to the folk who went to jail, and who subsequently inspired a movement of civil disobedience protesting at the fencing-off of the land. A movement that would change laws and would lead us to a place where we can enjoy the right to roam across huge areas of our uplands.

We made a draft of the show, a ninety-minute theatre piece, anticipating where we would slot in the episodic events of our long run. The first pilot show was due to happen at the start of April 2020, so we aimed to do the run at the start of March that

year, leaving just enough time to neatly tie the whole thing up in time to put it before an audience.

Except that a few weeks before our planned run, I broke my toe coming downstairs for breakfast. I don't even know how it happened—my foot badly angled on a step, I'm not sure—so I was hobbling around uselessly and had to let Dan know that he'd have to do the run on his own. Never mind, we agreed, I could drive our camper van and be road support. It'll be fun!

Which it was, to an extent. But then I can say that because I wasn't doing the running. To cut a long story short, I know that as the second nightfall approached, Dan was losing interest in the whys and wherefores of the journey and wanted only to get one foot in front of the other, slowly, inexorably, towards that Kinder Scout summit finish. We'd agreed that, broken toe or not, I'd join Dan for the final ten or so miles up the finish, where we'd pop the cork on a miniature glass of champagne (okay, Co-op Cava) and toast the brave souls who'd opened up this land for us to enjoy.

That's not what in fact happened. Not long before that final slog, and in pitch darkness and sub-zero temperatures, deliriously tired and high on the exposed, wintry moorland that was Bleaklow, Dan gave up the fight and turned around, heading back down the long climb he'd just come up to rejoin the road crossing at Crowden. Once there, he wrapped himself in an emergency blanket, sat on the step of a water board building, and waited for me to realise he hadn't made it across the moor and drive back round to pick him up.

What we had now was an unfinished story. What's a narrative arc without a satisfying ending? How do we build a story of a journey, around a journey that we didn't actually finish? As I drove back to Lancaster, Dan beside me, exhausted, stuffing muesli bars into his uncooperative, dribbling mouth and occasionally nodding off, I tried to work out how all those Post-It notes were going to shuffle themselves into a show that wasn't just going to end with an abrupt, whimpering anticlimax.

I didn't have to worry much longer—two weeks after that in-complete run, the world was hit by the Covid pandemic and all

the shows we'd booked (around fifty, covering the whole country) were summarily scratched.

Dan and me still met, almost every week, on Zoom calls, running through parts of the script, editing and amending. But we still didn't have an ending. Then in April 2021, over a year since that inconclusive attempt, restrictions were lifted enough so that we were allowed back out, to gather and meet and run. Dan and me decided that since it was the eighty-ninth anniversary of the Kinder Scout mass trespass, we would run that last missing section of the long run together. The feeling of escape was palpable.

I'll let Dan tell the rest of this particular part of the story:

"We hadn't seen one another in person in over a year, and this seemed like the perfect way to reunite. We ran, together, the whole section I hadn't covered the previous March, over Bleaklow, over Kinder and on down into Edale. By day, and fresh, navigation seemed absurdly easy, although we did manage to entirely miss the summit of Kinder by taking a path Boff was adamant would join back up with the main route. We doubled back on ourselves, and made damn sure this time.

"It was a glorious day, and this had nothing to do with any sense of unfinished business, and everything to do with the hundreds of people we saw. And not just crusty middle-aged blokes like us. Everybody. Young people. Families. People of all races. So many young couples. Probably many if not most of these people had no idea what anniversary it was. They just knew that they'd been stuck inside for months, and isn't it a glorious day? Most of them I'd imagine had barely even heard of the Kinder trespass. Why would such a thing be necessary? On a day like today, the idea that access to this place could ever be forbidden is self-evidently absurd."

And that simple paragraph became the ending to our show. It wasn't a show about achievement and conquering the odds and all the other clichés—it became a show about, in part, how the best stories don't have to have happy, clean and obvious endings. How not getting to the end isn't always the important thing. I'll end this chapter with the lyrics to the final song in that show:

Run yourself invisible against the green and brown
Run the summits up, and then run the valleys down
This spinning ball of everything, it all comes back to you
The whole wide world connected to the patterns on your shoes

Run to find a clearer view—you're not running away, you're running to
These hills are ours—they're ours to borrow
These hills are ours—they're ours to share
To tell a story that we were there
These hills are ours
These hills are ours to share

Wonder

There are two meanings of the word *wonder*.
There's the *noun* (meaning *something amazing*) and
 the *verb* (meaning *to doubt, to question*).
 The first is an end in itself,
 the second is a beginning.
 The Greek poet Euripides declared: "Question everything.
 Learn something.
 Answer nothing."

 I wonder if.
 I wonder what.
 I wonder whether.
 I wonder.

At some point we stop being kids and we stop asking, "Are we there yet?"
We think there's an agreed truth in everything.
We think our phone has all the answers.
I love running. Off-road running, hill running, wherever-you-end-up-going
running. I can experience the wonder (meaning *something amazing*)
of an open moor, a forest trail or a mountain skyline. And in that running
I can test out the other kind of wonder—*the unknowing, the doubt.*
 What comes next? I don't know, let's find out.
 What's up there through that gap in the trees? I don't know, let's find out.
 What's across that stream? I don't know, let's find out.
This is wondering as an end in itself,
 wondering as a primal urge,
 wondering as the spark that begets possibilities.
 Wondering born of doubt.
 Doubt is vital.
 Doubt is the rebel and the nonconformist.
 Doubt challenges the status quo and
 the norm.

Here's a story.

There's a family sitting around a dinner table, three generations —grandparents, mum and dad, and grandkids. And someone comes up with a random question emerging from their conversation— "Who was that woman who starred in that film about the orphans and she married the bloke out of that war film?"

And before the question is done, the grandkids and the grandparents immediately reach for their tablets and phones, furiously tapping into Google. The dad—the middle generation, my generation —shouts, "Whoa! Hold on! What about if we try to work it out instead of looking it up?!"

And there's an intake of breath as the older and younger generations put down their devices and take in the enormity of that idea. The mum (the other half of that middle generation) slams her hands on the table.

Everyone now goes completely quiet.

"I've got a better idea," she says. "Why don't we just NOT KNOW?"

That's the story.

On that story hinges humankind's basic, fundamental problem: the desire to know everything. The desire to fill in every gap in our knowledge, and the inability to accept that there are some things we don't understand. The fear of wondering.
For example: **What Happens When We Die?**
Blokes with sexual hang-ups and guilt complexes and power, masquerading as religious leaders, have spent centuries telling us what happens when we die, and how that impacts on what we do while we're alive. Invented answers to unanswerable questions uttered by sexually frustrated men and written down in little black books.
And not enough people say, "Why don't we just NOT KNOW?"

> People are scared of not knowing.
> Scared of the dark.

Malcolm McLaren said that his rule was simply to "go through any door that you're not supposed to enter." It's the wondering what's behind the door that prompts you to open it. Nobody says it better than Shakin' Stevens, who hit number one in the charts with a revived rock'n'roll classic:

> Don't know what they're doing but they laugh a lot
>> Behind the green door
> Wish they'd let me in so I could find out
>> What's behind the green door

I love to wonder.
I love to look for answers,
and I'm happy that sometimes I don't find them.
My children sometimes ask me questions, and I tell them, "I don't know."
Curiosity and speculation, without conclusions, are paths in themselves.
The means doesn't always need an end. Wondering can be wonderful.

Writer Rebecca Solnit, perhaps joining in with Shakin' Stevens, sings, *"Uncertainty is not an obstacle to living but a wellspring of life."*

> **I wonder if.**
> **I wonder what.**
> **I wonder whether.**
> **I wonder.**

Trying to find something out
—the natural progression from wondering—
is a lesson in itself.

Maria Popova says,
"Allow yourself the uncomfortable luxury of changing your mind."

Uncomfortable now more than ever because we
live in a world of at-your-fingertips answers.

We increasingly don't wonder what to think anymore,
since our phones will tell us.

So. There's wonder, as in something amazing.
And there's wonder that questions things,
that thinks twice before answering.
That isn't afraid to say, "I don't know."

How does this chapter end?
"I don't know."

 not having knowledge delivered to us at the click of
a mouse, is the thing that keeps us guessing, and guessing is good.
As Erwin Schrödinger asked the world in 1935, is there a cat in the
box? If there is, is it alive or dead? According to quantum law, the
cat will be both dead and alive until someone looks in the box. In
quantum-mechanics-speak, the cat therefore retains the ability to
be both alive and dead until it is observed. In short, anything could
happen; the answer could swing either way. The cat being both
alive and dead at the same time is what holds our attention, what
keeps us interested.

With Hidden Noise

Not knowing,

Here's another story about a cat, or a story about telling a story about a cat:

A teenage boy is left in the family home for a week when his parents and younger siblings go on holiday. Among other typical instructions, he's entrusted with the family cat—she's an old cat and needs attention, so make sure she's fed and watered, don't leave her out at night, that sort of thing.

A week passes by and the family return home, exhausted from a long drive. They open the front door and find their son watching TV.

"Hi. Anything happen while we were away?"

"Erm...well yeah, the cat died."

There's a pause before the youngest sibling bursts into tears and Dad slaps his forehead in bewilderment. He stares, puzzled, at his son.

"The cat died? Is that how you tell us? Just like that, 'The cat died'? Didn't you think you could have broken the news to us all in a better way, with a bit of care and thought?"

The boy is unsure what to say.

"Er—yeah, er—how do you mean, in a better way?"

Dad plonks down a suitcase and sits down in an armchair.

"Well, you could have given us a ring on Monday last week. Could have told us that, I don't know, maybe that the cat had climbed on the roof of the house and wouldn't come down for night-time. But that nevertheless, she was perfectly happy up there, just peacefully sitting on the roof. Then on the Wednesday you might have rung and said, the cat's still on the roof, I'm passing up food but she isn't eating it. But she looks so contented up there, quiet and calm. Then maybe on Friday, another phone call to tell us that the cat seems to be sleeping, but occasionally miaowing as if she feels this might be her way of saying a long and peaceful goodbye. Then on the Saturday, perhaps you'd ring and say that sadly, the cat has quietly passed away, that she seemed to slip gently from this life to the next with one long, contented yawn. Something like that."

The boy, listening intently, has a look on his face that says he's now understanding his mistake, that he's mad at himself for being so insensitive.

"I'm—I'm sorry, Dad. I didn't realise."

Dad shakes his head and forces the thinnest of smiles.

"Never mind, son. No matter. And anyway, how was your week at home? Any other news we should know about?"

"Yeah—yeah there is, Dad. You see, on Monday, Gran came round and climbed up onto the roof..."

[248]

As I said, that's a story about telling a story. All it's really saying is that the conventions of storytelling change from story to story, from time to time, from mouth to mouth. In the push to see how far the boundaries of art could be extended (and broken, and left behind in tatters) Dada artist Marcel Duchamp moved quickly from paint on canvas to the presentation of a urinal as a "ready-made" work of art. He titled that piece *Fountain*, but it's not the piece I want to tell you about; still, the story of *Fountain* works as a preamble to the story of *With Hidden Noise*.

The story of *Fountain* began with the foundation of the Society of Independent Artists in New York, a group modelling itself on the Salon des Indépendants in Paris. Duchamp himself helped to found the US version of the society, having moved from Paris to New York a year or two earlier. The society's bold and democratic declaration was that all members' submissions would be accepted for display at the inaugural exhibition, to be held at the Grand Central Palace in 1917.

The initial idea for *Fountain* was born during a conversation between Duchamp and artist Joseph Stella. Here let's imagine the two opening another bottle of wine after a long evening of emptied bottles, egging each other on and laughing at various absurd ideas, half aware that late-night ideas rarely make it to the next morning. But this was Duchamp at his most mischievous—he did like a joke—and the next day he strolled down to a local plumber's shop (advertising itself as a Purveyor of Fine Sanitary Ware) and bought a urinal—a plain, white enamel gent's toilet urinal.

This he signed "R. Mutt, 1917" and promptly submitted it under that name to the Society of Independent Artists opening show. He was a member, after all, and all members' work was admissible. At which point the society's ten-man board of directors rejected the urinal on the grounds that it could not be considered a work of art. Not only that—but that it was "indecent." Duchamp resigned from the society, citing censorship, though he was, of course, delighted. Even more so when the board issued a statement to the press stating: "The *Fountain* may be a very useful object in its place, but its place is not in an art exhibition and it is, by no definition, a work of art."

Duchamp retrieved the urinal, from where it had been unceremoniously hidden away behind a partition in the exhibition space, and promptly took it to be photographed. Which was just as well, since *Fountain* itself was then somehow lost and never turned up. (The Duchamp urinals you can see in various galleries around the world are *all* FACSIMILES.) ▮he twist somewhere ∏ear the still-wagging tale᷍ of *Fountain* iˢ thᵃt in 2004 it TOPPED Δ po▮ of five hu▮dred Bri▮ish arᵗ experts Δs ᵗhe siⁿGle *mo*ˢᵗ in*f*luentl▮l artᵂork of ᴛʜe twen▮leth cen▮▮ry. ▮▮ ▮ ▮▮▮, ▮▮▮'▮ ▮ ▮▮▮▮ ▮▮▮▮ ▮▮▮▮▮ ▮ ▮▮▮▮. ▮▮▮ ▮▮'▮ ▮▮▮▮▮

▮▮▮▮▮ ▮▮ ▮▮▮▮ ▮▮▮ ▮▮▮▮▮▮▮▮▮▮ ▮▮ ▮▮▮▮▮▮▮▮▮▮ ▮▮▮▮▮▮ ▮▮▮▮ ▮▮▮▮▮ ▮▮ ▮▮▮▮, ▮▮▮▮ ▮▮▮▮ ▮▮ ▮▮▮▮, ▮▮▮▮ ▮▮▮▮▮ ▮▮ ▮▮▮▮▮. ▮▮ ▮▮▮ ▮▮▮▮ ▮▮ ▮▮▮ ▮▮▮▮ ▮▮▮ ▮▮▮ ▮▮▮▮▮▮▮▮▮ ▮▮ ▮▮▮ ▮▮▮▮▮ ▮▮ ▮▮▮▮▮▮▮ (▮▮ ▮▮▮▮▮, ▮▮▮ ▮▮▮ ▮▮▮▮▮ ▮▮ ▮▮▮▮▮▮) ▮▮▮▮ ▮▮▮▮▮ ▮▮▮▮▮ ▮▮▮▮▮▮▮ ▮▮▮▮▮ ▮▮▮▮▮ ▮▮▮▮ ▮▮▮▮ ▮▮ ▮▮▮▮▮ ▮▮ ▮▮▮ ▮▮▮▮▮▮▮▮▮ ▮▮ ▮ ▮▮▮▮▮ ▮▮ "▮▮▮▮▮▮▮▮" ▮▮▮▮ ▮▮ ▮▮▮. ▮▮▮ ▮▮▮▮▮ ▮▮▮▮ ▮▮▮▮ ▮▮▮▮▮▮▮▮, ▮▮▮ ▮▮'▮ ▮▮▮ ▮▮▮ ▮▮▮▮▮ ▮ ▮▮▮▮ ▮▮ ▮▮▮ ▮▮▮ ▮▮▮▮▮; ▮▮▮▮, ▮▮▮ ▮▮▮▮▮ ▮▮ ▮▮▮▮▮▮▮ ▮▮▮▮▮ ▮▮ ▮ ▮▮▮▮▮▮▮ ▮▮ ▮▮▮ ▮▮▮▮ ▮▮ ▮▮▮▮ ▮▮▮▮▮.

▮▮▮ ▮▮▮▮ ▮▮ ▮▮▮▮▮▮▮ ▮▮▮▮ ▮▮▮ ▮▮▮ ▮▮▮▮▮▮▮▮ ▮▮ ▮▮▮ ▮▮▮▮▮ ▮▮ ▮▮▮▮▮▮▮▮ ▮▮▮▮▮▮ ▮▮ ▮▮▮▮ ▮▮▮▮, ▮ ▮▮▮▮ ▮▮▮▮▮▮▮ ▮▮▮▮ ▮▮ ▮▮▮ ▮▮▮▮▮ ▮▮▮ ▮▮▮▮▮▮▮▮▮ ▮▮ ▮▮▮▮. ▮▮▮▮▮▮▮ ▮▮▮▮▮ ▮▮▮▮▮ ▮▮ ▮▮▮▮ ▮▮▮ ▮▮▮ ▮▮▮▮▮ ▮▮ ▮▮▮ ▮▮▮▮▮, ▮▮▮▮ ▮▮▮▮ ▮▮▮▮ ▮▮▮▮▮ ▮▮ ▮▮▮▮ ▮▮▮▮▮ ▮ ▮▮▮▮ ▮▮ ▮▮▮▮ ▮▮▮▮▮▮. ▮▮▮ ▮▮▮▮▮'▮ ▮▮▮ ▮▮▮ ▮▮▮▮▮▮▮▮ ▮▮▮▮▮▮▮▮ ▮▮▮ ▮▮▮ ▮▮ ▮▮▮▮▮▮' ▮▮▮▮▮▮▮▮ ▮▮▮▮▮ ▮▮ ▮▮▮▮▮▮▮ ▮▮▮ ▮▮▮▮▮ ▮▮ ▮▮▮ ▮▮▮▮▮▮▮ ▮▮▮▮▮▮▮▮, ▮▮ ▮▮ ▮▮▮ ▮▮ ▮▮▮ ▮▮▮▮▮ ▮▮▮▮▮▮ ▮▮▮▮▮▮ ▮▮ ▮▮▮.

▮▮▮ ▮▮▮▮▮ ▮▮▮▮ ▮▮▮ ▮▮▮▮▮▮▮▮ ▮▮▮ ▮▮▮▮ ▮▮▮▮▮ ▮ ▮▮▮▮▮▮▮▮▮ ▮▮▮▮▮▮▮ ▮▮▮▮▮▮ ▮▮▮ ▮▮▮▮▮ ▮▮▮▮▮ ▮▮▮▮▮. ▮▮▮▮ ▮▮'▮ ▮▮▮▮▮ ▮▮▮ ▮▮▮ ▮▮▮▮ ▮▮▮▮▮ ▮▮▮▮▮ ▮▮▮▮ ▮ ▮▮▮ ▮▮▮▮ ▮ ▮▮▮ ▮▮▮▮ ▮▮ ▮▮▮▮▮ ▮▮▮▮▮, ▮▮▮▮ ▮▮▮ ▮▮▮▮ ▮▮ ▮▮▮ ▮▮▮▮▮▮ ▮▮ ▮▮▮▮▮▮ ▮▮▮▮ ▮▮▮, ▮▮▮ ▮▮▮▮▮ ▮▮▮▮ ▮▮▮▮-▮▮▮▮ ▮▮▮▮ ▮▮▮▮▮ ▮▮▮▮ ▮▮ ▮▮ ▮▮▮ ▮▮▮▮ ▮▮▮▮▮▮. ▮▮▮ ▮▮▮ ▮▮▮ ▮▮▮▮▮▮▮▮ ▮▮ ▮▮ ▮▮▮▮ ▮▮▮▮▮▮▮▮—▮▮ ▮▮ ▮▮▮ ▮ ▮▮▮▮—▮▮▮ ▮▮▮ ▮▮▮▮ ▮▮▮ ▮▮ ▮▮▮▮▮▮ ▮▮▮▮ ▮▮ ▮ ▮▮▮▮ ▮▮▮▮▮'▮ ▮▮▮▮ (▮▮▮▮▮▮▮▮ ▮▮▮▮ ▮▮ ▮ ▮▮▮▮▮▮▮ ▮▮ ▮▮▮▮ ▮▮▮▮▮▮ ▮▮▮▮) ▮▮▮ ▮▮▮▮▮ ▮ ▮▮▮▮—▮ ▮▮▮▮, ▮▮▮▮ ▮▮▮▮▮ ▮▮▮'▮ ▮▮▮▮ ▮▮▮▮.

▮▮▮ ▮▮ ▮▮▮▮▮ "▮. ▮▮▮▮, ▮▮▮" ▮▮▮ ▮▮▮▮▮▮▮ ▮▮▮▮▮▮▮ ▮▮ ▮▮▮▮▮ ▮▮▮▮ ▮▮▮▮ ▮▮ ▮▮▮ ▮▮▮▮▮▮ ▮▮ ▮▮▮▮▮▮▮▮▮ ▮▮▮▮▮▮ ▮▮▮▮▮▮ ▮▮▮▮. ▮▮ ▮▮▮ ▮ ▮▮▮▮▮, ▮▮▮▮ ▮▮▮, ▮▮▮ ▮▮ ▮▮▮▮▮▮' ▮▮▮▮ ▮▮▮ ▮▮▮▮▮▮. ▮▮ ▮▮▮▮▮ ▮▮▮▮ ▮▮▮ ▮▮▮▮▮'▮ ▮▮▮-▮▮▮ ▮▮▮▮▮ ▮▮ ▮▮▮▮▮▮▮ ▮▮▮▮▮▮▮ ▮▮▮ ▮▮▮▮▮ ▮▮ ▮▮▮ ▮▮▮▮▮▮ ▮▮▮▮ ▮ ▮▮▮▮ ▮▮▮ ▮▮ ▮▮▮▮▮▮▮▮ ▮ ▮▮▮ ▮▮ ▮▮▮. ▮▮▮ ▮▮▮ ▮▮▮—▮▮▮ ▮▮▮ ▮ ▮▮▮ "▮▮▮▮▮▮" ▮▮▮▮▮▮▮ ▮▮▮▮▮▮ ▮▮▮ ▮▮▮ ▮▮▮▮▮, ▮▮▮▮ ▮▮▮▮▮▮▮, ▮▮▮▮▮ ▮▮ ▮▮▮▮, ▮▮ ▮▮▮▮▮, ▮▮▮▮▮▮. ▮▮▮▮ ▮▮▮▮ ▮▮ ▮▮▮▮ ▮▮▮ ▮▮▮▮ ▮▮▮▮▮ ▮ ▮▮▮▮▮▮▮ ▮▮ ▮▮▮ ▮▮▮▮ ▮▮▮▮▮: "▮▮▮ ▮▮▮▮▮▮▮▮ ▮▮▮ ▮▮ ▮ ▮▮▮▮ ▮▮▮▮▮ ▮bjᵉᶜt ▮▮ ▮▮▮ ▮▮▮▮▮, ▮▮▮ ▮▮ ▮▮▮▮ ▮▮ ▮▮▮ ▮▮ ▮▮ ▮▮▮ ▮▮▮▮▮▮▮▮ ▮▮▮ ▮▮ ▮▮, ▮▮ ▮▮ ▮▮▮▮▮▮▮, ▮ ▮▮▮▮ ▮▮ ▮▮▮."

[250]

███████ ███████ ███ █████, ████ ██████ ██ ███ ████ ███████████ █████ ████ ██████ █ ███████ ██ ███ ███████ █████, ███ ███████ ████ ██ ██ ██ ███████████. █████ ███ ████ ██ ████, ████ ███████ █████ ███ ████ ██████ ████ ███ █████ ██████ ██. (███ ███████ █████ ███ ███ ███ █ ██████ ████████ █████ ███ █████ ███ ██ ████████.) ███ ████ ██████████ ████ ███ ████-██████ ████ ██ ████████ ██ ████ █ ████ ██ ██████ █ ████ ██ ████ ███████ ██████ ███ ███████ ██ ███ █████ ████ ██████████ ████████ ██ ███ ████████ ██████.

And here, by way of light relief, is a joke:

A comedian is peeling a banana, saying:

"*One skin, two skin, three skin,* [pregnant pause]...*five skin.*"

It's the omission that's important. When a comedian is telling this joke onstage, nobody shouts out the missing words. It's called "an orphaned punchline"—instead of words, we're given an idea, a thought.

Here's another joke:

"What's the difference between *a* Joke *and* A hypothetical question?"

Not so influential as his famed urinal was Duchamp's *With Hidden Noise*, created in 1916 and in many ways more interesting than 1917's *Fountain* in that its main purpose was to exist as a puzzle, a guessing game, to which there was no answer. It was one thing for Duchamp to challenge notions of art by claiming that something he bought in a plumber's shop could be designated as "art" simply by signing it, and yet another to declare that art could exist as a well-kept secret.

With Hidden Noise, on display in the Philadelphia Museum of

Art, is a ball of twine trapped between two brass plates and fixed by four long, thin bolts. It's not much bigger than the size of a clenched fist, and it sits behind glass on a shelf along with some other Readymades. The noise referred to in the title is, comically, a noise made by a hidden object inside the reel of twine. I say comically because the noise can only be heard by shaking the sculpture, which is now forlornly inert in its glass case. Here's the puzzle, the secret—the object inside the sculpture, the thing that makes the noise when rattled, is unknown to everyone, including Duchamp himself. He asked a friend, Walter Arensberg, to place an object of his choice inside the twine, then to seal it with the bolts. Arensberg died in 1954 along with the secret of what makes the noise.

So the sculpture becomes not about the object that we can see on display but about what we might imagine is inside the object; it becomes about wondering, and becomes a game. And if the game is simply Duchamp laughing at us for spending our valuable time wondering about something unknown, then that's all the more reason to love it: imagination-in-a-box. There's a filmed interview with Duchamp from 1956 where Duchamp picks up *With Hidden Noise* and shakes it, a half smile across his lips. He admits, proudly:

> Arensberg put something inside the ball of twine and
> never told me what it was, and I didn't want to know, it
> was a sort of secret and it makes a noise, so we call this
> a Readymade with a Secret Noise, and…I never know,
> I don't know, I will never know whether it's a diamond
> or a coin.

Tellingly, Duchamp here refers to it not as *Hidden* but as *Secret*— a much more definite unknowing. *With Hidden Noise* was created almost exactly a year before *Fountain* and would never come close to matching the urinal's significance in the history of art. *Fountain* had shock value: Duchamp continued over the years to invent stories as to how it originated, inventing a series of possible

suspects who had created the urinal-as-artwork and had Duchamp present it to the Society of Independent Artists. And in a deliberate debunking of the veneration of the artist, he had no qualms about crediting the plumbing manufacturer (J.L. Mott Ironworks, Fifth Avenue, New York).

A handful of latter-day academics have suggested that *Fountain* was not created by Duchamp at all but by the artist Baroness Elsa von Freytag-Loringhoven—a good story, but one without any basis in fact.* Duchamp's photograph of *Fountain*, taken by his friend Alfred Stieglitz, created an immediate and intentional visual record of the thing. The story at the heart of *With Hidden Object*, on the other hand, was to be permanently withheld; it's a story that relies on its definite lack of an ending.

The 1960s saw the idea of "conceptual art" become a recognised movement, with an explosion of artists across the world questioning the production, reproduction and meaning of art through visual and nonvisual ideas. The Art & Language group's Mel Ramsden produced a framed work featuring only the words:

> The content of this painting is invisible; the character and dimensions of the content are to be kept permanently secret, known only to the artist.

It's hard not to see how Marcel Duchamp was telling the same joke half a decade earlier, a joke whose punchline has yet to be delivered. Let's be clear about one thing, though—the ball of twine at the heart of *With Hidden Noise* is far too small to house a cat.

Schrödinger, according to some accounts, did have an actual pet

cat, which he called Milton. This was while he was living for a while in Oxford. And that previous to that he looked after a stray cat at his home in Huttenstrasse, Zürich. Both these claims, once part of Schrödinger's Wikipedia page, have since been taken down as "without enough evidence." So as the veterinary surgeon says to Schrödinger, who has come to collect Milton after an operation: "Well, Mr Schrödinger—I have good news and bad news."

* I'm all for a fresh view of women's roles historically in art, how they have been underplayed and written out, absolutely. But I don't believe the claim that Duchamp's *Fountain* was created by Elsa von Freytag-Loringhoven and that he somehow stole her work. There are all sorts of reasons why I'm convinced that the story is fantasy, not least of which is that Freytag-Loringhoven never mentioned it while she was alive and that the story has been spread by just two academics, who have written books about it and basically become famous on the back of a good story.

That story has now been definitively and exhaustively debunked, but nevertheless it still circulates, like the one about Adolf Hitler only having one testicle. As kids we used to sing in the playground about Hitler's lack of a bollock—"Hitler has only got one ball, the other is in the Albert Hall..."—and it was many years later that I found out that the story was invented by songwriter Toby O'Brien in 1939 as part of a propaganda program. Hitler's doctor, Erwin Giesing, and his personal physician, Theodor Morell, disregarded the idea of Hitler's *monorchism* (yes, that's the word for it) and confirmed that there was, in fact, nothing unusual about Hitler's testicles.

My son, Johnny, has the middle name "R. Mutt." I don't think he'd appreciate it being changed to "Elsa von Freytag-Loringhoven."

No.6

Casey Orr

The world is a wild and benevolent garden filled with chance meetings and unexplained departures.
—Simon Van Booy

I met Casey in a nondescript bar in San Francisco during a monthlong tour of the USA. It was 1992 and we'd arrived after a typically exhausting day of travelling and had the luxury of a day off before three nights of concerts in and around the SF area. A handful of us decided to wander around the city in search of a bar, and that's how we ended up in a tacky and too-loud place with a mirror ball and one of those DJs that speaks on the mic between records. Casey was a tall bleached-blonde punky-looking girl standing against the wall with her friend Eliza. As the evening wore on,

Eliza (I later found out) said to her, "If you don't go and proposition someone in the next five minutes I'm off." Casey came and danced with me. She said, "You're cute." I said, "That's what you say about a dog." And we both laughed.

We got married eighteen months later and now here we are, still massively surprised at that turn of events that completely and utterly changed both of our lives. A dance, a joke about a dog, and *blam!* The world became a very different place. And since I'm meeting up with all these people, these Disrupters—some of whom have no

idea who I am or why I'm arranging to see them—it seems perfectly reasonable, no, *essential*, to say a thank you to this woman who turned me upside down and shook all the past out of my pockets.

For some reason, probably the simple reason that it occurred to me at the time, I decided to record a conversation with Casey recently while we were out on a five-mile walk through the wooded hillside above our house.

Me: *Were you aware, at that time, in those two or three days when we first met, that our meeting could be life-changing?*

Casey: *No. I didn't trust myself enough then to think that.*

Me: *I think I knew.*

Casey: *What hooked me in to you was that you wrote me a letter.*

Oh yes, the letter. This letter was written somewhere on tour, after we'd left San Francisco and headed off to Los Angeles and then Las Vegas, heading east across the baking-hot innards of the country towards Texas and Tennessee and a jumble of places I can't remember.

Casey: *You wrote a letter which said, "You don't need to do anything about this, I'm just telling you*

that I love you." And it was that sentence, it gave me a freedom. It blew my mind, I guess. And then when we eventually talked, you made it clear that you were dedicated to your creative life. To art, and to your art. But that you loved me. And I thought, I'm dedicated to my creative life too. So maybe I should be with this person, because... I need someone who understands that.

Now, it seems so simple and easy. Something as huge as meeting the person you will spend the rest of your life with, the person you'll raise children with. All down to that one meeting in a bar, that throwaway "If you don't go and proposition someone in the next five minutes I'm off." I don't believe much in luck, beyond the where and to whom you were born. But meeting in bars, that's just luck, isn't it? In this case, the most fundamental type of disruptive luck. Like stepping on a landmine, or being hit by lightning. But then as soon as you get beyond the initial fortune of meeting, then you see the revolving cogs and wheels of how a relationship might make sense and develop—and this can happen so ridiculously quickly that it feels almost supernatural, out of this world. But it's not. Because following hard on the heels

of that initial spark of chance there are a bundle of match-ups and agreements and shared ideas which will suffice as reasons to fall headlong into the madness of love.

"This is hilarious, I have to say," laughs Casey. "That we're walking, having a conversation about falling in love. For your book. Everything becomes about art and ideas. Like falling in love is some kind of artistic idea."

"But that's okay, isn't it?"

"Yeah!"

Part of the beauty of falling in love, though, is that you don't have to know that you're compatible or similar or beautifully matched-up. You have no idea who you might fall in love with. It's a diversion that you often don't have any control over. You can't guess where the story may be going.

Me: That "not knowing" is part of love's beauty.

Casey: It is. That uncertainty of what might happen is just... delicious. That wondering what comes next. You can kind of, worry about it. Or just think, ride this, see where it goes, see where it takes you.

I ask Casey to remember a moment, a person, a thing in her life where she felt that similar shifting of her world. Her reply is uncannily similar to my own version, my watching Sex Pistols on Granada TV and not having a cultural vocabulary for what I'd just seen.

"It was seeing David Bowie on Saturday Night Live in, I think, 1979. I was eleven years old, and I watched Bowie being carried onstage in some sort of fibreglass dress that he couldn't walk in. He was backed by the German artist Klaus Nomi, and drag artist Joey Arias, I found out afterwards—and sang 'The Man Who Sold the World.' Then he changed into an army uniform—a women's uniform—with military skirt, and performed 'TVC 15.' Seeing it on my TV in my little Delaware living room. The queer art of it, the spectacle of it. Me and my sister were just thinking, 'What is this wonderfulness!' But when you see something and think, 'Okay, that's it—I'll never be the same...'"

I go back and search YouTube and find this Bowie performance on Saturday Night Live and I'm struck by how shocking this performance would still seem (in 2024) to a mainstream American audience. I begin to understand how an eleven-year-old Casey would see it—Bowie bursting onto late-night TV in all his glorious,

spectacular, trashy cabaret androgyny. It's beautiful.

Writer Jay Griffiths will tell me, when asked about her particular Disruptors, that for her it was a teacher—but could just as easily have been a hero, a parent, a book, a falling-in-love with a TV pop show… all part of the swirl of unasked-for possibilities that disrupt the straight and narrow.

Casey is still in that world of uncertainty and wonderfulness, her new photographs recording the lives of a generation of nonbinary, fascinating and possibly shocking young people. We're both of us carrying with us the shockwaves we felt in our youths and trying to pass them on, desperate not to forget how important those disruptions were, how powerful they can be.

And yes, Casey—you made the top ten Disrupters.

In at number six.

Inger and the Lucky Dog

> I'd rather regret the things that I have done than the things
> that I have not done.
> —Lucille Ball

Just up the road from where I was born, there's the small industri-
al town of Todmorden, commonly known simply as Tod. Steep-
sided valleys run from the ribbon of the town up to somewhere
halfway to the heavens, covered in scrubby heather that looks like
a threadbare carpet. There's a train station, several chip shops, a
legendary pub called The Golden Lion and a grand old town hall.
It's now wholly and officially in Yorkshire, but until 1888 it strad-
dled Yorkshire and Lancashire, with the boundary line running
right through the town hall.

At one end of the town is Centre Vale Park, a wide-open space
with a little bicycle track, tennis courts and a lucky dog. *Lucky Dog*
is cast from bronze and is a smidgeon bigger than "life-sized," all
shiny and smooth from where people have patted and stroked its
metal coat. And that's the thing—people travel from miles around
to see the dog and to pat it, eager to make a wish and test if *Lucky
Dog* is actually lucky. There are tales around town of people who've
been brought good fortune after stroking *Lucky Dog*.

Magician and illusionist Derren Brown made a film about *Lucky
Dog*—he wanted to test the idea that people who think they're
lucky have more chance of being lucky, and vice versa: if you think
you're luckless, you probably won't find yourself being lucky.
Reason being (to take his hourlong show and reduce it to a sen-
tence) that people who feel they're lucky are actively looking for
opportunities that chance throws their way; those who think
they're unlucky switch off from the same opportunities.

That makes sense, without delving into any magic or illusion

(or peer-reviewed psychological studies): if you're open to try new things, then you increase your chance of good stuff happening. Stroking *Lucky Dog* just demonstrates that you're willing to give something a go. (For the record, I'm too boringly level-headed to stroke a sculpture of a dog in the belief that it might bring me luck. But if it counts as balance, I'm often happy to throw caution to the wind, even if it's meant broken ribs and severed arteries.) In short, lucky people are those people ready to jump in and test the water. Fortune favours the brave and all that.

Here's a story about my old friend Inger, who I met up with a few years ago while helping to put together an exhibition based on the East Lancs punk scene in the late 1970s. I haven't had a conversation with Inger since she left the Colne area for London around four decades ago. Since then she's brought up two daughters, working in the film, arts and publishing industries until she suffered a brain haemorrhage several years ago. Lately she's been recovering, gradually piecing her life back together, travelling up north occasionally to look after her mum (who still lives in Colne). We meet at her mum's postwar semi-detached, tucked away off the Colne bypass. You know, one of those roads that are designed to funnel traffic past a town but instead, with the addition of fast food drive-throughs and cheap supermarkets and bargain stores, become a permanent traffic jam.

Inger asks if we can walk to the nearby park, since it's a place she's particularly fond of—it's where she used to come during the punk era to escape her parents, meet friends and smoke cigarettes. There's a café where a friendly dog yaps for attention and they sell tea in big mugs. Inger sits at an outside table, draws breath and begins to talk. The words come tumbling out in what feels like an emotional and heartfelt gathering of the past, a keeping of personal accounts with life's ongoing checks and balances:

> "I think I was looking for something before punk. I did an art foundation course at Nelson & Colne College, but I didn't want to go to university. Around that time, I started making my own art and writing stories and things. The only option that seemed to be offered to me

was to go to Manchester University to do an art degree, but I didn't like the idea of it. It felt very prescriptive. And so I didn't want to do that. And I also think around that time I had a boyfriend and I didn't want to go away, I wanted to stay in this area. So for some bizarre reason, I got a job in a mill. Just round here, down at the corner, in a weaving mill.

"All my family had worked in the mills, so I was a bit intrigued—to do that job and have a real working experience. So I went to work there, and it was hell on earth! I mean in a physical sense, but the camaraderie was second to none. I earned twenty-three pounds a week, working seven in the morning till four in the afternoon. But all the while I think I was looking for something —I started working there just before our local band Notsensibles played with UK Subs in Colne, at the Union. I'd never seen anything like it. I'd heard a bit of the music on the radio, just hints of music. When I heard about the gig I was just like, 'Oh my god, I've got to go to that.' Because it was sort of an explosion. And I was living in this tiny place. And I knew I had creativity in me."

It strikes me, listening to Inger, that one of the things that punk threw up was it gave kids an outlet to be creative, to be brave, to be open to new ideas. It wasn't an academic or tutored creativity, it was a learn-as-you-go-along, stick-it-together-with-tape-and-sewing-machine-and-photocopier burst of ideas and possibilities.

"I still remember that gig. Because literally that night, I felt like a giant **ON** switch was turned on inside me. And I connected with this energy—it was like it made me come alive. It actually electrified me, turned something on. And I also liked it because there were girls there as well as men, and it all just felt like it connected with some sort of raw energy inside me."

There's a tangible and inspiring passion in Inger's voice, sitting here in this small-town park with old blokes getting ready to play

bowls and the little wooden café looking like it's held together with fifteen coats of green paint. A lot of people reading this will identify with that moment of catching onto something spirited and intense, identifying like-minded people and watching a world opening up. Let's face it, for a lot of people in East Lancs, the 1970s were a time of closing down—the textile industry leaving behind huge empty mills, a male-dominated pub culture of fighting and crap covers bands and once-dominant local football teams dropping down through the leagues. The clichés took root: landscapes dotted with factory chimneys, dole queues and rotten concrete shopping centres.

> "You know, there's some film online somewhere that someone took of that UK Subs gig. It's so funny. Because being here in the late '70s was like being in the late '50s anywhere else. And there were no big shops in the town, there was a market and an indoor market, lots of pie shops and bread shops and small shops. But there was nothing going on whatsoever."

Inger is right—in the 1970s, the only story around here was about post-industrial malaise: once-thriving towns becoming ghost towns, their shrinking populations hemming everyone in—our minds, like the factories, shutting down. Punk gave people an alternative narrative, especially for girls like Inger. For the first time, women were properly involved in the music and the culture, feeling like more than accessories. Girls could look for inspiration from Siouxsie, Poly Styrene, The Slits, The Raincoats, Chrissie Hynde and Debbie Harry—all of them powerful, iconic and mouthy, writing songs and fronting bands.

> "All the girls that were involved around here, they were quite united, dancing in a rough, physical way, in a way that girls were not supposed to be. And I just felt like that as well. And that early period, with girls and young women, there was no question about whether you could be involved or not. It was a very equal scene in that way. If you had a thought or an opinion or something you wanted to say about a piece of music or whatever, it was

listened to really equally; it was very democratic. Because
as we progressed on to the opening of local punk venue
the Railway Workers' Club, and going to see bands play
around other places in the North, there were a lot of girls
and young women involved. You felt like a person!"
This explosion of lifestyle and energy led to Inger leaving the mill
and getting occasional work in a hotel in the area. It was while
working there that she found herself behind the bar where,
bizarrely, the Monty Python cast and production team happened
to be staying. They were working on the Python film *Meaning of
Life*—shooting scenes set on a typically Northern cobbled back
street—gathering for drinks at their hotel each night after filming.

"What happened was that in 1980, the Monty Pythons
came to Colne and I was working in a hotel in Nelson
called the Spring Bank. And a lot of the film crew were
staying there, and they invited me along to the set. And it
ended up where during the daytime I went to the set
helping the wardrobe lady every day, while still running
the bar every night for about two weeks. I was dead on
my feet! But at some point John Cleese fell ill, and my
boyfriend at the time was the same height as Cleese, so
they asked if he'd be a film stand-in.

"So then the two of us got invited to go to London to
where they were doing the last shots for the film. And I
ended up being the housekeeper for the wardrobe lady,
and just stayed down there and ended up working in
the film industry for about three years, *Star Wars* and
Superman and all of these films."

So Inger literally ran away to join the Circus (and this story is
worth telling simply for that final line).

"This song is Copyrighted in U.S.,
under Seal of Copyright #154085,
for a period of 28 years, and
anybody caught singing it
without our permission will be
mighty good friends of ours,
'cause we don't give a darn.
Publish it. Write it. Sing it.
Swing to it. Yodel it. We wrote it,
that's all we wanted to do."

—Message from Woody Guthrie
 in a booklet of lyrics distributed to fans

The Devil's Interval

The reason it's unsettling is that it's ambiguous, unresolved
—it wants to go somewhere. It wants to settle either here,
or there. You don't know where it'll go, but it can't stop
where it is.
> —Gerald Moshell, professor of music at
> Trinity College in Hartford, Connecticut

Western classical and popular music rests on a set of rules that are
rooted in fixed musical scales, reinforced by the instruments we
play. Working with string players from Iran several years ago, I was
reminded that musical scales—the gaps between each note—are
different according to culture and geography. The traditional
Persian scale contains quarter tones that don't normally exist in
Western music. These are differences that have existed for centu-
ries, differences that, like language, are either a barrier to commu-
nication or a beautiful challenge. We train our ears and brains to
listen based on our own singular heritage, a heritage that's often
been passed down through the years as "correct," and a correctness
that may be rooted in (for instance) class or religion. Who gets
to decide what is high art and low art? Is it my secondary school
music teacher, sitting by the open classroom window smoking his
cigarette as we listened in bored, agitated silence to Debussy?

I learned to read music at church. Our church was a disused
1940s swimming baths that sat overlooking the railway station in
Rosegrove, a part of Burnley that might have been famous for
having hosted—in an upstairs pub folk night—a solo touring
Paul Simon in 1965, but nobody could remember if it had actually
happened. We had our own hymn books full of songs written by
Mormon pioneers as they crossed the States to Salt Lake City;
some were jaunty, enthusiastic songs designed to be sung while

working ("Put your shoulder to the wheel, push along / Do your duty with a heart full of song"), others were dreary and seemed to lack any discernible rhythm, with words about dragging yourself tempest-tossed through life's trials and tribulations. I used to stand with my mum, looking at the peculiar squiggles in her hymn book and wondering why the words skipped from one set of lines to another. Then one Sunday, as we sang to close the morning service, it clicked—heaven's rays shine down on this young kid with his basin-head haircut!—and I realised that the dots went up and down according to the notes we were singing. The fact that I'd discovered it myself rather than being taught it meant I eagerly welcomed this new language into my life along with football and *Thunderbirds*.

Shortly after this, my sister was encouraged to have piano lessons, taught by an old woman who held a ruler at all times in order to rap childish fingers when they strayed. I declined the voluntary abuse and listened to my sister's Marc Bolan records instead. Bolan was a man-boy so devilishly beautiful that he made rock'n'roll boogie sound like sin itself. The Mormon Church had a living prophet who made occasional pronouncements on music, perhaps realising what the teenage Latter-day Saint membership was listening to at home. He told us that *"the most effective preaching of the gospel is when it is accompanied by beautiful, appropriate music"* while the hymn books themselves were prefaced with a dedication that read: *"Music has boundless powers for moving families toward greater spirituality and devotion to the gospel. Latter-day Saints should fill their homes with the sound of worthy music."*

The words "appropriate" and "worthy" were descriptors with enough open-ended looseness (to my young mind, at least) to perhaps allow Marc Bolan to slip in alongside the Mormon Tabernacle Choir. For, no matter how keen religious leaders were to steer teenage minds away from devilish music, let's face it: they were fighting a losing battle. There was already a long-established connection between the driving, rhythmic and uplifting music of the gospel tents and Pentecostal meetings (Hallelujah!) and the foot-stomping rabble-rousing of rock music. Witness (and there's a

shared word, right there) Jerry Lee Lewis, one foot on the pianner, greased hair exploding like electricity as he shakes, rattles and rolls …all the while singing praises to the glory of God.

Godfather of Soul James Brown grew up under the influence of the preacher Sweet Daddy Grace, a cape-wearing tub-thumper who, according to his obituary in *Ebony* magazine, "cracked the whip in a circus of gaudy costumes, wildly gyrating acrobats and brass bands that played as if God were a cosmic hipster." Brown himself simply yelled, "Sanctified people got more fire!"

This musical fire certainly wasn't scripted by the devout spiritual forefathers of the Middle Ages, whose version of beginning, middle and end was soundtracked by devotional music sung at the altar with melodies often replaced by monophonic chanting— litanies delivered, solo and chorally, on a single note. Instruments were frowned upon by the church (St Jerome wrote that a Christian maiden ought not even to know what a lyre or flute is like, or to what use it is put) until the twelfth century, when a single organ was introduced to accompany the chants. As opposed to pipes and lyres, an organ was thought to inhibit, rather than encourage, rhythmic movement. Tell that to Jerry Lee.

Which brings us to the infamous Devil's Interval, a particular (and some would say peculiar) "clashing" musical sound made by playing notes separated by six half tones. Some sources maintain that church leaders in twelfth-century Europe declared that the jump between these notes, or the dissonant chord made by playing them together, encapsulated the very essence of evil. So sure were they of the power of this musical incongruity that they banned it, reputedly relying on torture to ensure that the ban was upheld. When I say "Some sources maintain," what I mean is that, since little documentation survives from that time, it may be a well-constructed myth. The idea that sacred music could be disrupted by the introduction of an odd chord or jump between notes is outlandish, but perhaps (as the quote at the start of this chapter explains) it isn't so much about the sound of the interval itself as about the feeling that the music hasn't resolved, that it is waiting around for an acceptable major chord to give us a satisfac-

tory musical passage. Music's liminal space, a place with possibilities—*you don't know where it'll go.*

A quick example of the Devil's Interval: *The Simpsons'* theme tune. The tritone comes in almost straight away, on the second note of that famous three-note opening vocal harmony—it's the jump between *The* and *Simp.* Sing along and cross yourself, here goes:

 The

 Simp—
 —sons

!

Hollywood Ageing Cream

Bliss was it in that dawn to be alive, but to be young was
very heaven!
　　—William Wordsworth

When Sandra Bullock appeared towards the end of the film *Bullet Train*, it was a shock. Surgery had smoothed and stretched her features into a sort of blurred version of herself, no hard edges, no creases, nothing to indicate the ageing process. And straight away the film and its story and its dialogue and its various stars all firing guns at each other disappeared as I went down an instant wormhole that led down, down, down into Sandra Bullock's fear of getting old, or at least her fear of looking old, and I wondered how Hollywood does that to people, how it equates beauty with youth, and suddenly I was sad for Sandra and sad for all the women (since it is mainly women; Hollywood men are allowed to grow old with a sort of rugged, paternal grace. And they still get to have on-screen romances with women half their age) who have to watch Sandra and think that surgically altering your face until you're smoothed out into a Gaussian-filtered mush is okay, it's a way to stay in the game.

Nobody really wants to get old, do they? Casey's grandmother used to warn us, regularly, "Don't get old. It sucks." Ageing brings ill health, things start to drop off, scars don't heal, hair falls out and you shrink. Nobody wants that, truly, but once we move into old age, once we realise *we are the old people our grandparents warned us about*, then it's part of life's fascinating story to adapt and take stock, to enter an agreement with the passing years, to embrace an uneasy acceptance of where we're heading. We can put up a fight by keeping healthy and active, but at some point there's a huge *BUT* in the story of our lives that prevents it from having the

"happily ever after" ending—happily ever after walks into a long sunset, forever. Life, in contrast, commonly ends with fluorescent lighting above a hospital bed, a last pained gasp while wired to a machine.

So much of our culture is fixated on youth. And it's understandable—in youth we have energy, hope, optimism. We're still on the way up. And when we're young we look at the older generations and we see them as unhealthy and tired, we see them as people who gave up on dreams of a better world and instead started to wear comfortable stretchy clothing and voted for whichever political party would best protect their life savings.

The idea that we get more conservative as we get older is generally overstated—it fluctuates, country to country, generation to generation—but undoubtedly, since the 2008 financial crash and the subsequent lack of stability in jobs, in housing and in savings for the young, there's a definite age gap opened up. Generally speaking, the young want a socially liberal world that is empathetic, diverse and inclusive; the old want to hide in the editorial columns of the *Daily Mail* nodding along to Gary Barlow. I mean, old folk don't make getting old seem at all attractive—I should know, I'm in there with them, fighting off an online bombardment of products and services that have decided I'm of an age to start using elasticated shoelaces, automatic jar openers and cuffed jogging bottoms. My primary aim when I'm watching my son doing tricks and flips at the skatepark is to not look like a paedophile.

Hollywood deals with the problem of ageing by ignoring it. George Clooney and Julia Roberts still get to star in films as "older people" simply because they still look fabulously fit and beautiful. You won't see the scene in the kitchen where George, in his jogging bottoms, waxes lyrical about his new elasticated shoelaces. Or, when you can't ignore old age, you do what Sandra does and pretend it isn't happening. All this stuff, it's not a great model for real life, is it?

Rock 'n' roll acts in the same way. Some artists manage (or managed) to grow old with a degree of cool (David Bowie, Dolly

Parton, Yoko Ono), but mainly they just disappear from view, popping up as figures of fun in the tabloids. Look at the musicians we class as icons, how many of them died young: Ian Curtis, Kurt Cobain, Amy Winehouse, Tupac, Nick Drake, Karen Carpenter, Billie Holiday, Jeff Buckley—all talented and beautiful and preserved in the amber resin of youth. We love their stories, their Beginning, Middle and (untimely) End. In reality, the vast majority of pop stars end up wandering around their big kitchens looking for their automatic jar openers and wondering how to use the damned fiddly TV remote.

Writer David Cox looked at a large swathe of Hollywood classics and came to the conclusion that "there have been a good few kindly old grandmas, but more often the elderly have been shown as ineffectual, grumpy, behind the times, depressed, lonely, slow-witted, sickly, whining, rude, miserly, hard-of-hearing, ugly, interfering, heartless, intransigent, doddering, mentorish, frisky or profane." What isn't usually shown, however, are any of the everyday realities of getting old—diabetes, chronic back pain, repeated night-time trips to the loo, obesity, cancer. The stuff that defines old age. Why? Because we want stories that make us feel good about our lives, that give us purpose, aspiration and hope. Even to the point where we're sold a story that tells us it's better to die young (preferably in a hail of bullets, like Tupac) than to die as a shuffling diabetic.

Johnny Cash was a long-established legend by the time he reached his sixties. True, he hadn't made a great record for a couple of decades, and he only made the news when he was doing something awkward like touring with evangelist Billy Graham or becoming addicted to painkillers. In 1990 the Man in Black recorded an album titled *Johnny Cash Reads the Complete New Testament*. While the legend remained, preserved in all its rebel-outlaw glory since the 1960s, Johnny Cash the person seemed to be fading, disappearing from view. This is how such stories end: a long silence interrupted by a radio obituary.

But then producer Rick Rubin disrupted the narrative by making a trip to see Cash playing in a small dinner theatre in

Orange County, California. After the show, a barefooted, bearded Rubin—known for his work with Beastie Boys, Slayer, Public Enemy and Red Hot Chili Peppers—approached the Man in Black and asked if he'd visit Rubin's studio and play some songs, just him and his guitar, no band. The outcome of Rubin's enthusiasm—to rediscover the deep, passionate voice that had held such gravitas in the 1960s—was a run of six incredible albums (the *American Recordings* series) culminating in the posthumously released *American VI: Ain't No Grave*, recorded shortly before Cash died in 2003.

The first song Johnny Cash ever wrote and recorded was "Hey Porter," written in 1954 by the twenty-two-year-old singer newly returned from a spell in the air force. The song is about a train journey: a young boy is returning home to Tennessee, pestering the railway guard with his repeated, nagging "How much longer?" In 2003, the seventy-one-year-old Cash, wheelchair-bound and suffering from a neurodegenerative disease, wrote his last song, "Like the 309," about another train journey—this time, it's the train that will carry his coffin to its resting place. The voice is fragile and uneven, but it is unmistakably Cash. A defiant, adamant, in-your-face refusal to "cry and whine," it ends—as did his unlikely career—with the lines, "Write me a letter, sing me a song / Tell me all about it, what I did wrong / Meanwhile, I will be doin' fine / Then load my box on the 309…"

The biopic of Cash's life, *Walk the Line*, was a critical and box office success, nominated for several Oscars. But like most music biopics, the film hammers the complicated narrative of Cash's life into a smooth, glossy and ultimately flat story that decides to ignore that final surprising decade. A few days after I'd seen the film, I was shopping, jet-lagged, in an all-night grocery store somewhere outside Wilmington, Delaware. The tannoy system was playing Johnny Cash's "Folsom Prison Blues." A man wheeling an overfilled shopping cart passed by me and caught my eye, two middle-aged men with our packets and tins, humming along to "I shot a man in Reno…" The man stopped and said, "You seen the film? The Johnny Cash film?"

"Yes," I said, "I've seen it."

He couldn't contain his enthusiasm. He was wearing slippers.

"What a film, whoo boy!"

"Yeah," I agreed, smiling. I wasn't about to get into a critique of how Hollywood portrays our generation's cultural heroes, how it carefully turns life's complex and awkward journeys into myth and legend. How these biopics rarely acknowledge old age, how Hollywood tends to linger on the geniuses who had the film-friendly fortune to die young.

"And that prison scene! You think that was true? That he actually played in a prison?!"

"Yeah, that was true."

"It was? Oh my! Amazing!"

And with that we parted, heading off to our different aisles in search of the truth.

POSTSCRIPT:

There's a lovely snippet of an interview that Johnny Cash's daughter Rosanne gave to an audience at Harvard in 2010. She was asked whether she had enjoyed the film *Walk the Line*.

"I thought what anyone would think if they made a Hollywood version of your childhood. Nobody would like that."

Rosanne refused to go to the premiere, having seen the film at home. She said seeing the film was "painful, because it had the three most damaging events of my childhood: my parents' divorce, my father's drug addiction, and something else bad that I can't remember now."

Hope

Life's under no obligation
to give us what we expect.
—Margaret Mitchell

The traditional story form
has always incorporated
 hope.
 The idea that, despite
 the setbacks and struggles,
 our storybook heroes
 (masquerading as ourselves)
 will put
 hope
 and action
 together and
 force a satisfactory
 ending.
 Rebecca Solnit's version of
 hope,
 which she writes about in
 her book
 Hope
 in the Dark,

 is practical and inspiring.
 She writes of a world where,
 even though we are living
 through notably disastrous
 times, watching the rise to
power of populist billionaires
 against a backdrop of
 climate catastrophe,

[274]

there are events and
communities to celebrate.
 There is always
 hope,
 and we can use
 hope
 to change the world.
 That's not the same
 as storybook
 hope,
 where we expect
 a happy ending—it's a
 hope
 that we have to intervene on,
 fight for, a
 hope
 we have to force.
I've stuck to that mantra of
 "act upon
 hope"
 for decades now,
 as a watchword for progress,
 a way out of this mess.
 But that
 hope
 seems a lot more precarious
 now than it did back then.
 It's fair to say that things
 have got worse, and
 continue to get worse.
 There are numerous
 victories, of course,
 all the time, everywhere.
 Victories that give us
 hope.
 But.
 But the last decade of

political battering has
been enough to get
under the skin of
the most positive of people.
Aristotle, the man who I've
been holding responsible for
my wayward exploration of
the story form, said,
"Hopefulness
creates confidence,
which, if derived from the
right sources, can lead to
the virtue of courage."
In other words,
hope

can spur us on to
the pursuit of the noble.
So I hang on to it,
and work with it,
and refuse to be dragged
into being a cynic.

Writer Jeanette Winterson
is notably forthright in
her defence of
hope.

Jeanette wrote *Oranges Are
Not the Only Fruit*, a thinly
disguised memoir, and
followed it with a series of
wonderful, gorgeously
crafted books. Jeanette's life
story is a lot like mine—
we were both brought up in
small Lancashire towns, our
mothers both took up with
fundamental, proselytising

churches after God came
knocking on the door of
our terraced council houses.
All that stuff.
Unlike Jeanette Winterson,
I had a sister and she
had a father.

I loved reading,
and then I loved writing.
Eventually I wondered
if this was an interesting
enough story to tell—
the huge cotton mill at
the bottom of our street,
the broken-glass-strewn
recreation ground,
the weekly visit from the
pop van dispensing fizzy
drinks. A strange mix
of mill chimney nostalgia
and fundamentalist religion,
Beatles songs on the radio
and Enid Blyton hardbacks
from Burnley Central Library.
Then I read
Jeanette Winterson's
*Oranges Are Not the Only
Fruit*, and I went to see her at
a book launch in Leeds,
and I realised that
though her story is weirdly
similar to mine, hers is better.
Much, much better.
Her Bible-bashing
Pentecostal upbringing
was more extreme,

her love of books
more committed.
(She ended up with a
master's degree at
St Catherine's College,
Oxford.) And she can
set a house on fire
with her writing.
Jeanette,
like Rebecca Solnit,
comes across as a positive,
hopeful
person.
Recently she has been
writing and talking a lot
about artificial intelligence,
about it possibly being
a force for good:
that the challenges
it might bring
are exciting,
fascinating challenges.
And I want to agree,
I want to share that sense of
hope,
but I struggle with it—
I can't care about the
exciting possibilities of
this new technology
until I can know who
will ultimately control it.
Who presses the "go" button.
I'm a generally
hopeful
person,
but I saw what happened

to the internet: saw the rapid
slide from a huge network
of ideas and a progressive
tool for education into a
New Improved Marketplace
that can dictate who wins
and loses elections.

Hope

is a great story,
but it needs to be more
than relentlessly positive.

At the end of 2020, just
when the Covid restrictions
had been briefly lifted,
me and Josh decided to go on
a road trip. Josh is a good
friend who likes nothing
more than to get in a car and
drive. Anywhere, just to be
behind the wheel, reliving a
thousand cross-country road
trips he'd taken as a young
man, often following around
bands from gig to gig.
He's still looking for that
off-the-beaten-track
experience, rolling up
cigarettes with complete
strangers, determined to wear
shorts right through winter,
cooking up meals on road-
side camping stoves. He's a
food writer, an illustrator
and a part-time adventurer
who took up skateboarding
as a fifty-year-old.

On the spur of a last-orders-
at-The-Black-Horse moment,
we decide it would be fun to
visit the three places on
mainland Britain called

Hope

—three

Hopes

in three different countries.
There's a

Hope

village in the English Peak
District, a community
nestled at the foot of two
hills called Lose Hill
and Win Hill (really).
Then there's

Hope

in Flintshire, Wales,
a small community
(a pub, a church, a shop)
with the grandly titled

Hope

Mountain to its west.
It isn't a mountain—
it's a hill with a trig point.
Then finally, in the very
north of Scotland,
there's the most
northerly of the
Munros mountain
range,

Ben

Hope.

It summits at 927 metres
(definitely a mountain!),

and from there you can
look north to Loch
 Hope
 and the North Sea.

Since we would be setting off
 in the grip of winter,
 we imagined Ben
 Hope
 might be too deep
 in snow to climb,
 but since this journey
 was all about
 Hope
 we just packed gloves and
 boots and set off.

 Why did we
 decide to do this?
 It just sounded funny,
 that's all.
Interesting and unnecessary.
 At first we tried to justify it
 by saying we'd make
 a podcast about it.
 We even borrowed a digital
recorder. But it didn't take us
 long to think that making a
podcast was somehow trying
 to turn a mad idea into a
 product—and it definitely
wasn't a product, it was just
 a story without a structure,
 without a purpose.
 The primary role of
religion was always to give
 purpose to life (and death).
 To invent reasons for both.

Then when religion buckled
under the weight of
the Enlightenment,
along came capitalism
with another set of reasons:
the purpose now
is to work, to accumulate.
Once we had God,
now we have the
almighty Growth.
Jumping into a car and
visiting three far-flung places
called

Hope

was our two fingers
to purpose—
it just sounded funny.

First port of call is the Peak
District, where (due to Covid
restrictions) the B&B we are
staying in is completely and
strangely empty. Breakfast
is left on a tray outside our
room by a landlord with a
cheery "Good morning!"
(We never see him.)
It's December-cold, there are
flurries of snow, but we pull
on coats and head off to
walk both Win and Lose
Hills. Legend has it that a
long and bloody battle took
place in 626AD, between
two rival kings: Edwin from
Northumbria and Cuicholm
from Wessex. It isn't clear

what their dispute was about,
but they ended up each
camped with their armies
on the two opposing hills.
A daytime raid on Win Hill
by Cuicholm's army was
rebuffed when Edwin's army
pursued the tactic of rolling
boulders down the hill to
crush the advancing enemy.
Edwin's victory meant that
the hill he occupied was
named Win Hill, and
Cuicholm's slightly higher
summit was named Lose Hill.
But that's just a beautiful
myth, of course. And though
this story is retold and
reprinted as part of

Hope

village's heritage,
no record has ever been
found of a battle. The name
of Lose Hill may, instead,
derive from the Old English
word for pigsties.
 By the time we conquer
the higher slopes of Win Hill
and set off down to the
valley that bisects the two
hills, Josh is in need of a
cigarette and a sit-down.
Climbing Lose Hill,
he takes frequent rest stops
and shakes his head as if
wondering what he's let

himself in for. I begin to get
a little worried about our
plan—two days from now—
to climb Ben

Hope

in what will
probably be thick snow.
"You going to be all right
climbing a proper mountain,
mate?"
"Aye. Don't worry—as long
as I have my cigs I'll be fine."
Arriving back in

Hope

village, we jump in the car
and set off for another

Hope

village, the Welsh one.

Not much of a drive, but
enough for Josh to tell me
all about the mechanics
of cruise control.

zz

When I wake up I realise
I've been dreaming about
artificial intelligence.
Josh's love of cruise control
has me wondering about
how to run over
your enemies in
a driverless car.
I rub my eyes.
We are in the heart
of Flintshire's

Hope,

with its impressive church.
Facing the main road, the
glass-boxed nativity display
in the graveyard is a perfect
mismatch of shop dummies
and jumble-sale cloaks and
headdresses, with the
manger/crib being notice-
ably empty. As we prowl
around the churchyard, a
kindly-looking man wearing
a tweed jacket approaches us
and asks what we're
looking for.

"We just wanted to look
around the church.
We're visiting different places
called

Hope,

and we thought it would be
nice to visit the church.
Are you the vicar?"

"I'm a custodian.
The rector isn't here. I should
tell you that the church has
been closed for services for
over a year. Due to the
restrictions. But if you only
want a look around…"
What a lovely bloke,
with a green woollen tie
and his head slightly at an
angle, his eyebrows set to a
constant expression of
"Can I help you?"

He opens the main door of
the chapel and we pull on
our masks and walk in.
There's one question
I want to ask.
"Do you get people
coming here, like us,
just to say they're looking for

Hope?"

"Oh yes. Regularly.
From all over the world.
Americans, Australians…"
We ask about church
services, and he explains
that each Sunday under
normal circumstance there
would be a "traditional"
service and a "modern"
service. He declines to say
which is more popular, but
he does let us know that he's
eager for the church to
resume its

"Hope

Church Pet Service,"
a thanksgiving service for
pets "to celebrate God's
wonderful creation."
We say our goodbyes
and head for

Hope

Mountain, which is a bit of
a grassy bump and an
anticlimax after the thrill of
the church—then get back
into the car and head

northwards, towards
Scotland. Josh grips the
steering wheel, turns on
the cruise control and
sets the sat nav

for Ben
Hope.
Ben
Hope

is two days' driving, so we
decide to listen to an online
collection of dance remixes
of songs by anarcho-punk
outliers Crass. This is a
project where the band
had released the separate
instrumental and vocal
recordings of their first
album and encouraged
people—anyone, anywhere
—to submit a remix. There is
an online playlist where you
can listen to them all—
all 222 of them.
Two hundred and twenty-
two. Let's go, number one.
Press play.

While we listen,
we talk about
hope.
I'm a reasonably
hopeful
person, and will be generally
upbeat about things,
trying my best not to get
too bogged down in the

depressing day-to-day politics
on the news. My ongoing
mission is to celebrate the
(large and small) victories
that challenge the seemingly
endless rolling news of war,
climate catastrophe,
devious politicians and TV
celebrities. The *shitshow*,
as it's sometimes referred to.
Josh is not like me.
He finds the concept of

 hope

 just too wishy-washy,
 and he reckons
 we don't need

 hope

 as much as we need to blow
 up the Houses of Parliament.
 From our conversations
 I don't get the impression
 he's developing a
 growing sense of

 hope,

 mainly there's just an
 ongoing sense of hunger—
 Josh likes to stop in every
 town or village that might
 have a pie shop. Set the
 cruise control to Steak &
 Kidney. We drive steadily
 northwards through
 Scotland, staying overnight
 in Perth in another
 seemingly abandoned hotel,
 a grand affair with lots of

old, dark wood and a
sweeping staircase.
We barely see anyone—
the pandemic has left these
busy little communities
feeling like ghost towns.
 The following day we
drive an uncountable
number of miles. Josh does
all the driving. It doesn't
matter how much I offer to
take over, he won't give up
the steering wheel. He loves
it. Loves his cruise control
and won't let me touch it.
We drive through rainstorms
and snowstorms, past
unruffled herds of stag deer,
through genuine whiteouts
that force us to slow to a
crawl. We drive through an
afternoon of dull sunlight
that can't dim the beauty of
the mountains around us,
seemingly getting higher
and more impressive as we
move steadily towards
the north coast.
 And then
we're at the foot of
Ben

Hope,

 pulling into a lay-by
 alongside an empty and
freezing B road, sharing the
 valley with a winding river

that moves sluggishly in the
icy wind. Josh makes sure
he's got his cigarettes and
a lighter and we set off,
straight up the steep and
rough path that dwindles and
disappears and reappears
again, reaching the snow line
about halfway up. From here
we walk through deepening
snow, and soon we hit the
clouds. With there being
no sign of footprints or
way markers, we follow a
compass bearing up, up, up
into the thickening cloud,
visibility dropping to twenty
or thirty feet. Josh has to keep
stopping to rest, but tells
himself that he won't reward
himself with a cigarette until
we get to the summit. We
plod on, breathing heavily
into the thick gloop, until the
steepness becomes gradually
more shallow. I warn Josh
to keep close, since there
are now steep drops on
both sides of us.
The
fact
that
we
can't
see
them

makes
them
scarier.
And then there's a
dark shape in front of us,
an ice-covered trig point,
and we're there, and Josh can
get his cigs out and celebrate
for several ice-cold minutes
before we turn around and
head
back
down.

The next day we begin the
long drive home, somehow
fulfilled by the purposeless
adventure of it all.
Experiencing things,
isn't that purpose enough?
I'm not sure if the trip
taught us anything about
hope,
though
—the writing of
Rebecca Solnit and
Jeanette Winterson does
that. Maybe next time we'll
invite them; we still have
almost a hundred Crass
remixes to get through.
In the meantime, here's
Winterson being interviewed
in 2022, outrageously
hopeful
about the beginnings of
artificial intelligence and the

end of humans as a species:

"It's so strange, isn't it...
we might be gone.
We've only been here three
hundred thousand years,
folks, so don't get excited!
That's a very short blip in
time, and I do think we
might have reached the
end of our usefulness,
in this present iteration
—because we're going
backwards now, aren't we?
We are so going backwards.
This isn't working in the way
we thought it would; I mean,
look what is happening out
there in the world. Maybe
this nasty, brutish species
needs to get a reboot, and
this is our chance.
 "AI isn't interested in
the status symbols that
we're interested in.
It's not interested in land
grabs and Ferraris and yachts
and billions in the bank.
It doesn't go shopping,
that's not going to be where
its interest comes from.
It may be that we,
in that symbiotic exchange,
might learn to give up on
this lunatic materiality that
has accelerated since the
Industrial Revolution,
and learn to have some of

those price-sensitive values
that are the best of us."

Aah, such optimism.
Or a simple belief
in a good story
having a happy ending.
As I was writing this book,
I drove out of Leeds
with some bloody awful
Drive-Time Radio
playing in the car.
The two
yammering presenters,
in between giggling
at each others' inanities,
promised us,
the listeners,
a real treat.

"Something that AI
has cooked up
to brighten your week."

I knew it would be
something ridiculous,
or frivolous.
Instead it
was something
that made me
profoundly sad.

"Here we are then,
we promised you a treat,
and here we have it.
A new song created using
artificial intelligence
—let's hear it,
it's the late great
Johnny Cash singing
'I'm a Barbie Girl'…"

Good Idea , Bad Idea

My
Nadeem
—guitarist
our
schoolboy
obsessive
excitable
and
of
cars,
punk
legend
my
of
'n'
anyway),
motormouth
the
surreal
Night
Will's
in
Florida—
the
to
of

a puzzle, a wish.
he'll come up with an idea,
minutes throughout the day
at least once in every five
—ideas based on puns—
Stupid, unworkable ideas,
Nadeem is full of ideas.
chopper...and the rest.
quirky hotrods, a Harley
a Plymouth hardtop, a few
a Chevrolet El Camino,
a 1960 Eldorado Brougham,
classic 1950s Cadillacs,
or already transformed, three
wrecks ready to be transformed
cars, four handfuls of them, old
being Nadeem's collection of
cave of a place. The treasure
up, a magical brick-and-mortar
parked up, lined up and pinned
nonetheless—stacked up,
auto-related jumble, but jumble
filled with jumble, mainly
door opens onto a huge space
blast of a fiery summer. The
two warehouses in the hairdryer

friend
Khan
in
first
band,
and
collector
builder
custom
Pakistani
rockabilly
(in
history
rock
roll
enigmatic
at
monthly
Bingo
at
Bar
Orlando,
opens
padlock
one
his

"Someone should invent a vacuum cleaner that has a built-in compass. Because it sucks to get lost when you're cleaning."

Or

"Why isn't the opposite of exhausted, hausted?"

Or

"I was at the Barbie movie thinking about a candy called Raisingnats, chocolate-covered gnats, naturally. But they'd be awfully small and it would take thousands to fill a box."

Or

"Ruin a singer-songwriter's name by adding a letter. I'll start—Labia Siffre."

Or

"I'm watching an ad for the Titanium Shaver, and I'm thinking that I too would like to have five independently rotating heads."

Every so often Nadeem has an idea which, instead of disappearing with a giggle and a shrug of the shoulders, becomes an ACTION. For a while recently, Nadeem kept seeing the same religious zealot outside the local clinic holding aloft a six-foot-tall placard reading

GOD
WILL FIND
A SPECIAL PLACE
IN
HELL
FOR
WHORES,
ATHEISTS,
QUEERS,
SKATEBOARDERS,
DRAG QUEENS,
PUNKS

[etc, etc, a long and lengthening list of America's most interesting people].

[295]

The tallness of the sign led Nadeem to wonder out loud about having an overlong sign that was horizontally as wide and impressive as the Zealot's sign. He made one. It was six feet wide. It read

OPPOSE

He went down to find the Zealot and stood in front of him with his board until Zealot left, cursing.

Here's another one—Nadeem's band Obliterati decided that they'd buck the trend and have a 50th Anniversary Reunion Concert right now, rather than waiting forty-five years. They invited friends, dressed in old folks' clothes salvaged from thrift stores and played with the aid of walking frames. Instead of a drum stool, the drummer sat on a commode.

Nadeem doesn't seem to make a distinction between actioned and unactioned ideas—both are given equal time and space in his daily thinking. Thoughts function as sparks, flashes of inspiration, off-the-cuff wonderings and flights of fancy. Tony Wilson, head of Factory Records and a devotee of the wayward (sometimes brilliant) reasoning of the French Situationists, claimed repeatedly that ideas needn't be made concrete to be good. To this end he made sure that Factory Records catalogued not just records, DVDs and CDs but ideas.

> FAC1 (the very first product with a Factory catalogue number) was a poster.
> FAC7 was a design for a menstrual egg timer (which was never made).
> FAC47 was the new Factory logo.
> FAC51 was a club, the Hacienda.
> FAC61 was a lawsuit between disaffected members of the Factory organisation.
> FAC83 was a birthday party.

VERTICALITY

FAC148 was a sponsored bucket, donated to a rebuilt mill.

FAC191 was the Hacienda cat.

FAC201 was a bar.

> You get the idea—and fittingly, when Wilson died,
> his coffin bore a plaque that declared it to be
> catalogued as

FAC501.

There are ideas you have at the pub, daft ideas full of purpose, only
by the time you wake up next morning they've either disappeared

boardroom table should have had the nerve to put the project down before it had a chance to be made.

"I've had an idea. It's about a huge shark that terrorises swimmers."

"It's been done. Next."

Tony Wilson understood, like Stalin (and also not like Stalin at all), that ideas inspire and excite, provoke and trigger. They don't have to have an outcome, and by the same reasoning, if there's no outcome it doesn't mean the idea was useless. Ideas are there to prod and poke as much as they are to build and create. And so Nadeem carries on, endlessly throwing out the silliest of ideas like someone throwing bread at the ducks on the pond. George Bernard Shaw, vegetarian playwright, tells this little story: "If you have an apple and I have an apple and we exchange these apples, then you and I will still each have one apple. But if you have an idea and I have an idea and we exchange these ideas, then each of us will have two ideas." What happens to the ideas isn't the important thing here—Shaw is just happy that we get double the ideas before we get to the part where the ideas might lead to something. Tony Wilson was a man who carried around quotes in his head; he understood the power of reeling off Shakespeare, Dickens, Debord, Marx (Karl) and Marx (Groucho). He parroted artist Sol LeWitt: "Ideas alone can be works of art. They are in a chain of development that may eventually find form. All ideas need not be made physical." He could switch between references to classic Greek literature and reciting lines from the first Stooges album, often with little attempt to reach a conclusion or a point, just throw in the word-grenade and stand well back.

DO NOT RETURN TO THE FIREWORK ONCE IT HAS BEEN LIT.

I love Nadeem and his ad hoc chaotic approach to ideas, plans and schemes. Several years ago he decided to build a carport outside his single-storey house in Orlando. He had steel tubing made specially at a downtown welding shed as supports for the carport, but when he returned with the heavy rods, his wife, AnnaMarie,

or become half remembered as completely unworkable and im-practical. But still, the idea made a good story, despite it being formless. One spring in 1988 a group of us were seeing out the evening at the White Horse Inn, which boasted a weekly quiz and a telly that showed the football. Unusually for Armley, in the rough-edged heart of West Leeds, it was also a pub where you could have a drink without a local meathead offering you outside. Someone (I don't remember who) brought up the news that the thrash-metal hardcore punk band Napalm Death were presently recording an album of 100 songs. A hundred! We laughed until someone (I don't remember who) said, "Wouldn't it be funny if we recorded an album of 101 songs?" And someone else (I don't remember who) said, "Yes, that'd be really funny, we should do it!"

And we all laughed and went home.

The next morning some of us dimly remembered the conversation we'd had. An album with 101 songs. And somehow, over breakfast, we decided to have a go. It took two months from idea to vinyl, and a lot of night-shift (half-price) studio recording time, and help from all sorts of friends, but there it was—*101 Songs About Sport*. Catalogue number PROP4. It wasn't a great album. Or more honestly, it wasn't even a *good* album. It was awkward and disjointed, and songs came to a halt before they'd got going—we had 101 of the things to record, we couldn't have them outstaying their welcome. But here's the thing: the story of the album, of having the idea and then making it happen, that story is better than the record. It could have, and possibly should have, remained an unfulfilled idea. Something to chuckle about. Instead we had to try and shift a thousand copies of the thing.

Joseph Stalin knew it. He said, "Ideas are more powerful than guns." I went to see the heavily trailered *Meg 2* recently. It's a film about a huge shark that attacks sun-seeking holidaymakers. It's a truly awful film, with dialogue that sounds like it's been written by a twelve-year-old with crayons.

CHARACTER ONE: That was close!
CHARACTER TWO: Too close.
It should have stayed as an idea—someone around the executive

said categorically that she didn't want a carport in front of the house. She put her foot down. No. Nadeem grumbled and whined for an hour before looking at the steel posts and realising they were the right length for a car chassis, so he set to work making an unfeasible vehicle he calls Carpor-T—a bright green T-bucket hotrod with an exposed Daimler V8 engine, an open top, huge wheels and a horn that plays "La Cucaracha." It's an outrageous, ridiculous machine built on the remnants of an idea.

All Nadeem's cars are ideas. He has twenty-one. Some are half-baked never-get-round-to-it ideas, some are mad-enough-to-have-a-go ideas, some are simply dead ideas. Others are finished, completed and fulfilled ideas, polished to a perfect sheen, chrome gleaming, split-screen window screens, tyres newly whitewalled. The neatest story here would be for every car to end up like that, fully functioning and ready to head out west. But the best story is in the muddled chaos of ideas that these vehicles represent— a beautifully scatterbrained man with a warehouse full of beauti- fully

s
a
c
t
b
r t
e
a r
i
n e
d

ideas.

No.7
Rod Dixon

An actor must never be afraid to make a fool of himself.
—Harvey Cocks

I meet Rod in the café at Leeds Playhouse, newly refurbished with a multicoloured facade that looks onto the bus station and with a big neon sign that reads

I GET KNOCKED DOWN, BUT I GET UP AGAIN

...about which I won't say anything more, except to note that it makes me really happy that the sign overlooks a gathering space for skateboarders, those teenaged disrupters, kids who completely transform the precise urban planning around every city, who see every concrete environment as a challenge. These skaters, all battered trainers and scuffed trousers, they wheel around the hard grey landscape seeing steps, kerbs, ledges, walls and planters as obstacles to conquer, as places to play. All the better that the skaters unknowingly get knocked down and get up again, and again, and again, and again, and again, attempting the same pop shove-it, kickflip and nose manual repeatedly until they get it right. Then all the surrounding skaters bang the floor with their boards to show their appreciation, a beautiful ritual that goes mostly unnoticed every day, across every town and city in the world.

Rod stands up to give me a big hug that comes with

a couple of pats on the back. I laugh and tell him, as we draw away from each other, that this is a man-thing: peppering your hug with one or two back pats, as if to say, *it's a hug but hey we're still guys, y'know?* Women don't pat.

The patting is funny because, of all the people I know, Rod is never one for social niceties; he's a disrupter through and through. He's cast himself in that role, and revels in it. He's the man who "always goes too far." He's the "there's always one!" He's the impish, baldheaded, grinning Scouser who became the artistic director at Britain's leading radical theatre company, Red Ladder, and returned it to its loud, politically outspoken roots. Here's how I met Rod: I'd written a short musical about the area where I lived, Armley in Leeds. Rod had taken a role in the show as an actor, "to keep his hand in," which was funny because Rod clearly didn't learn any of his lines yet somehow flustered and blustered his way through the show. After the show, Rod and me went to the pub. We bonded over a book by 1960s playwright John McGrath, *A Good Night Out*, a sort of manifesto for bringing theatre back from its stolid, highbrow, middle-class gentility and into the hurly-burly of popular culture. After another pint, I ventured an idea that I wanted to write a play with music based on the history

of the Yorkshire Luddites, called *Riot, Rebellion & Insurrection—A Musical Comedy.* All I had was a title. He laughed and said, "Go on then. Write it and we'll make it." And suddenly I wasn't "playing at" writing theatre, I was writing theatre. *Ping!* goes the silver pinball, flipped off at an improbable angle against the rubber-edged bumpers and bashers, *ding*

ding

ding

ding

ding

ding

and flashing lights, off on its journey from here to somewhere else. Writing full-scale touring musicals wasn't ever part of any plan, despite a crushing youthful love of *West Side Story* and *Oliver!* What Rod did, though, seemingly as a matter of habit, was blatantly—not unknowingly, or subtly, or quietly—disrupt. It's in his bones. In this café overlooking the skaters, he sometimes reels himself back in—he's the naughty kid in the classroom who knows he's "spoiling it for everyone, Dixon!" but it's in his nature to flick ink pellets or scrawl swearwords on the blackboard or mimic the teacher.

McGrath's *A Good Night Out* was published in 1981 and effectively threw a stink bomb under the stage of

traditional theatre (yes, I'm still back in the classroom). The *Financial Times* called the book "the classic statement of the aims of the counter-theatre movement," implying that it was actually anti-theatre. (It wasn't. Disruption isn't the same as destruction.) Here's what the book tells us, in the tiniest of nutshells: After setting up the groundbreaking 7:84 Theatre Company (named because 7 percent of Britain's population owned 84 percent of its wealth), he took up a job in 1970 at Liverpool's Everyman Theatre. What he immediately noticed was that there was a tangible dislocation and difference between the culture inside and outside the theatre walls. Inside was frosty, intellectual, polite. Outside, the city hummed with music, poetry, art and comedy, a popular cultural explosion of vibrant ideas that ran through the pubs, clubs and dance halls of the city. He vowed to change this, to let the city into the theatre, and to reclaim theatre for working-class people who had been alienated from it. In short, McGrath was in love with storytelling but asserted that the way we were telling our stories onstage was frigid and mannered.

Rod Dixon cast himself as a character born from both McGrath's manifesto and the pages of *The Beano*. At an early rehearsal for one of the touring shows we made together, he introduced himself to the assembled cast by playfully dropping his trousers, unaware that the underpants he was wearing didn't fulfil the simple function of hiding his bollocks from plain sight. *Oops*, he said. Sometimes he'd overstep the mark and upset people. But like a Liverpudlian Malcolm McLaren, he wasn't afraid to put his foot in it. Nursing his coffee across the table from me, he pauses and thinks before saying, "I'm not sure it works if you set out deliberately to disrupt. It's like an alchemy, it's to do with time and place ... I think if you try to plan that sort of thing, nine times out of ten you look like a dick. I've gone out to be disruptive and I end up looking like a grumpy, awkward sod." But then, another pause. "But sometimes I can't help myself. When I left a previous job in theatre, someone made me a T-shirt that just said

JUST SAY WHAT YOU THINK ROD, DON'T HOLD BACK

... and it is a flaw, I'm embarrassed sometimes. But there's a place for it, for putting your foot in it."

Despite how it sounds, though, Rod's devil-may-care attitude comes from a place of deep, thoughtful care both for theatre and for the world. He wants this art

form to have meaning, to say things about us and about the state of the nation. To make people think. He doesn't want the niceties and pleasantries of a careful and polite theatre. Rod tells stories of how delighted he was when, at one of Red Ladder's shows, he spotted a Tory councillor in the audience who was guffawing guiltily to a comedic song about police brutality. More than once I've been with Rod as he's left a theatre production during the interval, saying, "Well, it looked good. The set was good. The acting was good. The casting was good. The music was good. But what was it saying? Nothing."

In truth, Rod Dixon's ideas belong less to the cosy Playhouse café we're sitting in and more to the skateboard kids out there below us, claiming the space, (mis)using the urban sprawl, transforming all the carefully planned neatness into a messy, lively playground. Rod's own "disruption" moment is a lovely recounting that brings the story back full circle to Liverpool's Everyman Theatre.

"There was a girl who went to St Julie's, the girl's school near us, we used to walk past each other on the way to our separate schools. She was gorgeous! Then one day I got back late after school and she was heading back the other way, into the city centre. I said:

Where are you going?

I'm going into town.

Where?

To the Liverpool Everyman.

What's that?

It's a theatre. Come with me.

Why, what is it?

Youth theatre. Learning to act. Just come with me.

"So I did, I followed her to the Everyman and started doing theatre. I didn't tell anyone for ages. But it was a laugh, and it was fucking brilliant!"

I ask if he knows what happened to the girl. Rod doesn't know, and I tell him he needs to find her somehow so he can say thank you. He replies that, no, that would be stalking.

As we gather our coats and cups, I wonder whether finding someone from your past to say thank you to them can be classified as stalking, and then I decide that it doesn't matter, since this is my final thank you. The skateboarders outside are still getting back up again, and again, and again, as Rod gives me an almighty hug.

"No patting," I remind him.

"No patting," he agrees.

Making It Up as You Go Along

Ideas without action aren't ideas.
—Steve Jobs

Yes they are.
—Me

In the economic sinkhole of the mid-1970s in Britain, a gradual gathering of homeless people in West London began to squat empty and near-derelict homes in and around the Freston Road area. The houses had previously been earmarked for demolition as being "unfit for human occupation," but instead, people moved in, cleaned up and began to renovate and rejuvenate these terraces of condemned housing, working together to create an ad hoc community. They had their own pub and meeting space, shared garden spaces and a plan of action that kept the houses fit for purpose— with free (stolen) electricity, a regular news sheet and a semblance of equality, freedom and communal living.

But in 1977 the Greater London Council, seeing how the area had developed way beyond their control and seemed to be taking on a life of its own, announced that they were going to bulldoze Freston Road and evict its two hundred occupants. An emergency meeting of the squatters led to the immediate declaration of *the Independent Republic of Frestonia*. The threat of eviction strengthened the community and transformed it from a loose-knit cluster of homeless idealists into a self-proclaimed nation-state. They flew their own flag, made their own stamps, and designed and printed their own passports, announcing to the media that they were devolving from the UK and as such demanded the rights of any European nation-state.

This response worked beautifully: the traditional oppositional

approach (barricades, bailiffs, heavy-handed police, arrests) was utterly undermined by the Frestonians' comically absurd declaration of independence. They were invited onto national TV news programmes and made the daily newspapers, adopting the Latin motto *Nos Sumus Una Familia*—We Are All One Family—and compounding their approach by applying to join the United Nations and writing their own national anthem:

"Long live Frestonia! Land of the free!"

The wit and ridiculousness of the Frestonians' actions became their saviour. Of course, they were never going to create some kind of separatist squatters' haven. But the publicity they gained meant the GLC had to tread uncharacteristically carefully, and through extended negotiations an agreement was made, guaranteeing that all the current residents would be properly rehoused.

Frestonia was an idea that grew, in its beautifully unplanned way, into several other ideas…and eventually into a story that just sort of stumbled into an ending. It took two hundred people to have faith in it as an idea, two hundred people to allow it to be made up as it went along, and two hundred people to see it become something real and practical. "Ideas," says renowned comic book writer and anarchist Alan Moore, "are bulletproof." What you do with those ideas, how you can allow them to blossom without relying on the straitjacket template of traditional storytelling, is a measure of how exciting they will become.

> My approach to any medium is like the first I ever worked with as a child, clay or plasticine; the thing to do is play with it, see its possibilities and feel it in your hands, see what shapes you can make from it. And that is basically how I approach any medium. It was how I approached comics, magic, how I approach everything, and that is the fun for me, is that play, that exhilaration, seeing all the new things that can be done with that specific medium.
> —Alan Moore

That's My Story and
I'm Sticking to It

We were the people who were not in the papers. We lived
in the blank white spaces at the edges of print. It gave us
more freedom. We lived in the gaps between the stories.
—Margaret Atwood, *The Handmaid's Tale*

My old friend Daniel is talking on the phone from Vienna, where
he lives and works. As he talks I'm looking at the framed photo-
graph of him on my living room wall, posing in a claret-and-blue
Burnley team shirt, kneeling as if for one of those 1970s football
cards. The photograph is from the 1990s, when Daniel was
Danyella. The beautiful androgyny of that picture links perfectly
with the story Daniel is telling me, which takes in the Bay Area
punk scene, a Hollywood soap opera and a tale about cooking
lobsters.

The story is complicated, as a lot of stories inevitably are. Real
stories, I mean—not the ones we watch on TV. Greek scholar
Heraclitus said, "No man ever steps in the same river twice, for it's
not the same river and he's not the same man"—*everything flows*,
he wrote. He believed in the changing nature of life, and argued
against previous teachings that described the world as static.
Static like a soap opera, which, by its nature, has to cycle the same
characters around and around, irrelevant of the huge upheavals
and tectonic shifts going on around them.

Here's Daniel's story.

At some point in the gradual, complicated switch from Danyella
to Daniel, sometime around 2003, he/they landed an audition for
a Hollywood TV series called *The L Word*, a groundbreaking show
that featured TV's first ensemble cast of lesbian and bisexual

female characters. Daniel was cast as Moira, who over the course of several seasons would be transitioning to Max. This was ground-breaking—a first TV fictionalisation of a complex and important subject.

But before we get to see Daniel-as-Max-as-soap-opera-character, let me go back further to that San Francisco Bay Area punk in the early 1990s, touring with her band, helping to set up queer spaces and writing for zines. "We had a monthly music night at the Epicenter Record Store collective called QTIP: Queers Together in Punkness. Our community was intergenerational and diverse in terms of gender and sexual identities that were in constant flux." So for over a decade, Danyella was centred in that diverse and changing punk community, exploring gender and sexuality in a scene where *everything flowed*. When Danyella signed up for *The L Word* she was expecting to bring these ideas with her—she believed that her character—Moira, then Max—would challenge normative roles and assumptions. She was wrong.

The L Word's trans character was, instead, straight society's version of trans: a conflicting and conflicted counterbalance to the corporate, feminine main characters, and a caricature of masculinity and anxiety. The message was: transitioning is hard, and painful. At the point that Max exited the show, he was left, ridiculously, pregnant and alone. What compounded Danyella's worries about the character she was playing was that the mainstream media repeatedly referred to Danyella as "a cis actor"—not only a badly written character but a *fake* badly written character.

The show's writers were out of their depth; the world was changing and they couldn't keep up. When a reporter in an old John Ford movie declares, "If the truth and the legend don't match, print the legend," he's telling us how Hollywood tells its stories, and in the case of Max in *The L Word* it was a story that was sensationalised, rendering Max as an oversimplified caricature. One episode had the cast of beautiful, shimmering, gossipy femmes around a table in a restaurant eating lobster. As the "ladies" chat and laugh, Moira/Max launches into a sordid and depressing tale of how lobsters react when they're being boiled alive.

I know something interesting about lobsters. You
don't have to put a lid on the pot when you cook
female lobsters. Does anybody know why? When you cook
a pot of male lobsters, and they realise they're in
this pot of boiling water, they all start totally
freaking out, they're like, fuck, we gotta get out of
here! And they start making these little ladders and
helping each other get out of the pot. So you have to
put a lid on the pot to keep them inside.

The table is quiet now. There's a tangible awkwardness as Max
drags the atmosphere down, down, down.

But female lobsters? You don't have to put a lid on
the pot, because once they realise they're in a pot
of boiling water they all just start grabbing each
other and holding each other down. They're like, "If
I'm gonna die, everyone's gonna die." None of them
wants to let any of the other ones get out of the
pot. It's a real shame, isn't it?

The ridiculous thing about this party-spoiling tale—a ham-fisted
way to characterise Max as moody, alienated and woman-hating—
is that it's not true. It's a myth; whatever the screenwriter wanted
to say concerning the communal males versus the selfish females,
the story is simply made up. Print the legend.
 There's a story told by English folk legend Martin Carthy. (He
tells a lot of stories, often while he's onstage tuning up. The stories
are generally longer than the songs he's talking about.) He says
that he noticed as a young man that a lot of male folk singers have
a "folk voice"—a sort of quivering warble that somehow sounds
like a "proper" English folk singer is supposed to sound. For years
he wondered why people who talked in a generally normal voice
would suddenly adapt this "warble" to sing traditional songs. At
some point, given access to the extensive music library at Cecil
Sharp House, he was able to listen to original recordings of the

great folk singers of the past, recorded onto wax cylinders by collectors like Percy Grainger and Cecil Sharp himself. The Edison Bell phonograph that was used to make the recordings just after the turn of the nineteenth century—between 1903 and 1907—was a rough and precarious machine that captured the performances onto a wax cylinder which, when played back, inherited a slight wobble due to the instability of the machine. And that wobble, thought Martin—that was what the up-and-coming folk singers of the 1960s were imitating.

What I'm trying to say is that often stories get stuck in a time, they represent just one version of a thing, a single viewpoint in a single moment—and that there's a danger that, as is the case with Hollywood and *The L Word*, that version of the thing can become the truth. Daniel said, in an interview with Drew Burnett Gregory for online publication *Autostraddle*:

"When I got the job on *The L Word* I was excited about the possibility of telling our stories. I thought my character could be the story that would represent queer outsider people. And once I realised it was going to be a trans story—which wasn't something I knew when I first got the job—I thought we'd get to show a thriving, amazing person and community and a lot of what I had been experiencing for fifteen years. But that wasn't the case. And I'm just an actor. I didn't have control over the storyline. At first it was just cool to have a job! All my friends were blown away, like 'what, you're on TV?? This is crazy!' But then I started to have misgivings—they're going to tell it like this? Why are they doing that?"

In the case of Daniel and *The L Word*, there is a happy ending (of sorts). The criticism that the show received from the very community it was trying to portray meant that, years after the series had seemingly aired its final show in 2009 (after six seasons), Daniel was approached by the show's producer Maija-Lewis Ryan and asked if she'd appear in a sequel called *The L Word: Generation Q*, which would try to address some of the issues the original had got wrong. In the original series, Daniel's character, Max, had been left alone and with no resolution—Ryan told Daniel that "Max has

meant so much to me and my generation, and I really wanted to see him thriving and happy and having a great life like he deserves." The show was made, and apologies were offered; Daniel wasn't the only trans person on set anymore, and it felt like the show's writers were now catching up with a changed world.

The show's original executive producer, Ilene Chaiken, had formerly said, "I won't take on the mantle of social responsibility. That's not compatible with entertainment.... I am making serialised melodrama. I'm not a cultural missionary." This was said even as the show's publicity advertised it as "groundbreaking." If you choose to make a TV drama—and create a character—that tells a story of gender politics, against a real-world background noise of polarising culture wars, then you'd damn well better be prepared to take on that mantle of social responsibility.

By the time *Generation Q* was made, it was clear that the producers were more in tune with a changing world and were now prepared to take on that duty (a duty of care) of being cultural missionaries. That's what Daniel wanted all along—what punk had taught him—change, challenge and community. Everything flows.

"My story matters. It took me a long time to realise. It matters because it happened and because it's useful to people. 'Oh, Max, he's just a guy in a soap opera, he doesn't matter compared to stuff in the real world.' That's not actually true, because his story is part of the imagination of generations of people who got us here. And it matters because I'm a representative of those people."

A Lovely Mess

It contradicts everything, revolutionises everything,
overturns everything in me—astonishes and overwhelms
me as much as overjoys and intoxicates me.
—Austin Dickinson, letter, 1882

That's love, unpredictable, shocking and chaotic. For while being
the central pivot for so much of our nicely crafted storytelling, it is
also one of the greatest disrupters of real-life stories. We're prepro-
grammed to understand how and why people fall in love, but are
so often surprised when love doesn't behave in the way we expect
it to. There's the nagging, growing attraction, the kind of love you
really don't want but it just keeps on tugging at your sleeve until
you can't ignore it. There's the boom-blast shock of head-over-
heels infatuation, the kind of love you could never have prepared
for. And in between these two, a spectrum of love-disruptions that
turn the narrative upside down and inside out.

Meet Angela King, twenty-three years old, stalking the bars of
South Florida as part of a gang of violent Nazi thugs. Angela has a
swastika tattoo on her finger and the words "Seig Heil" etched into
her lower lip. This is the late 1990s. The gang carry firearms, rob
stores at gunpoint and mercilessly attack strangers. Then, after one
such rampage, King is caught and arrested, tried and sent to prison
in Tallahassee, where Jamaican prisoners immediately single her
out as a committed racist.

Angela says that one day she was walking down a corridor when
a Jamaican inmate, "a notorious badass," challenged her about her
racist views. The two began to talk. They became friends, then
cellmates, then lovers, the first serious gay relationship either had
ever had. After several years, King was released from prison. One
of the first things she did was start having her neo-Nazi tattoos

removed—which she replaced with a new tattoo, reading simply:

love is
the
only
solution

This is from *Brain World* magazine: "People in the early throes of love have brain activity that matches the brain activity of a drug addict in need of a fix. It's involuntary. The brain's fear-alert system —the amygdala—and our judgment and reasoning system—the anterior cingulate cortex and prefrontal cortex—are nearly muted while the neurotransmitter dopamine floods the brain's pleasure and reward centers. What's more, brain circuits associated with states of obsession, mania, and recklessness are also activated. Amphetamines, cocaine, and opiates such as heroin, morphine, and OxyContin trigger these same circuits."

Plato was right when he wrote in 370 BC that "love is madness," but the best part of the madness, as the scientist tells us, is involuntary. (Wise men say, "Only fools rush in," but I can't help falling in love with you.) Humans as a species are driven to survive, and reproduction is the most important part of survival. "The brain is naturally selected to focus on reproduction, even if you're not consciously intending to do so," says Loretta G. Breuning, PhD. She may well have gone on to offer the following scientific analysis: "Like the river flows surely to the sea, darling, so it goes, some things are meant to be." The surge of hormones and chemicals that overwhelm the body when you fall in love overrides your logical, rational thought. It's this powerful act of overriding that means neo-Nazi Angela King could fall in love with someone she perceived as her enemy. Falling in love also takes over a lot of mental space, stopping us from spending time following the accepted,

learned, routine patterns we already have in place. We become, for a while, someone who is learning things for the first time. Love is a shock tactician, lurking, ready to pounce.

> Love is merely a madness; and, I tell you, deserves as well a
> dark house and a whip as madmen do; and the reason why
> they are not so punish'd and cured is that the lunacy
> is so ordinary that the whippers are in love too.
> —William Shakespeare, *As You Like It*

And then there's heartbreak. A study made of songs written since the 1960s showed that the majority (67 percent) were, in various guises, about love. And of these, twice as many were about heartbreak than about falling in love. Singer Nick Cave told an audience at a poetry festival in 1999 that "the love song is never simply happy. It must first embrace the potential for pain. Those songs that speak of love, without having within their lines an ache or a sigh, are not love songs at all." (I assume he's never heard "Teenage Kicks," but we get the picture.)

Scientists call the pain of heartbreak "stress-induced takotsubo cardiomyopathy," or more commonly "broken heart syndrome." Psychologists have long asserted that the pain of a broken heart is a necessary part of our survival instinct—a "social-attachment system"—and it's there to encourage us to maintain long-lasting relationships. Which possibly explains why we are so attached to heartbreak songs; perhaps, too, they are just easier to write than love songs. Falling in love is such a chaotic emotional turmoil that it isn't easy to describe.

"(Sittin' On) The Dock of the Bay" is a song cowritten by Otis Redding and his collaborator Steve Cropper. Steve played guitar in Booker T & The MGs but, more significantly, co-wrote a clutch of classic songs with some of the best Stax and soul artists ("Knock on Wood," "In the Midnight Hour"...). The way Steve talks about the writing of "Dock of the Bay" has always fascinated me, and reminds me of the story my friend Alice told me about rain being added to a TV scene to double the sadness. Different people place

the song's origin in various places, but the most likely seems to be in the houseboat community of Sausalito in California, during a six-night string of shows at a jazz club in North Beach. This was August 1967, and the houseboat belonged to infamous promoter Bill Graham. According to Steve, Otis came up with a title along with a tune and a few scraps of lyrics, including the line "Watching the ships roll in...and then I watch them roll away again." What Steve claims to have added to the song's lyrics is crucial; where Otis was fixated on the gorgeous lilt of the tide, the solemn peace of that ebb and flow, Steve thought the song needed some of that cardiomyopathy—broken heart syndrome. The universal sadness of being lonely. A selection of the lines Cropper added were:

> *I've had nothing to live for*
> *Look like nothing's gonna come my way*

> *Looks like nothing's gonna change*
> *Everything still remains the same*

> *Sittin' here resting my bones*
> *And this loneliness won't leave me alone*

And then, with a turn of phrase, we're not just "wasting time" anymore, we're depressed, alone, fearing for our future. And that feeling cuts deep, strikes that big old universal chord (a minor seventh...) and draws us into its world of heartache. And, sod Aristotle and the three-act structure, there is no happy ending, no resolution. Just a whistle that cuts deep as a knife—a whistle that Otis originally used as a placeholder since he knew he wanted to add more words there, words which were never written because (adding to the pathos) he died in a plane crash shortly after the recording session. It feels callous to write it, but there's something about the tragedy of his death, the hopelessness of the lyric—nothing to live for—alongside the catchy melody and that unforgettable whistle that makes the song just perfect.

Shakespeare knew how to write tragedy, and to make it popular.

Watching *Hamlet* some years ago, for at least the third or fourth time in my life, I still forgot how incredibly tragic is that final scene, where almost every major character, including Hamlet himself, lies bloodied and slain on the stage. Hamlet's dying words are simply:

The rest is silence.

After which Shakespeare adds, as a stage direction—

[Dies.]

Shakespeare doesn't make it easy. He's trying to tell not just a good story but a truth. We all know the line *If music be the food of love, play on*. From *Twelfth Night*. But the lines immediately following it, we might not: *Give me excess of it, that, surfeiting, the appetite may sicken and so die*. This is Duke Orsino speaking to his friends, and he's basically saying, "Let's be honest, being in love is great. But it can also make you sick. Sick enough to fall out of love."

Love is a complicated business, designed to disrupt. There are no easy patterns, no fixed structures—if anything, there is a tangled structurelessness. Whenever friends and relatives visit from other countries, I have a set collection of places I like to take them. Most people know Britain as a roll-call of London-centric tourist attractions, so it's rewarding to show off the North, a spread of odd and beautiful places ranging from the fading garishness of Blackpool to the geological wonder of Malham Cove, the stone-solid history of Hadrian's Wall to the picturesque bustle of Whitby Harbour. Somewhere in that tick-box of places to visit, should visitors stay long enough, is Heptonstall, a tiny dark-stoned village perched on a hilltop above the Calder Valley, all cobbled streets, centuries-old inns and breathtaking views across the Pennines. Heptonstall has two poignant attractions (though to call them attractions seems wholly wrong): the burial place of the leader of the infamous Cragg Vale Coiners, a gang of eighteenth-century counterfeiters (and, locally, heroes) who were eventually hanged,

and the final resting place of the poet Sylvia Plath, whose grave in the sprawling Heptonstall cemetery is a place of pilgrimage for poetry-lovers and feminists (if pushed, I'd call myself both).

Sylvia Plath died a tragic death, committing suicide while her two children slept, and her writing on the agony of lost love makes it hard for her to escape the mantle of "doomed genius." She wrote (in both poetry and in now-published journals and letters) of her marriage to poet Ted Hughes and their turbulent, fiery life together in a remote house in the Calder Valley, settled into the valleyside half a mile away from her eventual grave. Ted and Sylvia met at a party in Cambridge in 1956 and fell immediately in love—a fierce, passionate romance that grabbed their creativity and whirled it around, the pair spinning together into marriage within the year.

That is the story's beginning, a beginning we can know and understand. The story's middle (to cut a long paragraph short) is a muddle of alleged literary inequalities between Sylvia and Ted, her sewing the fraying cuffs of his jackets and preparing dinner for the children, him winning literary prizes and heading off across the world to accept them. And what might be the end of the story is not really an end at all, it's mainly a fog of war, starting with Hughes as adulterer and stumbling towards Plath's modest headstone in Heptonstall. Plath had attempted suicide several times and was later known to have been bipolar, so it was an oversimplification to lay the blame for her death at Hughes's feet. Nevertheless, Ted didn't help himself by setting up himself and his sister Olwyn (who was openly hostile to Sylvia) as legal gatekeepers of Sylvia's legacy. Ted eventually published some of Sylvia's work, but along the way he adjusted and reorganised some of her words, leaving himself open to criticism from what he called "the libbers."

This is where the Heptonstall headstone becomes a material witness to the ongoing chaos: the name etched into the pale stone is "Sylvia Plath Hughes," and over the years there have been repeated attempts to scratch out the "Hughes," sometimes resulting in the stone having to be removed for repair. The accused "libbers" (such an ill-advised word for Hughes to use—a dialogue-closing,

dismissive and belittling word) are trying to rescue Plath from being seen only as an adjunct to the towering and legendary Hughes, while Ted himself, eventually, replied in 1998 by publishing *The Birthday Letters*, a collection of poems about his marriage to Sylvia. Despite Hughes's confessions of enduring guilt and love, there is no conclusion to Sylvia and Ted's story—only the tumult and bedlam of varied accusations. Maybe the badly scratched-out name on a headstone says as much about love as Shakespeare's *Romeo and Juliet* ever could. Paul Valéry, French poet and essayist and a prolific writer of poetry, philosophy and fiction, is best remembered as the author of a single, succinct phrase:

Love is being stupid together.

A Man Walks into a Library

A man walks into a library. He asks the librarian—"Do you have any books on shelves?"

When you ask a writer if there was a book that changed their life, they'll often talk about a book that was so inspiring that it made them want to be a writer. Simon Schama says: "I read Richard Cobb's *The Police and the People*. I had never read anything like Cobb's exercise in total immersion.... That was the kind of history I knew I wanted to write. I still do." Zoë Heller: "A couple of novels that I read in my teens—*Middlemarch* by George Eliot and *Our Mutual Friend* by Charles Dickens—made me want to be a writer." Somehow this isn't the same as reading a book that upturns the tables and walks off with your life. It's more about being inspired, not changed. I prefer Jay Griffiths's version of the book that changed her life:

"There was one book when I was about eleven, it was Heinrich Harrer's *Seven Years in Tibet*, it was on a bookshelf in my father's library. I'd seen the title and I couldn't physically reach it... but it looked amazing. Growing up in middle-class Surrey, nobody mentions places like Tibet, but I knew that as soon as I was eighteen I would try to go to Tibet. I got as far as Dharamshala in northern India, which is where the Dalai Lama lives, so it's kind of like a little Tibet."

I'm sitting with Jay in her living room in small-town mid-Wales, the scene set to optimum cosiness by a wood-burning stove, a small piano, two big old squishy sofas and a blind cat called Twilight. Jay is a proper writer, a writer's writer; she gets up and sits at her desk and pours her heart and soul into every word, every day. So I love that the earliest inspirations she took from reading were not to be inspired to sit and write but to head out into the world.

[319]

Stories can make you do that, can act as wake-up calls, can light up the cartoon bulb in your mind that says, here's something you hadn't thought about before. Now, of course, we can scroll through digital stories in a thousand formats, but for many of us a good place to start would have been the library. I assume I'm not the only person with a distinctly nostalgic view of my hometown library, an island of ideas in a sea of adolescent mischief, football and vinyl records. Saul Bellow said, "People can lose their lives in libraries. They ought to be warned!"

Libraries, even now, are quiet places. Despite the shift away from the oppressive historic cliché of the shushing librarian and the advent of the public library as a community hub stocked with computers and kids' reading clubs, the library still has an atmosphere of calmness and communal orderliness unlike other public spaces. But look, see the people browsing through the shelves, reading snatches of pages, trying this, trying that—see the people savouring the warmth, bags at their feet and heads buried in books at the short tables—see the child following words with her finger in the big square fantastically illustrated hardback—see the student copying sentences into a notepad with a left-handed slant—all of them have the noise of other worlds and other places in their heads. A cacophony of ideas and adventures. Paula Poundstone writes that *the truth is, libraries are raucous clubhouses for free speech, controversy and community.* And somewhere, today, in one of these libraries in a town somewhere near or far away, someone will read something that will truly change their life.

When I wrote a book about mountain running over a decade ago, I had a meeting with the publishers in a swanky London office where someone brought tea and biscuits and the chairs reclined by simply leaning back, in a way you don't want them to in a meeting. As we sat around discussing this book about scrambling up and down hills, one of the people who worked in the swanky office said, "You mustn't write in a way that encourages people to try doing what you've done. Yours isn't a 'how-to' book, those books have very limited appeal. No, what people want to read is about something they wouldn't contemplate doing them-

selves. When you write about the Ben Nevis race, you're not selling your reader the idea of doing it themselves—they don't want to run up and down Britain's biggest mountain in shorts and a vest. They want to sit in their armchairs and read about an adventure they don't fancy doing themselves. The biggest-selling sports books in the world are mountaineering books. Books by people who climb the world's highest mountains. The readers don't want to conquer Everest—they want to read about it, in front of a nice fire and a holding a glass of whisky."

This makes a lot of sense (and it sells books). The story stays in its place as a story, with its beginning, middle and end (person decides to climb mountain, person gets to the top despite various difficulties, person returns home safely). But an essential part of any book is the reader. The reader's imagination. And sometimes, beautifully, the reader's involvement can stretch beyond that of passive companion and stray into a world where the reader stops reading and follows a thought that the book has sparked up, a flash of an idea that is allowed to grow into something unexpected. I can't imagine a bigger compliment to an author than, "I read your book and it made me get off my arse and..."—and whatever, anything, something.

Jay is thinking back to her childhood now and her memory-eyes are casting across the bookshelves in her parents' home, seeing the embossed titles and the colours in the hardback spines. Memory settling on the books that still strike a match somewhere in her brain, a somewhere where something changed, something fundamental and important.

"There was a series of kids' books by Willard Price called *The Adventure Series*, with titles like *Amazon Adventure* and *African Adventure*, about these two brothers, Hal and Roger... and they went out across the world, they had a powerful effect on me—knowing there is a world that isn't wretched small-minded stock-broker-belt Surrey. There *is* a world out there!"

This is proper derailing of ideas, in the sense that a door is being opened up in an otherwise blank wall. A lot of people think back to a book that changed their life and come up with, instead, a

book that taught them something. There's a difference, isn't there? Great books really do teach us things about our lives, about morality, love, fear, the big stuff. *To Kill a Mockingbird*—who can read that without coming to an understanding of racism, privilege and the law? But then there are sometimes books that change us, that fundamentally alter the course of our lives.

Here's mine (despite extensive research into which books have changed people's lives, I can only think of one for myself). It's not even a book. I don't know what it is, to be truthful. It's a series of books, or booklets, and it's called *Anarchism Lancastrium*. I was given that first copy sometime around 1978, by a friend in Burnley called Spider. Yes, he did (and still does) look sort of spider-like. Spindly limbs in snug-fit black jeans and a black leather jacket. He'd already introduced me to a meeting of the Direct Action Movement, a weekly get-together of older blokes discussing syndicalism and vanguardism. One meeting was enough; I didn't go back.

I'd heard about anarchism as a political theory but had never read anything other than oblique references to writers and historic champions of its cause on record sleeves. Then Spider gave me a copy of *Anarchism Lancastrium*—a literary magazine in a landscape shape, printed by hand on a letterpress printer, a collection of scurrilous jokes and scholarly essays, rumours and diatribes, insights and cartoons. It included free stickers and leaflets along with one page made of government-issue toilet paper. Every page was a patchwork of different-sized lettering, marginalia and upside-down quotes. This book—or whatever it was—this book shocked me into taking its ideas seriously. Of course! Life's stories, its politics and its history, its troubles and its love affairs, its joyous ups and its doomy downs, don't have to exist in neatly set blocks of dense type, they can come at you in unexpected ways, like this thing I was holding, this magazine/book/missive/compendium/pamphlet/manual. Manual, that's the word. A manual where the instructions aren't instructions at all but starting points to your own discoveries.

Anarchism Lancastrium was the brainchild of lifelong anarchist

Peter Good, whose hand-printed concoction eventually morphed into *The Cunningham Amendment*, Peter's continuing attack on the staid and the formal and the neat-and-tidy everydayness of war, poverty and inequality. Good's own book-that-changed-my-life, I heard in an interview, was a copy of *Freedom* magazine from a newsstand in Manchester at the age of fourteen, which he "read and read and read." I find something fascinating and fantastic about other people's stories of disruption, of the moments where they changed—Paul on the Road to Damascus, seeing a newsstand where a dusty old newspaper seller is waving the last copy of *Freedom* and shouting, "Man Stops Persecuting Christians! Read all about it!"

So I nosed around a bit and asked people which book, if any, changed their life. Most of the initial responses were about books that didn't so much result in a life-altering upheaval but instead contributed to a shifting of ideas about the world. All very well, but I was looking more for the revolution rather than the evolution. Less shifting, more upheaval. Songwriter and mother-of-five-daughters Tracey Curtis told me that the book that changed her life was *Unconditional Parenting* by Alfie Kohn. "Because," she said, "it changed the way I parented."

Janet Swan: "*To Kill a Mockingbird*. It made me question everything, join groups for change and solidarity, maybe even become a speech therapist—the story of Boo Radley spoke to me as much as that of Tom Robinson."

Nick Hall: "*Swallows and Amazons* made me want to spend as much of my life outdoors and in the countryside as possible...I read it at a pivotal moment in my young life."

I loved finding out how many people have read books which literally (ha!) changed their lives. Interestingly, of all the people who told me about a life-changing book, only one person nominated a self-help book, a book specifically written to help people change their lives. Linda Leaa Sardi told me about *S.U.M.O.—Shut Up, Move On*, a straight-talking guide to succeeding in life, it says on the front. I have to admit, that kind of front-and-centre claim would have me running in the opposite direction, but Linda

said, "I met the guy at a conference and all the things he said really got in my head. I read the book and think about it almost every day. So simple—and I guess lots of people write similar stuff—but in order to change you have to want to."

My favourite is from Jules Gibb, a committed radical voice and inspirational choir leader. She said, simply—"The book that changed my life was Steinbeck's *The Grapes of Wrath*. It led me out of the military and into activism." In the right hands, books are dangerous, powerful things. The infamous 1933 Nazi book burnings were held in the cobblestoned Bebelplatz in Berlin. Students and professors, accompanied by bands playing music, burned over twenty thousand books written by mainly Jewish, communist, liberal and radical authors, before a large audience at the university's Old Library. The burnings, attended by around forty thousand people, were part of a movement to eradicate any "un-German spirit." Bertolt Brecht's clever reply to the spectacle was to write his poem "The Burning of the Books," which tells the story of a banished writer, who, upon scanning the lists of "excommunicated texts" and seeing that his name is not on there, becomes enraged. He writes a letter "to the morons in power," and with "his blazing pen" he demands, "Burn me!"

Here's an old joke to book-end this section (Fiction, Humour, J):
I hear that Donald Trump's library has been burned to the ground. Tragically, both books were destroyed. To make it worse, he hadn't even finished colouring in one of them.

Weather Events

Do it yourself: a screwdriver, a tin-opener and a radio.
When you hear the explosion—boom!—don't worry,
don't panic, because the windows are whitewashed.
The windows are whitewashed, so the neighbours won't
know that you've shit your pants.
 —Lyric by Dunstan Bruce, 1983

I grew up in a world where the fear of the H-bomb was everywhere. Nuclear warfare was our bogeyman, the sword of Damocles, the big *BUT* that threatened to interrupt our ongoing story. While we laughed at the government's comically inadequate preparation for nuclear attack, we acknowledged that the threat was real and it was scary. The women surrounding Greenham Common airbase —with its arsenal of US nuclear warheads—made it clear to us that we were a strategic target. Similarly, accounts of what had happened at Hiroshima and Nagasaki reminded us of what being targeted meant in tragic human terms.

In 1984, in a weekly live broadcast from his ranch in California, US President Ronald Reagan was caught on TV cameras jokingly issuing a statement saying, "My fellow Americans, I'm pleased to tell you today that I've signed legislation that will outlaw Russia forever. We begin bombing in five minutes." That someone in charge of the world's largest nuclear arsenal could talk so frivolously while a camera was pointed at him only compounded the sense that all-out nuclear war was possible. General Power (you couldn't make it up), in charge of US Strategic Air Command in the late 1950s, came up with the idea of ensuring that a number of nuclear-armed bomber planes were always in the air so as to survive (and retaliate, after) a first strike by Russia. He once argued against restraint in warfare, saying:

The whole idea is to kill the bastards. At the end of the war, if there are two Americans and one Russian left alive, we win!

This was the grim reality behind all those CND marches and anti-war songs that I grew up with, marches that usually culminated in Trafalgar Square with prominent union leaders giving speeches and every shade of lefty group trying desperately to get you to buy their newspapers. And we had music to remind us of the bomb, music from Gil Scott-Heron, from Paul Weller, from Poison Girls and Crass, we had films and TV dramas, poetry, art and a million badges and stickers. The fear was everywhere. And then ... then it wasn't.

There are all sorts of reasons put forward as to how that global fear of the bomb became little more than a background hum, but the most obvious one is simply ... we forgot. We forgot about Hiroshima. The generation that grew up with the horror that was the destruction of an entire city from just one bomb simply got old and died. If you were old enough to register the news of the attack in 1945, you would now be approaching ninety years old, reminiscing quietly about Gil Scott-Heron in his denim bucket hat at one of those huge CND gatherings singing "Shut 'Em Down." (Harsh, I know, but despite not approaching my nineties, I count myself as one of the "reminiscing class," growing up in a world before digital technology.) For us, Hiroshima and Nagasaki were the disruptions that alerted us to the horrific possibilities of nuclear war. Do we really need these disruptions to wake us up again?

As a writer you have a duty to be a messenger.
—Jay Griffiths

I'm talking about climate change. We know the science, and the predictions, and we know the warnings and the promptings. But somehow, it seems, the alarm clock hasn't gone off. I know people—clever, thoughtful people—who dismiss the catastrophic

changes that are destroying people's lives as "weather events. We've always had them." It feels to me that, just as we have let go of the tangible, visceral and human horror of Hiroshima, we (and by "we" I mean us in our northern hemisphere, centrally heated, digitally connected homes) don't have an innate understanding of typhoons, tsunamis, droughts and forest fires. What will it take to wake us up enough to force real change?

Ronald "bombing in five minutes" Reagan was known among journalists and aides for his ill-advised off-the-cuff ad-libbing, his sly distracted chuckle, his air of not-quite-understanding-things. And then the distractedness and the misunderstandings grew, and it became clear that Reagan was ill. His doctor diagnosed the former president with Alzheimer's disease. He and his wife, Nancy, had always toed the Republican line that any research into diseases like Alzheimer's which benefitted from the use of days-old human embryos was counter to their strict anti-abortion policies; one such line of research was embryonic stem-cell research.

But Reagan's gradual slide into the fog of Alzheimer's, which Nancy characterised as "slipping away to a distant place where I can no longer reach him," prompted his wife to become a champion of stem-cell research, to the point of setting up and funding an institute for research and study. She had witnessed at first hand the life-changing disruption of the disease and was now committed to finding a cure. This wasn't about ideology and political points-scoring anymore, it was manifest and palpable. For Nancy, it was the alarm clock going off.

Some time ago I was reading an article about climate emergency —and specifically our willingness to turn a blind eye to it—which was accompanied by a photograph of a tornado ripping through Kansas. Kansas has a lot of tornadoes, and I know that because of my thorough research of *The Wizard of Oz*. The twister picks up Dorothy and her dog Toto and deposits them in the Land of Oz, where she looks at Toto and says:

"I have a feeling we're not in Kansas anymore."

I looked up the weather records for Kansas and found, not unsurprisingly, that the state is indeed a hotbed of tornadoes, having

[327]

an average of around ninety each year—an average that, since the 1980s, has been going up and up. *The Wizard of Oz* is, like *Alice's Adventures in Wonderland*, a beautiful story that ends with the simple fact of "…and then I woke up and realised it was all a dream." Which, let's face it, is a cheap conclusion. But that version of an ending is ideal for a generation that has forgotten Hiroshima, that is content to sleep and dream that a hero will come along and save the day, and even if the hero doesn't turn up, someone gently says, "Wake up," and we realise it was all a dream.

I remember at school, studying history. A triple period on a Friday afternoon, three hours solid of tedious sequential textbook events, badly taught by a bored and sneering teacher who pronounced the word *bourgeoisie* as

<div align="center">

bore – gee – oy – seh

</div>

and dismissed us all as disinterested idiots and he was right because we were, we every last one of us hated the subject and the way we were taught it. And what he taught us was that history was a series of chronological events that fed into each other neatly and logically and any imbalances were temporary and everything always tipped back to the status quo, the way things are, the kings and queens and governments and wars and laws.

"1848—how do we describe that year, Whalley?"

"Sir I can't remember sir."

"We call it: the turning point in history upon which history failed to turn."

Hiroshima is forgotten. There's a strand of thinking that maintains that "history does not make leaps." It's called the gradualist approach, and it's a theory introduced by two Scottish geologists called James Hutton and Charles Lyell in the late 1700s. Jimmy and Chaz insisted that all change and variation are gradual in nature and happen over time, as opposed to in large steps. But these two were obviously forgetting about the comet that smashed into the earth and wiped out the dinosaurs. And they were long gone by the time Johnny Rotten appeared on television, looked straight at the camera and shouted:

GET OFF YOUR ARSE!

History is full of decisive moments of change, full of people shouting at the world to take notice, but inevitably we are too busy looking at the royal family waving from the balcony. Novelist Amitav Ghosh says that "it is a fact that catastrophes waylay both the Earth and its individual inhabitants at unpredictable intervals and in the most improbable ways." But do we take any notice of catastrophes? And if we do, are we doomed to forget them within

a generation? As I write this, today's BBC news headline—front and centre—is

AMERICAN XL BULLY DOGS TO BE BANNED BY END OF YEAR—SUNAK

Meanwhile, further down the page, smaller and much less shouty:

DEVASTATING FLOODING HITS EASTERN LIBYA

This second headline refers to an event where two dams burst in the wake of Storm Daniel in 2023, washing away entire neighbour-hoods with up to twenty thousand deaths. Storm Daniel itself was seen as a direct result of climate change—but still, our news out-lets prioritise a handful of dog attacks over twenty thousand lost lives and impending climate catastrophe.

The ten-kilometre-wide asteroid that plunged into the earth sixty-five million years ago, causing massive tidal waves, fires, almost complete darkness and the extinction of 75 percent of the earth's animals, was an unpredictable catastrophic event. But what we are strolling gently into, with our bully dogs beside us, is a catastrophe that we have predicted, that we have created, that we can see happening.

The *Guardian* newspaper has trumpeted its decision to alter its language on climate issues. They will no longer say climate *change*—instead it will be climate *emergency*. Global *warming* will become global *heating*. Climate *sceptics* must now be called climate *deniers*. Small steps, a slow evolution of semantics, gradual-ism in action. Meanwhile, the fossil-fuel companies and oil-mad nations continue on their merry way, greenwashing their dirty linen. What we need is a tear in the fabric. A shock to the system. Or as my grandad might have said, "a firework up their back passage."

We need this shock to our system, because this time
we are the dinosaurs, and this time too we
might not simply wake up in Kansas
realising it was all
a dream.

Epilogue

We are living in a world in which it is almost impossible to
be honest and to remain alive.
　—George Orwell

Significantly, neither of George Orwell's classic novels, *Animal Farm* and *Nineteen Eighty-Four*, have happy endings. Orwell simply stops both narratives at a point where hope has died, where resistance to power has been snuffed out. The pigs have become the new masters; Winston loves Big Brother. Such apparent finality, but also such honesty. Through all of his writing career, Orwell, to the best of his ability, refused to lie. He believed in, to quote Christopher Hitchens, "an elusive but verifiable truth." This took great courage, since he was simply unwilling as a writer to manufacture for his novels a classic story-form ending—a resolution—to soften the truth about the totalitarian, dystopian nightmares he was portraying in these two books.

"When I sit down to write a book," he wrote, "I do not say to myself, 'I am going to produce a work of art.' I write it because there is some lie that I want to expose, some fact to which I want to draw attention." In Orwell's writing, the truth trumps everything. If it leaves the reader with a sense of bewilderment or uncertainty, so be it. Orwell's last word on this came shortly after the publication of *Nineteen Eighty-Four* (his final book), in response to critics making inaccurate assumptions. He made the statement while incredibly sick with the tuberculosis that would shortly kill him. A statement that put the book's conclusion firmly in the hands of the reader. If you want life to have a narrative arc with a satisfying resolution—create it yourself.

"The moral to be drawn from this dangerous nightmare situation is a simple one. Don't let it happen. It depends on you."

But that's Orwell's ending, not mine. This book isn't a warning, or a call to arms; it isn't even striving for some kind of truth. (This book isn't quite sure what the truth is.) I have no reason to end this book with a sense of honest, brutal despair, especially after I've spent so much of time travelling around the country to visit those wonderful Disrupters. I want to end this book with the same sense of adventure that it began with: a journey through stories, stories about people, a winding, meandering celebration of tales that necessarily took in various stopping points telling my own story of life-changing meetings and friendships.

Sitting down with John and Sue from Welfare State International in their gloriously ramshackle house perched at the sea's edge in Cumbria, drinking tea and trying to fumble my way through the first of the book's thank-yous…what I got in return from them was a beautifully matter-of-fact sense of getting on with it, shoulders-to-the-wheel, cracking on with life and all its ridiculous twists and turns. And if they spin some young lad's life off its axis on the way, then good, and if he's going off to write a bloody book about all this, then great, and how about another cup of tea and have we showed you this poster for an event we're planning in the town?

Life goes on for us all in its messy and sometimes unpredictable ways, and it would do us good to pause for a moment and realise that we're not living in a script or a novel, that we're simply gathering threads along the way and seeing which ones tie up and which ones hang loose…this should have a Johnny Cash soundtrack, where he's singing about the ties that bind, "*I Walk the Line*" with its strange musical structure that skips up or down a key on every verse, up and down and up and down. (On the recorded version you can hear Cash humming the note he's trying to hit at the start of each verse.) So this is an ending that, while it might not be a classic Aristotelian resolution, lets the book find hope in the people it's met along the way. I love the truthful horror of Orwell's endings, but (that word again, right at the end)…but such an ending wouldn't fit in here. So here we are, I give you: *a happy*

ending.

About the Author

Boff Whalley is a former guitarist and songwriter with anarchist band Chumbawamba.

He has written several touring plays and large-scale musicals, created projects at Manchester Museum, Somerset House and the Tate Gallery, and composed for Welsh National Opera.

Boff has published three books (*Footnote*, Run Wild* and *Faster! Louder!*) and continues to write songs for the situationist Commoners Choir as well as collaborating with a wide range of artists and activists. He once had a job building plywood grottos for supermarket Santas.

When he isn't writing, it's a good bet Boff is fell running across the hills of Northern England, where he lives in Yorkshire with his family and a very old cat.

I muſt trouble the Reader to Correct the Errata *of the* Prefs, *as he finds them. For I am quite Tyr'd.*

About PM Press

politics · culture · art · fiction · music · film

PM Press is an independent, radical publisher of books and media to educate, entertain, and inspire. Founded in 2007 by a small group of people with decades of publishing, media, and organizing experience, PM Press amplifies the voices of radical authors, artists, and activists. Our aim is to deliver bold political ideas and vital stories to all walks of life and arm the dreamers to demand the impossible. We have sold millions of copies of our books, most often one at a time, face to face. We're old enough to know what we're doing and young enough to know what's at stake. Join us to create a better world.

PM Press · PO Box 23912 · Oakland, CA 94623
510-703-0327 · info@pmpress.org · www.pmpress.org
PM Press in Europe · europe@pmpress.org · www.pmpress.org.uk

FOPM MONTHLY SUBSCRIPTION PROGRAM

These are indisputably momentous times—the financial system is melting down globally and the Empire is stumbling. Now more than ever there is a vital need for radical ideas.

In the many years since its founding—and on a mere shoestring—PM Press has risen to the formidable challenge of publishing and distributing knowledge and entertainment for the struggles ahead. With hundreds of releases to date, we have published an impressive and stimulating array of literature, art, music, politics, and culture. Using every available medium, we've succeeded in connecting those hungry for ideas and information to those putting them into practice.

Friends of PM allows you to directly help impact, amplify, and revitalize the discourse and actions of radical writers, filmmakers, and artists. It provides us with a stable foundation from which we can build upon our early successes and provides a much-needed subsidy for the materials that can't necessarily pay their own way. You can help make that happen—and receive every new title automatically delivered to your door once a month—by joining as a Friend of PM Press. And, we'll throw in a free T-shirt when you sign up.

Here are your options:

$30 a month Get all books and pamphlets
$40 a month Get all PM Press releases (including CDs and DVDs)
$100 a month Superstar—Everything plus PM merchandise & free downloads

For those who can't afford $30 or more a month, we have Sustainer Rates at $15, $10 and $5. Sustainers get a free PM Press T-shirt and a 50% discount on all purchases from our website.

Your Visa or Mastercard will be billed once a month, until you tell us to stop. Or until our efforts succeed in bringing the revolution around. Or the financial meltdown of Capital makes plastic redundant. Whichever comes first.